Mary Magdalene

Mary Magdalene

A Visual History

Diane Apostolos-Cappadona

t&t clark

LONDON · NEW YORK · OXFORD · NEW DELHI · SYDNEY

T&T CLARK
Bloomsbury Publishing Plc
50 Bedford Square, London, WC1B 3DP, UK
1385 Broadway, New York, NY 10018, USA
29 Earlsfort Terrace, Dublin 2, Ireland

BLOOMSBURY, T&T CLARK and the T&T Clark logo are trademarks of Bloomsbury Publishing Plc

First published in Great Britain 2023

Cover design by Jade Barnett
Cover image: Bernat Matorell, *Altarpiece of Saint Mary Magdalene from Perella* (1434–52: Museu Episcopal de Vic, Vic). © Museu Episcopal de Vic, photograph by Gabriel Salvans.

A catalogue record for this book is available from the British Library.

A catalog record for this book is available from the Library of Congress.

ISBN: HB: 978-0-5677-0574-7
 ePDF: 978-0-5677-0575-4
 eBook: 978-0-5677-0576-1

Typeset by RefineCatch Limited, Bungay, Suffolk
Printed and bound in India

To find out more about our authors and books visit www.bloomsbury.com and sign up for our newsletters.

For my mother who started me on my journey to Mary Magdalene

Of all the personages who figure in history, in poetry, in art, Mary Magdalene is at once the most unreal and the most real—the most unreal, if we attempt to fix her identity, which has been a subject of dispute for ages; the most real, if we consider her as having been, for ages, recognized and accepted in every Christian heart as the impersonation of the penitent sinner absolved through faith and love.[1]

[1] Anna Jameson, *Sacred and Legendary Art, Volume I: Legends of the Angels and Archangels, the Evangelists, the Apostles, the Doctors of the Church, and Mary Magdalene* (London: Longmans, Brown, Green and Longmans, 1848), 332. Despite the minimal number of illustrations the publisher allotted to this author's text it is interesting to note that the frontispiece was a full-page engraving of the *Assumption of the Magdalene.*

Contents

Illustrations

Cover: Bernat Matorell, *Altarpiece of Saint Mary Magdalene from Perella* (1434–52: Museu Episcopal de Vic, Vic). © Museu Episcopal de Vic, photograph by Gabriel Salvans.

Preface: A Perilous Journey

In October 2005, I set out on a perilous journey to the land of Mary Magdalene in the south of France. Over several extraordinary days, I visited churches, cathedrals, and sacred sites dedicated to her from Saintes-Maries-de-la-Mer to Saint-Maxime-La-Sainte-Baume. I drove the ribbonlike narrow road on the edge of the massif on my way to climb the meandering path leading to La-Sainte-Baume. The views were fantastic and my experience in the cave/grotto where the Magdalene spent the last years of her earthly life was beyond words. However, I wasn't able physically to continue the trail upward on the steep massif to the small chapel of Saint-Pilon (Illustration 1) which required a second

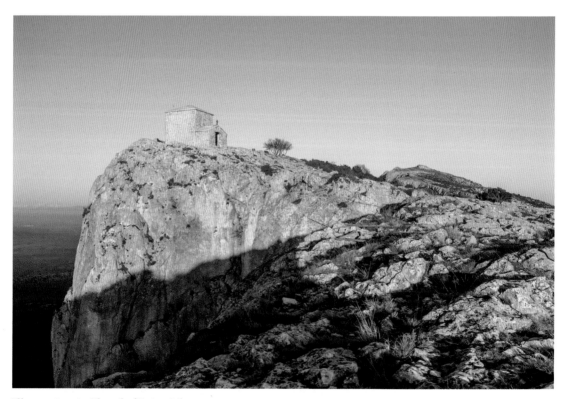

Illustration 1 *Chapel of Saint-Pilon.*

climb of another 3,261 feet.[1] The angels had transported the Magdalene there for her daily elevations to continue her prayers and contemplation, and to receive celestial sustenance. Neither of these climbs was easy, and the latter was extremely precarious reminiscent of the climb up to the top of Mount Saint Catharine in the Sinai Desert.

So, when in late August 2020 I read the story in *The Art Newspaper* that the plaster model for a permanent marble sculpture in that chapel had been smashed, I knew that those who effected this distressing action in some way had meaningful connections with Mary Magdalene.[2] After all, the journey to the chapel is not a gentle walk in the country but a trek of over 3,000 feet above La-Sainte-Baume. I know there is no justification for such damage to a work of art, and yet, I recognize that an act such as this is evidence that Mary Magdalene continues to provoke emotional and spiritual

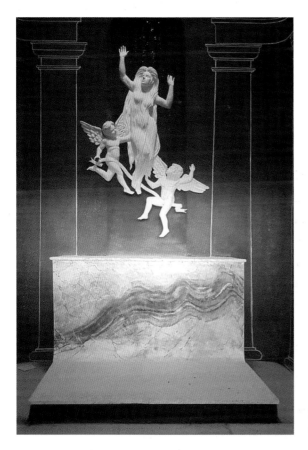

Illustration 2 *Altarpiece of Mary Magdalene, Chapel of Saint-Pilon.*

[1] Since my visit to La-Sainte-Baume and given the increased interest in pilgrimages to Magdalene sites, there has been major restoration to this location including the renovation of the Chapel of Saint-Pilon which was concluded in 2015. The installation of the plaster sculpture was temporary until the completion of the final version in marble which was to be put in place in late August/early September 2020.

[2] This story and images of the damaged plastic sculpture are available online at https://www.theartnewspaper.com/2020/08/21/vandals-smash-statue-of-mary-magdalene-in-french-chapelapparently-because-she-is-naked (accessed September 30, 2021).

responses. Apparently, the perpetrators were offended by this otherwise traditional depiction of the penitent Magdalene whose nude body was covered by her long hair and in a state of elevation by her celestial companions (Illustration 2).[3] They left a note which said in part that they "did not accept that a great saint like Mary Magdalene [should] be represented in such a way."

Following the principle that there is no such thing as a benign image, I know that such a tenet is not singular to visual depictions of Mary Magdalene. Art in all its forms might be described as "perilous" as it is invested with power, especially with the power that can initiate attitudes and values that shape definitions and perceptions of gender. Every image evokes some form of response be it emotional, rational, spiritual, or profane.[4]

Similarly, there are no innocent eyes with which one sees a work of art for (to paraphrase Kenneth Clark) someone somewhere will look at a depiction of Mary Magdalene and see an erotic, pornographic, devotional, sacramental, or spiritual presentation of the female body.[5] The lens through which each of us comes to see and to know is shaped by our familial, cultural, and social worlds; and further influenced throughout our lives by economics, politics, and religion. In some way, each of us carves out our individual identity through our life journey. One's own way of seeing develops through that journey and is predicated on how we have come to know. Some might refer to this as "baggage" and, to be truthful, no one may have more baggage than Mary Magdalene.

Our challenge in the twenty-first century is to recognize how the multiplicity of roles that have culturally been determined to define being female—from being good wives and mothers to courageous female heroes to seductive, thereby perhaps evil, *sexual* women—are illustrated in the narratives of the Hebrew and Christian Scriptures which have dominated Western cultural definition and continues to shape female identity.

Mary Magdalene: A Visual History, then, by outlining the transformations in her imagery and its meanings in response to the alterations in cultural and theological perceptions is one approach to unravel the many threads that have created the Magdalene mosaic over two-thousand years.[6] By examining how the Magdalene is depicted and reworked in relation to what is written and said about her over the Christian centuries, one is observing "the unsaid" that must be acknowledged.

[3]For a discussion of the origin and tradition of this imagery, see the discussion relating Mary Magdalene with Mary of Egypt on pages 36–8 and 46–7 of this present volume.

[4]The classic study of response is David Freedberg, *The Power of Images: Studies in the History and Theory of Response* (Chicago: University of Chicago Press, 1989), 1.

[5]See Kenneth Clark, *The Nude: A Study in Ideal Form* (Princeton: Princeton University Press, 1984 [1956]).

[6]I have carefully chosen to use the term "mosaic" to identify the many threads and conflations that have come together over twenty centuries to become Mary Magdalene. Just as an artist creates a mosaic from multiple pieces of multi-colored stones, broken into various sizes and shapes, to create a picture, so the wide-ranging oral, devotional, textual, legendary, and visual traditions of Mary Magdalene have merged into one discernible female figure.

Yet this path is no less perilous than the one leading up to the Chapel of Saint-Pilon, for by her very nature the Magdalene is ambiguous and constantly in flux. Discoveries not simply of lost documents, like the Gnostic texts, and recent archaeological investigations are complemented by the surfacing of previously unknown or undocumented works of art. As if the new discoveries of research materials and works of art about Mary Magdalene were not enough, there are also new definitions or clarifications about her identity from religious leaders. The most recent pronouncement from the Vatican in February 2021 affirms the absolute distinction between Mary of Bethany and Mary Magdalene, and firmly establishes the unified celebration of Saints Martha, Mary, and Lazarus.[7] Studying Mary Magdalene is truly a perilous journey.

Some final words of caution as you begin reading *Mary Magdalene: A Visual History*. It is amazingly easy for an author to say what her book is not about, but it is difficult to try to define it. To be honest, I believe it is impossible to write *A* book about Mary Magdalene—*A* book which tells us everything we need to know about her in her over two-thousand-year journey in Christianity. For every image and symbolic motif of the Magdalene that I can write about there are not simply hundreds but probably thousands of others. To be as fair to her as possible, a complete analysis would require a multi-volume encyclopedia and then would probably only scratch the surface of her visual history, and her place in literature, music, and the performance arts, let alone Christian theology, liturgy, and church history, and finally, perhaps finally, women's and gender studies.

[7]See the Decree of the Congregation for Divine Worship on the celebrations of Saints Martha, Mary, and Lazarus, in the General Roman Calendar issued on February 2, 2021 and available online at https://press.vatican.va/content/salastampa/en/bollettino/pubblico/2021/02/02/210202c.html. For a discussion of other twentieth-century documents defining/redefining Mary Magdalene from the Vatican see pages 21–2 of this present volume.

Acknowledgments

I have taken this opportunity to revise and update my 2002 exhibition catalogue *In Search of Mary Magdalene: Images and Traditions*. While following the style of most exhibition catalogues into divisions of essays and shorter passages on specific works or motifs, the format of that earlier book was deemed a successful read by critics and students. As that earlier work is no longer available, I expanded my essay in Part One to include new information related to the Magdalene in terms of historical, theological, and cultural studies as well as some correctives to my earlier thinking.[1] My expectation is that readers, especially those new to Mary Magdalene studies, will receive a thorough grounding in the tradition so that upon reaching Part Two the motifs will easily fall into place and result in a wider view and, perhaps, new questions for future explorations. As I revised and supplemented the key motifs in Part Two, I followed a path from the most recognizable or expected topics to the more recent considerations. Naturally, along the way, I fell into the proverbial "catch 22" of any book about the visual history—I had to exercise a dependence upon words and texts to promote an understanding of the meaning of the Magdalene's visual imagery and motifs.

No book is the singular achievement of its author. I am indebted to those colleagues and friends who have supported me throughout the drafts and rewrites of my essays and books on the iconology of Mary Magdalene, and to those research librarians who assisted my searches in a myriad of untold ways. Although these individuals and libraries are too numerous to mention, several must be thanked for their efforts "above and beyond the call of duty." I am grateful for the continuing support of the research services of the Inter Library Loan Department at Lauinger Library, Georgetown University; Woodstock Jesuit Library; and the many museum archives and curatorial files that were made available to me over these many years. All the earlier scholars who sought to understand the "Magdalene mosaic" have been the foundation of my research and many of those resources have been mentioned in either the notes or the select bibliography of this present volume.

[1] I am reminded of what may be an apocryphal story about the preeminent twentieth-century Catholic theologian Karl Rahner, S.J. (1904–84), who when musing on perfecting a text that he might later want to deny was advised by his elder brother Hugo (1900–68), also a Jesuit theologian, that he should simply publish all of his ideas and then later publish revised editions of his works.

I am grateful to the anonymous readers of the manuscript that has become *Mary Magdalene: A Visual History*. Each of them reviewed my work meticulously and even in their most critical comments sought only to strengthen the final product. My earlier publication, *In Search of Mary Magdalene: Images and Traditions* (2002), benefited from the invaluable counsel offered by Erika Langmuir and Joseph N. Tylenda, S.J. During the research and writing of *Mary Magdalene: Toward a Visual History* both I and my text profited from the sage counsel and support of Steven P. Zorzos, Protoprebyster of Saint Sophia Greek Orthodox Cathedral, Washington, DC, and my Georgetown University colleague, Drew Christiansen, S.J. Authors like myself with learned friends such as these have been gifted in a special way as I have witnessed those friendships in the sharing of knowledge. Beyond this advice and support, however, the responsibility for this text and any omissions or questions of interpretation can only be laid at my feet.

Dominic Mattos, Senior Publisher at Bloomsbury T&T Clark, has supported my research and writing in the field of religion and the arts since our initial conversation about my guest-edited *Biblical Reception 5: Biblical Women and the Arts* (2018) and more recently *A Guide to Christian Art* (2020). Sarah Blake, Assistant Editor at Bloomsbury T&T Clark, provided much needed support in the organization of illustration permissions and the production process. I am delighted to acknowledge them not only for their professionalism and patience as I worked through this present publication but for their continuing interest in both my own research and the larger field of religion and the arts.

As with every publication, lecture, or award, my deepest personal and scholarly indebtedness continues to remain with Laurence Pereira Leite, who introduced me to the study of Christian iconology and supervised my initial research on the iconography of Mary Magdalene in the late 1960s. This book, however, is dedicated to my mother who when I was a small child began my interest in Mary Magdalene. Little did she know then that it would become a lifelong occupation. Functioning, as they used to say, as a team, my parents provided unceasing love and support which allowed me to continue with a life of the mind surrounded by books, paintings, and little dogs. Celestial messengers will kindly deliver both the news of this publication and my continuing gratitude.

Diane Apostolos-Cappadona
Georgetown University
Washington, DC
January 2022

Introduction

Mary Magdalene is perhaps the most enigmatic figure in the Christian Scriptures. Biblical scholars proclaim that the text is clear as to her identity. There are only twelve Gospel passages that relate to her—the first being the story of the expulsion of the seven devils from the woman named Mary of Magdala by Jesus of Nazareth, and the remaining eleven having to do with the episodes of his Passion, Death, and Resurrection. Yet in both the hearts and minds of Christian believers, and in the teachings of diverse Christian theologies, this woman's identity has been muddled, conflated, and transformed. My interests are clearly to try to see how and why this happened in Christian art, and how our "reading" of that art brings us to an understanding of who Mary Magdalene was and is.

After many years of looking at Mary Magdalene in her many forms, activities, and personae in Christian art and cultural history, I recognize that she is perhaps the most flexible female figure in Christian art. The Magdalene is shaped, formed, transfigured, and re-formed in so many ways that one would need to write a multi-volume encyclopedia to encompass all her images, meanings, and symbolisms. I believe this is part of her appeal both in the more than twenty centuries of Christianity for Christian believers, and for contemporary artists, authors, and filmmakers. To sort out what I refer to as the Magdalene mosaic[1] may seem a daunting task at first. However, I propose to begin that pilgrimage through the lands of Christian art and Christian cultural history; and to initiate our journey with one of my favorite paintings of the Magdalene.

A very close friend who had retired to Paris to pursue his art was leading me around the then newly opened Musée D'Orsay when I was overwhelmed by the presentations of figures and forms in Jean Béraud's (1848–1935) painting *La Madeleine chez les Pharisiens* (1891: Musée d'Orsay, Paris) (Illustration 3). Like everyone else who found this painting that at that time was located in a darkened hallway on the way to the ladies' room, I became involved in the extraordinary group of gentlemen

[1]For clarification of what I intend with the metaphor of mosaic with reference to Mary Magdalene, see note 6 on page xviii of this present volume.

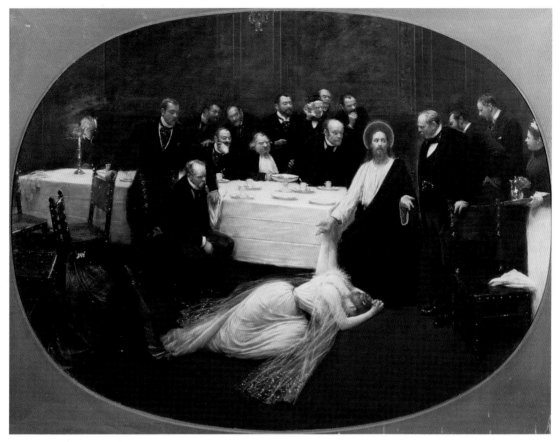

Illustration 3 *Jean Béraud,* La Madeleine chez les Pharisens *(1891: Musée d'Orsay, Paris).*

depicted in typically nineteenth-century evening dress represented in postures of disbelief and denial alongside a clearly guilt-ridden and prostrate Magdalene positioned at the feet of a classically garbed figure of Jesus seated at the end of the table.

However, as my eyes moved across the tableau of secondary players, it came to rest upon this intriguing depiction of Mary Magdalene who was also costumed in sophisticated nineteenth-century dinner dress with her reddish hair coiffured elegantly on her head. While her body was contorted in guilt and grief, her hands reached out toward "the feet of the master." My companion, who was both a dear friend and a painter, stared intensely at the same painting and turned to me calmly inquiring "Darling, isn't that your Haviland Limoges dinner set on the table?" So, there we were, two people looking at the same painting in the same location and at the same time, and we both saw something distinctly different and yet interrelated.

Throughout both the previous and ensuing years of our museum visits, Arthur cheerfully advised me that I came to evaluate each museum or special exhibition by the number of Magdalene images we

could find to discuss. When we travelled to the former home and atelier of the nineteenth-century French symbolist painter Gustave Moreau (1826–98), we found each room chockablock with so many paintings that there was hardly any sense of actual walls. Each room was lined further with cabinets filled with literally thousands of drawings and studies. I remember the stunned look on Arthur's face when I randomly opened a drawer to find it filled with wondrous sketches and drawings of Mary Magdalene. This made me wonder whether my search was not for Mary Magdalene but rather to consider whose Magdalene she was in every work of art I came to study.

Ideas and symbolic connections leapfrogged something like the experience of googling on the internet—one website leads you to a series of links and indiscriminately you begin to click on different links without stopping to take a deep breath and to ask yourself "What am I doing? Is this making any sense?" The desire for knowledge and especially for answers is a common human phenomenon, and in the early twenty-first century, the answers can't come quickly enough. However, that long-ago afternoon at the Musée d'Orsay in Paris, I remembered the warning of my first professor in the study of Christian iconography—the interpreting of signs and symbols—that this new way of *seeing* which allows for the recognition and connection of the meanings within the visual vocabulary in works of art was heady and exciting stuff. How many times did I hear Professor Leite caution me "Slow down, stop! Don't read too much into the signs and symbols without thinking about the cultural context."

It is human nature to slip into a fog, if you will, to forget perhaps momentarily that Western culture has ever been different from the world we know—that is, a world in which textual literacy is a given, if not a right, and no longer a privilege of class. However, most of the population, as Pope Gregory the Great (540–604) so astutely recognized in the late sixth century, was visually literate, that is, people could "read" the signs and symbols in pictures easier than the words on a page. Thereby he confirmed the need for Christian iconography that had slowly developed from the beginnings of Christianity. Parents taught their children the meanings of the animal, botanical, and geometric signs, especially in relation to understanding the Christian message and the visual narratives of Jesus as the Christ. Without doubt, we find a clear merging of Classical and Christian images, stories, and legends depicted on the earliest Christian frescoes and sarcophagi. However, in the modern world, we have lost that visual vocabulary and the meanings of these images, stories, and legends, and so we look perhaps quizzically, perhaps with despair at Byzantine or medieval works of art, and wonder "Why is there a fish on the table?" Or "Why is the baby Jesus holding a goldfinch?"

Christian art, like Christian faith, is a living reality and as such it responds and reflects changes in cultural attitudes, economic and political situations, and most especially the needs of believers. So that when someone like myself who studies Christian iconology says that Christian art is culturally conditioned and that the cultural conditioning affects the interpretation of iconography, I mean exactly that—as human history evolves, human beings ask different questions, have different needs, and see the world with different eyes from previous generations as well as by as yet unknown future generations. As

artistic styles evolve from medieval to Renaissance, for example, the artists not only painted differently but what they painted was symbolically embedded with different meanings just as our interpretative lenses are unique. Obviously, certain common human experiences exist—love, hate, jealousy, guilt, frustration, fear, grief, passion; however, the ways we frame these experiences, the modes by which we communicate, and the advances we make in science and technology transform how we see and what we see. Language and cultures change, and the visual vocabulary adapts to these changes. One quick example is the depiction of the Hebrew scriptural heroine, Susanna, known best in the motif of "Susanna-at-the-bath" (Dan. 13). However, if we surveyed the visual history of Susanna found in Christian art, we would find that earliest Christian art in the catacombs depicted her as a lamb placed between two wolves while Medieval visual narratives concentrated on the courtroom drama as the youthful Daniel interrogates the two elders. The Susanna that we normatively imagined as a beautiful nude woman really didn't get into the bath too often before the art of the Renaissance and Baroque periods.

To interpret the story or image of Susanna requires not simply a reading of the biblical narrative, or a knowledge of Christian symbolism, but also a recognition of cultural history. To interpret, or "read" what I refer to as the Magdalene mosaic, then, we need similarly to consider the tradition of Christian iconography and commensurately to recognize the normal transformations of those signs and symbols in different historical periods. As history advances from the first century into the twenty-first century, different issues, events, and concerns are the focus of human interest and thereby of the Christian faithful. Most especially, I believe we need to recognize that human beings are fundamentally human—that is, curious and inquisitive. When I looked at Béraud's interpretation of the prostrate Magdalene I came also to recognize that there were layers upon layers of stories, meanings, and interpretations placed upon her both before *and* after his painting. When I translated this particular image into words, then, I needed as much as possible to be open to all those layers as to what I have learned from the study of Church history and Christian theologies.

Modern scholars, whether historians or scripture scholars, are trained to separate out interpretations and emendations from the text. Scripture scholars, in particular, strive to return to the original words and meaning of the text. Sometimes this requires the effort of learning several languages, so that the purity of the original text can be restored and once that happens then they are able to ask questions about the language, linguistic structures, and interpretations of the text. In early Christian societies, the historical reality was that the Scriptures were more often heard than read, so that the fusion of oral and narrative traditions occurs in Christianity as in other world religions. A story gets "better" or "longer" or more involved with each telling. Different words or episodes are emphasized and sometimes embellished or tapered with each retelling. Human memory confuses common characters and actions that have become emblazoned in the human heart and imagination.

Historians, especially since the 1970s, have recognized the importance of the missing pieces such as popular culture, gender, race, ethnicity, and class. So, they have begun more and more to seek out

the outline of the facts and to build upon this outline with new interpretations. However, the truth is that even for modern historians, there are indisputable facts of history that can't be eliminated or ignored. Nonetheless, one of the keystones of modern scholarship has become the questioning and re-examination of the history which has been handed down to us by previous generations.

In my research and study of visual images, I am taken regularly to the points of "missing history" to the positions of reinterpretations in light of the images which form documentation that is just as valid as written texts and historical facts. Images such as Béraud's painting are the human realities which fill what I refer to as "*the space between*"[2]—the space between the paragraphs in a text, the space between indisputable historical dates and events, the space between human knowledge and human intuition. The Christian Scriptures, for example, provide us with many instances of "*the space between*," as for example in the biblical narratives which relate that Mary, Joseph, and the infant Jesus go into Egypt to escape Herod's decree of the Massacre of the Innocents, and then seven years later this familial trio departs Egypt and returns home to Bethlehem. However, we find nothing in the Christian Scriptures of what happens during those seven years, this for me, then, is "*the space between*." I find apocryphal stories, devotional books, pious legends, and works of art which come to fill this space in both spiritual and imaginative ways. I need to ferret out the interpretations and intentions of these responses in order to come to a recognition of both their meaning and their significance.

Throughout my own investigations, the question remains: Who was Mary Magdalene and how did she come to have such a significant and artistic influence in Christianity and in secular culture? The biblical woman, or women, who becomes identified as Mary Magdalene has been popular with believers from the earliest Christian times. Recognizable in Christian art and narrative from the fourth century as "the woman at the empty tomb," the Magdalene mosaic as I refer to it was codified by Pope Gregory the Great on the eve of the sixth century so that she became known as the repentant sinner; the fallen woman; the misidentified prostitute, albeit a reformed prostitute; and the faithful follower. Whatever the historical or scriptural accuracy of her image or her story, Mary Magdalene became a favored female figure and a model for Christian devotion, pilgrimage, sacramentalism, and most recently feminism. From her earliest representations in artistic and dramatic narratives, she was *the* first witness to the Resurrection and thereby became known as the Apostle to the Apostles. With the beginning of the Middle Ages, she garnered one of the most varied legendary and artistic iconographies of all Christian saints, both female and male. From the High Middle Ages into the Renaissance, her biography and iconography focused upon her personal life, especially her penance, missionary work, daily Elevations, and Last Communion as well as the posthumous miracles credited to her.

[2] See my essay "The Space Between Image and Word: The Journey from Rogier van der Weyden's *Descent from the Cross* to Walter Verdin's *Sliding Time*," *CrossCurrents* 63.1 (2013): 26–43.

So, the popular perception of Mary Magdalene became a fusion of her role as Jesus's close associate with her position as the archetypal penitential saint. Both the Reformers and the Roman Catholic Church emphasized Mary Magdalene as the archetypal female penitent while nineteenth- and twentieth-century artists transformed her into a *femme fatale*, a courtesan with a heart of gold, a prostitute, a pilgrim, a preacher, a spiritual seeker, and a feminist. The fundamental truth may be that whoever she was, Mary Magdalene represented for the average believer the fullness of human experience—sins, faults, doubt, despair, so "warts and all"—in her journey from sinner to saint. The question, then, that will guide us through this exploration through the visual history of Mary Magdalene is not "Who was Mary Magdalene?" but rather "How did Mary Magdalene come to be?"

As with the other major figures in the Bible from Eve to the Virgin Mary, there is no contemporaneous life portrait of Mary Magdalene. Therefore, there is no singular picture, photograph, or sculpture to point to, or one moment in history, to allow the confirmation that "*This* is what she looked like. *This* is who she was." Any discussion or analysis of the iconology of Mary Magdalene is hindered, if not also aided, by the layers upon layers of imbued meanings. As with the Virgin Mary, the Magdalene is associated with the visual attributes and characteristics of the goddesses and female heroes of the classical world,[3] and further enhanced by medieval and Renaissance artists in France, Germany, Italy, and Spain with additional elements of local color, traditions, and legends, especially in relation to indigenous goddesses and female heroes. Taken together, these earlier female deities and heroes can be characterized as representatives of love, passion, female sensuality, feminine sensibilities, justice, and fortitude.

The topic of immeasurable works of legendary and pious devotion, theological investigation, societal debate, and spiritual reflection as well as works of art in every diverse media throughout the twenty-one centuries of Christianity, Mary Magdalene is sinner, penitent, witness, contemplative, anointer, reader, preacher and more; and yet, she is also saint. Associated with multiple societal categories of women from repentant sinners and morally reprehensible "fallen women" to melancholy paragons of religious devotions; to social institutions such as asylums caring for unwed mothers or reformed prostitutes; to educational establishments such as colleges and libraries; and even to an adjective characterizing its subject as foolishly or excessively sentimental. In her many personae, she has been portrayed as a glamor girl, a weeper, a matron, a protectress, a contemplative, and a hag. As a spiritual figure, she has been entreated by cloistered nuns, abbesses, couturiers, women in childbirth,

[3]For example, the Egyptian goddess Isis was the wife of the god Osiris who had been slain by his enemies. After his death, his enemies proceeded to cut his body into pieces and to distribute those pieces in different places. Isis and her sister Nephthys sought out all the pieces in an effort to restore wholeness. Following a series of anointing rituals and prayers, the two women remained by his body and mourned Osiris. On the third day, he returned from the dead. However, there was one missing body part—his phallus. Therefore, Isis became further associated with the Virgin Mary as Isis's conception of her only son, Horus, was also miraculous.

infertile women, mourning mothers, unmarried girls, flagellants, philosophers, and penitents of all descriptions. Even in the twenty-first century, who she is is almost impossible to say; how she came to be formidable entails an arduous journey through a complex, if not oftentimes ambiguous, matrix of oral and written traditions, theology, spirituality, ritual, mythology, art, culture, values, and the human psyche. That she has become and remains all of these is more appropriate for this present study of her visual history.

My study of Mary Magdalene in her multiple modes and historical transformations traverses the coalitions, confusions, and conflations of image and story.[4] While the scriptural narratives might be deemed as providing a lucid definition of Mary Magdalene, her story and persona have become muddled over the centuries through the stimulation of pious legends, spiritual devotion, and traditional practices in the hearts and minds of believers. Many of her identifications, especially with the anonymous scriptural women, derive from the male voices of early ecclesiastical authors, and influenced both artists and the Christian collective. An overview of the visions, imaging, and reinterpretations of those scriptural narratives, patristic texts, and legendary stories is critical to the shaping of the Magdalene's iconography. Consider throughout this volume, my identification of the "Magdalene mosaic" and recognize that this present essay is one of many structural frames for this mosaic and the individual iconographic entries—from sinner and penitent to preacher and feminist icon—as those pieces help to begin to clarify the whole picture within the mosaic by means of artistic innovations and theological revisions.

From her origins as the first witness to the Resurrection of Jesus Christ and the first female penitent through her journey in the arts as one of the most popular saints in Christian history, the Magdalene has exhibited complexity and flexibility in her definitions, evolutions, and transformations. In codifying faith by "telling stories in pictures" and in simplifying theology by removing non-essential conundrums, images offer a concentrated and clearly defined corpus of human attitudes throughout history. Mary Magdalene engages and compels our attention as her images resonate with the celebrations and afflictions of the religious mythologies, cultural postures, grandiloquent allegories and sermons, and stereotypes which she has come to encompass.

Late-twentieth- and early-twenty-first-century scholarship has expanded the borders of religious studies, theology, and church history, by recognizing the importance of "the visual" as primary evidence for the critical understanding of history.[5] Without doubt, we know that the majority of people even

[4]See, for example, my exhibition catalogue *In Search of Mary Magdalene: Images and Traditions* (New York: The Gallery of the American Bible Society, 2003).

[5]For example, see Mary Ann Beavis and Ally Kateusz, eds., *Rediscovering the Marys: Maria, Mariamme, Miriam* (London: Bloomsbury T&T Clark, 2020); and Lieke Wijnia, ed., *Mary Magdalene: Chief Witness, Sinner, Feminist* (Zwolle and Utrecht: Waanders Publishers and Museum Catharijneconvent, 2021), exhibition catalogue.

into the twentieth century were visually literate. The symbolism of Christian art was premised upon the visual literacy of those who *looked* at the images, motifs, and symbols. Thereby to understand the meaning of an event or a person such as Mary Magdalene, we must *look* at the history of her iconography and incorporate what we learn from *looking* into the frames of scriptural tradition, devotionalism, pious legend, Christian theologies, and spiritual praxis. With this new attitude—acknowledging the importance of visual images as equal to textual documentations—and the concomitant questioning of preconceptions, we must concern ourselves with the crucial and *not* easily answerable question of how and why the acknowledged first witness to the Resurrection became so totally identified as a sinner, a penitent, and a reformed prostitute.

While the woman known as Mary Magdalene had been popular with believers from the earliest Christian times; by the fourth century, she began her journey as a role model for female believers and an identifiable artistic element in both religious narrative and personal devotion. By the late Middle Ages, Mary Magdalene garnered one of the most varied legendary and artistic iconographies of all Christian saints as exemplified by the Catalan painter Bernat Martorell (1400–52) in his *Altarpiece of Saint Mary Magdalene from Perella* (1437–52) (Illustration 4).

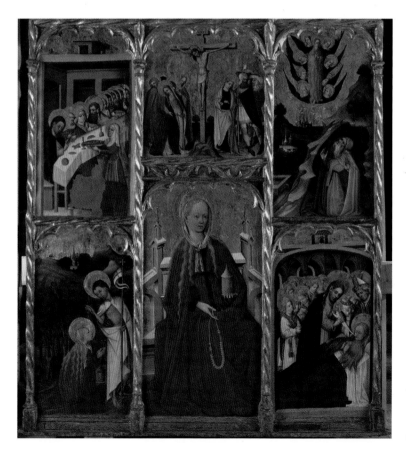

Illustration 4 *Bernat Martorell,* Altarpiece of Saint Mary Magdalene from Perella *(1434–52: Museu Episcopal de Vic, Vic).*

Looking across the presentation of six gilt-framed episodes, this mid-fifteenth century work provides visual testimony to the importance of both her roles in scriptural narratives and the importance of her ever-expanding cult. Looking at, or perhaps better said "visually reading" the separate panels from left to right, the biblical themes of *The Anointing at Bethany*,[6] *Noli me tangere*,[7] and *Crucifixion*[8] give way to the largest and central panel with a singular depiction of the red-robed and haloed saint whose long blonde tresses fall over her shoulders and down her bodice to her hips. She sits regally on a white throne as her posture and gestures affirm the fusion of the Magdalene as penitent and as saint as she holds her glass prayer beads[9] from a gold chain in her right hand while her outstretched and open left palm holds forth her traditional attribute of a (golden) unguent container. The further right panels of Martorell's altarpiece incorporate two central episodes from the Provençal legends—her daily elevations above La-Sainte-Baume and finally her death. In this last panel she is surrounded by angels and Bishop Maximin as Christ gently clasps her innocent soul imagined as an infant for her transfer to heaven.

Mary Magdalene represented different personae for the lay faithful, male and female monastics, and theologians. A survey of her iconography in Eastern and Western Christian art demonstrates that the earliest depictions of the Magdalene in artistic and dramatic narratives were as *the* first witness of the Resurrection and thereby as the Apostle to the Apostles. Medieval and Renaissance portrayals expanded to include the varied episodes of her Life, Penance, Last Communion, and Elevation. This visual evolution mirrored the rise of her importance in Christian spirituality from a historical role in the life of Jesus of Nazareth into that of the archetypal penitential saint who signified the centrality of the sacraments. During the Early Modern period, she became the spiritual and visual defender of the sacraments of the Roman Catholic tradition, while retaining a role as the female penitent in the Lutheran and Protestant traditions. In the nineteenth century, she was transformed into a *femme fatale* and a courtesan "with a heart of gold," while twentieth-century artists emphasized the multiplicity of her religious personae, especially that of the reformed prostitute, and most recently as a female hero. Hers has been a classic image of the redemptive and transformative nature of Christian faith. The Christian believer finds herself closer to accepting the reality of the otherwise abstract concepts of sin and forgiveness as concrete human realities through the Magdalene's story and imagery. She has come to represent visually and spiritually the fullness of the human experience in her journey from sinner to witness to saint.

[6]The partially damaged mid-section of the panel for this episode obscures the face and hands of Mary Magdalene and the feet of Jesus.

[7]A detailed discussions of the theme of the lower left panel can be found on pages 63–4 of this volume.

[8]The figure of Mary Magdalene is immediately identifiable from both her flowing blonde tresses and red garment, and her mediating position between the swooning figure of the Virgin Mary and the Crucified Christ in this upper center panel.

[9]On-site research at the Museu Episcopal de Vic on September 23, 2019 suggested that these beads might be made of amber or yellow glass. Throughout the history of Catholicism, the shape, size, and fabrication of rosary beads varied regionally given the availability of stones such as lapis lazuli, coral, pearls, and varied woods as well as in terms of social class and patronage.

Nonetheless the question remains: who was Mary Magdalene and how did she come to have such a significant spiritual and artistic influence in Christianity and in secular culture? There have been distinctive "approaches" to the Magdalene from her varied audiences: theologians, biblical scholars, art historians, feminists, liturgists, church historians, filmmakers, novelists, and believers. Mary Magdalene is complex, multivalent, and heuristic in that every proposed explanation like every new avenue of research leads not to a conclusion but to new questions. The fusion of theology, scripture, liturgy, devotionalism, gender, class, society, culture, and indigenous traditions which combine in her story and imagery affirm that the fundamental character of her uniqueness is the "mystery" of her ambiguity and complexity as well as the ever-present clarity of her faith.

The iconology of Mary Magdalene references motifs in which art history and theology are mutually fructifying. The patterns of sinner, penitent, anointer, weeper, witness, preacher, contemplative, reader, writer, patron, and popular culture and feminist icon[10] are not comprehensive but do suggest who Mary Magdalene is within the cultural history and contexts of the Christian traditions. Image and story work in unison to harmonize and to clarify religious tradition. Story blends personal and communal history as it explains the origin, meaning, and destiny of Mary Magdalene for both the Christian faith and culture. Image combines subject with object as it translates narrative into a reality revelatory of unexpected meanings and truths. Although not univocal or linear but rather affective and cognitive, images are principal historical witnesses in the study of Christian theology and cultural history. Taken together, image and story elicit a religious response in reflecting on who we are and what we perceive to have meaning and value.

As evidenced on the following pages, art, culture, and values are historically conditioned. Therefore, my explorations of the transformations of Mary Magdalene's identity, roles, and imagery are premised upon three ideas which relate "faith" with "culture" throughout Christianity's almost twenty-one centuries: metanoia, unction, and metamorphosis. Metanoia is the state of profound regret over actions, thoughts, or intentions which leads to a conversion in a person's heart, behavior, or thoughts; it is repentance. Unction is the act of anointing for either medical purposes or the religious ritual of consecration; it is the seal of spiritual healing and protection. Metamorphosis is the transformation from one form into another; it is the modality of the Magdalene's multiple personae. Thereby, the coordination of metanoia, unction, and metamorphosis is evidenced by Mary Magdalene. Conversion leads to healing, anointing is the sacred seal of that consolation, and together conversion and anointing bring about metamorphosis, or in the case of the Magdalene throughout the centuries, metamorphoses.

[10]Contemporary use of the term icon has emphasized the elevated and singular identity of an athletic figure or media celebrity without continuing the origin of the term as a "sacred figure."

Part One

Toward a Visual History

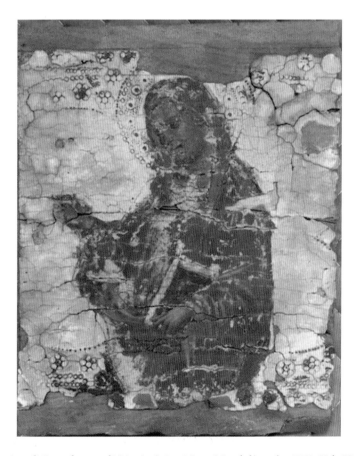

Illustration 5 *Martino di Bartolomeo di Biagio,* Saint Mary Magdalene *(c. 1370: Yale University Art Gallery, New Haven, CT).*

1

Scripture Sources

Mary Magdalene's story and image begins in the Christian Scriptures. Unfortunately, even the most careful readings of the Gospels of Matthew, Mark, Luke, and John do not offer a clear or definitive picture of who the Magdalene was within the original context of the life of Jesus of Nazareth. Nonetheless, these essential scriptural materials form the textual foundation for both the elusive figure and the enigma that became Mary Magdalene. The cultural historian Marina Warner astutely referred to this textual confusion as "a muddle of Marys."[1] However it is exactly this literal puzzlement that results in theological tangles and most importantly in the visual variety in any search for Mary Magdalene.

The roots of Warner's "muddle of Marys" are simple: first, the common use of the name Mary in the Christian Scriptures; second, the sparse descriptions distinguishing the many biblical Marys one from the other; third, a series of similar actions by several of the Marys; fourth, a series of similar actions by several "unnamed women;" and fifth, the common human need for clarity combined with the faulty realities in the fusion of oral and narrative traditions. A story gets "better" or "longer" or more involved in each successive telling. Each retelling emphasizes different words or episodes. Human memory confuses common characters who become emblazoned in the imagination. As the human eye follows the path of light in a painting in order to *see* what it is about, the human mind requires a similar directional force in the reading, telling, hearing, and re-telling of a story.

Warner's "muddle of Marys" begins with the cultural commonality of the name Mary, which is the Greek form of the Hebrew *Miryam* signifying "rebellion" or *marah*, an adjectival root intending "bitter" or "grieved." The careful reader of the Christian Scriptures finds seven women named Mary who play a role in the life of Jesus of Nazareth and the establishment of the early Christian community. Without doubt the three most famous and important of these women are the Virgin Mary, the Mother of Jesus of Nazareth; Mary of Bethany, the sister of Lazarus and Martha; and Mary Magdalene, my particular heroine. Additionally, there is Mary "the mother of James" or "of James and Joses" or "of Joseph" and

[1]Marina Warner, *Alone of All Her Sex: The Myth and the Cult of the Virgin Mary* (New York: Alfred A. Knopf, 1976), 344–45.

who is also referred to as "the other Mary" (Mk 15:40; Mt. 27:55–56; Mk 15:47, 16:1; Mt. 27:61; 28:1, 9), and Mary wife of Cleophas (Jn 19:25). Both play a role in the scriptural narratives related to the Entombment and Resurrection of Jesus Christ. Further, often identified as separate women from Mary Magdalene, Mary of Jerusalem (Acts 12:11–17) and Mary of Rome[2] (Rom. 16:1–16) played significant enough roles in the formation of the early Christian community to garner mention in Pauline texts. Although there are distinctions between the Virgin Mary and the other Marys, the lines of demarcation are not as evident among the remaining women.

The woman identified specifically by the Gospel writers as Mary Magdalene is one of the earliest and most devout followers of Jesus of Nazareth (Lk. 8:3); from whom he cast seven devils (Mk 16:9; Lk. 8:2–7); and who stood at the foot of the cross (Mt. 27:56; Mk 15:40; Jn 19:25). She was one of "the holy women" who, seeking to anoint the crucified body at the tomb, found it empty and heard the announcement of the Resurrection (Mt. 28:1–8; Mk 16:1–8; Lk. 24:1–10; Jn 20:1–9). However, consider that she is given primacy among the women disciples as evidenced by the simple fact that hers is always the first name in any scriptural litany of the holy women. She was the earliest witness of the Resurrected Christ and was sent forth by him to announce this news to his male disciples (Mt. 28:9; Mk 16:9; Jn 20:4–18).

Perhaps it is as the first witness to the Resurrection that Mary Magdalene's fundamental fascination is found. This is the only episode in her story on which *all* the evangelists, patristic fathers, and later theologians agree is that she was the first person not simply to see the empty tomb or to hear the angelic announcement that "He is risen from the dead." More significantly, *she* was *the* first person to *see* the Resurrected Christ. From this event, Western Christian artists would create the visual motif known as *Noli Me Tangere*[3] which depicts the Magdalene reaching with arms outstretched to touch Christ just after his Resurrection (see lower left panel of Illustration 4). Artists trusted unconsciously in her act of faith in *seeing* as a scriptural defense for the visual modality and for the significance of art in the Christian traditions. Her confidence in the evidence of her eyes triumphed over the fundamental (and perhaps more empirical) human need to touch.

The woman that the Christian traditions, devotions, and art know as Mary Magdalene is more than this female follower healed from her demons and faithful to her healer beyond his earthly sufferings and death. Traditionally, her geographic epithet "of Magdala" had a dual meaning which played a role in her transformation into the Mary Magdalene we have come to know and to love. For over 1400 years, it was reputed that Magdala was derived from the Greek form of *migdol* meaning "tower" or

[2]The "confusion" of these two women named Mary with Mary Magdalene will be clarified in the context of the discussion of the Eastern Orthodox Christian devotional and iconic traditions, see pages 23–6 of this volume.

[3]This Latin phrase is translated into English as "Do Not Touch Me," whereas the earlier Greek translates as "Do not cling to me." In the most recent documents on Mary Magdalene issued by the Vatican under the aegis of Pope Francis, the earlier Greek concept has replaced the ambiguous if not troublesome "Do not touch me." See pages 21–2 of this volume.

more specifically "watch tower." As a description of her actions—standing like a "watch tower" at the foot of the cross and at the tomb—this Mary was signified correctly by her epithet's etymology. During Jesus' lifetime, Magdala was a large, wealthy town on the western shore of the Sea of Galilee.[4] It was destroyed by the Romans as a result of the moral depravity of its citizens.[5] Such an identification endorses the theory that this Mary's "seven devils" were not some form of either demonic possession or nervous disorder but of promiscuity. If the then-contemporary understanding that possession was a metaphor for immorality not illness, then the emerging confusion of the sinner with Mary of Magdala becomes apparent.

Whether demons were signs of illness, possession or sexual vices, visual representations of exorcism whether supervised by Jesus as both spiritual and physical healer, or an ecclesial exorcist are extremely rare, if not non-existent. When this ritual of healing is envisioned either as a manuscript illumination or fresco, or more typically in liturgical plays or medieval dramas, dark malicious figures are expelled from every orifice of the body of the one being "cleansed," thereby contributing to the audience's perception of these "devils" as manifesting corporeal and soulful "possession." In the specific case of Mary Magdalene, the finest depictions of Jesus healing her of her demons are found in both the text and performance of the early-fifteenth-century and now-classic *The Digby Play of Mary Magdalene*,[6] and perhaps most spectacularly in Cecil B. DeMille's (1881–1959) masterful film of *The King of Kings* (1927). The identification of Mary as being "of Magdala," combined with the then-common understanding that physical and spiritual disease often went hand in hand, established her as a sinner. This leads to her later association, if not complete assimilation, with the nameless sinner (Lk. 7:37) and the unnamed woman taken in adultery (Jn 8:1–11).

It is the nameless sinner who "loved much" and was forgiven, and the unnamed adulteress, who have colored the Magdalene's persona in a manner distinct from the original scriptural texts. The nexus for the confusion, or conflation, of these two women is their shared experiences of sinfulness, repentance, and forgiveness, and their anonymity. Neither has a name or even an identifying epithet except for the category of sinner. Whether the Gospel writers chose to keep silent about these women's identities for reasons of social or cultural etiquette or felt that their names were inconsequential to the stories' pedagogical purposes is a subject of speculation. Their role as defining elements in the "composite Magdalene" figure as a moral reprobate is a historical reality.

[4]Currently ongoing archaeological excavations at Magdala may transform our attitude toward its social order.

[5]The "unsavory" reputation of Magdala is described in the Talmud and by Josephus (*Jewish Wars* 3:10) and Pliny. For a classic discussion of this tradition, especially as interpreted in the Talmudic sources, see Helen M. Garth, *Saint Mary Magdalene in Medieval Literature* (Baltimore: Johns Hopkins University Press, 1950), especially 77.

[6]From 23 to 25 May 2003, I traveled to Toronto to participate in "The Mary Magdalene Symposium" and view a traditional presentation of *The Digby Magdalene Play* during the Digby Magdalene and Saint's Play Festival at the University of Toronto.

The sins of which these two unnamed women, and thereby the Magdalene, are guilty are attributable to sexual incontinence—an obvious condition for the so-named "woman taken in adultery" and an assumption for the nameless female sinner. It is probable that Luke's anonymous female sinner was innocent of lust or sexual misconduct. The concept of "love" in the Hellenistic world had a variety of meanings from *philia*, "friendship love" or communal sharing, to *caritas*, "charity," to *agape*, "divine love." Would it be untoward to consider the possibility that what is taken as an admonition by Jesus, that this woman's sins are forgiven because she has "loved much," may be rather a description of her feminism as well as her Christian nature and not her sexual proclivities? Nonetheless the proximity of her story in Luke's Gospel to the passage introducing Mary Magdalene exacerbates the eventual maze of the female anointers.

There are four anointing, or unction, episodes which have significant ramifications for the evolution of the Magdalene. Building on Mark's earlier text, Matthew provides an almost identical report of the anointing of Jesus of Nazareth by an unnamed woman in the home of Simon the Leper two days prior to the Passover.[7] In both accounts, she carries an alabaster box containing precious ointments (or precious spikenard) that she pours over Jesus's head, an act which foreshadows the unction ceremony at his burial. Although this episode emphasizes the anointing theme, Judas's challenge to Jesus's authority combined with his decision to betray Jesus are thematic undercurrents. Curiously, this would be one of several scriptural, and later legendary, episodes in which the real or composite Magdalene's actions may be seen as correctives to those of a male disciple.[8]

The third story of anointing is distinctive in description and content as Luke relates that Jesus dines this time at the home of a Pharisee.[9] During the meal, an unnamed woman identified only as "a sinner" enters the room carrying an alabaster box of ointment. She washes Jesus's feet with her tears, dries them with her long flowing hair, kisses them, and finally anoints them with the precious ointment. When the Pharisee questions this action and the physical proximity of an unnamed sinful woman to Jesus, he reprimands the Pharisee by reminding him that he has not complied with the normal acts of hospitality. Jesus continues that this "unknown woman" performed them with great humility and love, and he pronounces her many sins forgiven.

The fourth unction account is unique in its identification of the anointer. Unfortunately, she is called simply Mary.[10] Since this episode follows the Raising of Lazarus and appears to have happened

[7] See Mk 14:3–9 and Mt. 26:6–13 respectively. Ironically, Bethany is also home to Lazarus and his two sisters, Mary and Martha. This geographic coincidence probably heightens the eventual confusion between Mary Magdalene and Mary of Bethany.

[8] See the discussion of the correspondence between the Magdalene's role in what has become known as the *Noli Me Tangere* to that of the male disciple in the *Doubting Thomas* on page 14, and footnote 7 on page 118 of this volume.

[9] Lk. 7:36–50. Luke's narration of the Feast in the House of the Pharisee follows his account of the raising of the son of the widow of Naim. This establishes the pattern of a foretype of the Resurrection of Jesus Christ followed by an anointing.

[10] See Jn 12:1–8. In the earlier Raising of Lazarus episode, John identifies the sister as "that Mary which anointed. . . ." (Jn 11:2).

in the house of Lazarus, this Mary is most likely Mary of Bethany, the sister of Lazarus and Martha. According to the Gospel of John, six days before the Passover, Jesus entered a home to partake of a meal when Mary anointed his feet and wiped them with her long flowing hair. The expected dialogue with Judas followed. Given the similarity in deeds, gestures, and effects—anointing with a pound of ointment of spikenard, alabaster boxes, tears, long flowing hair, repentant postures, and forgiveness for the female agent and betrayal by the male agent—the confusing conflation of the Marys and the anonymous women is understandable.

A further scriptural image, that of Mary of Bethany as the eager listener, is described in the Lucan account of Mary and Martha, the sisters of Lazarus.[11] Mary of Bethany garners Jesus' approval as the sister who listens carefully to his lesson. John implies that it is for her sorrow, copious tears, and faith in his message that Jesus raises her brother, Lazarus, from the dead. Following this miraculous narrative, John relates the story of the fourth anointing scene noting the anointer's prostrate posture and tears. The proximity of the events and the correspondence of characterizations commingle with the ubiquitous name of "Mary" and the otherwise unnamed women to create a homogeneous heroine, Mary Magdalene.

While not particularly influential on the iconology of Mary Magdalene until the late twentieth and early twenty-first centuries, the early Gnostic documents have played a role in the consciousness of the contemporary Christian collective. These texts included the fifth-century Sahidic Coptic Papyrus identified either as the non-canonical Gospel of Mary Magdalene or as the Gospel of Mary discovered in 1896 while a larger cache of Gospels and other "secret" documents were found in Nag Hammadi in 1945. The latter included the Gospel of Philip which has been singled out for the reference to Mary Magdalene as Jesus's "companion" and for being the one he loved above all others. Exactly, however, what those phrases mean remains a continuing debate among scholars of the Bible, the Early Church, and feminist and gender studies who also struggle as to the clear identity of the Mary in the Gospel of Mary Magdalene.[12] While these Gnostic documents support the conflations of Mary Magdalene with other biblical women, especially Mary of Bethany, no impeccable definition has emerged enhancing the continuing debate. As Mary Ann Beavis advises, "the notion that 'Mary Magdalene' was a Gnostic heroine needs qualification."[13]

The influence of the Gnostic texts on the depictions of Mary Magdalene in the visual arts was compounded in the late twentieth and twenty-first centuries with the rise of feminist theology and

[11]See Lk. 10:38–42.

[12]See for example, Karen King, *The Gospel of Mary of Magdala. Jesus and the First Woman Apostle* (Santa Rosa, CA: Polebridge Press, 2003), who supports the attribution to Mary Magdalene; and Stephen J. Shoemaker, *Mary in Early Christian Faith and Devotion* (New Haven, CT: Yale University Press, 2016), who maintains that the referent is the Virgin Mary.

[13]Mary Ann Beavis, "Mary Magdalene, II. Christianity, A. Patristics and Orthodox Churches" in the *Encyclopedia of the Bible and Its Reception*, Volume 17 (Berlin: Verlag DeGruyter, 2019): 1208–10, especially 1209.

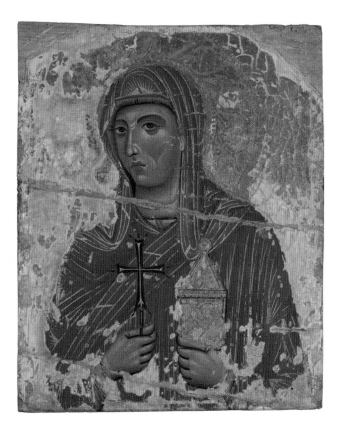

Illustration 6 *Master of Saints Cosmas and Damian,* Saint Mary Magdalene (c. *1270: Yale University Art Gallery, New Haven, CT).*

feminist art history.[14] Alternatively, these documents, especially the Gospel of Mary Magdalene, have provided inspiration and source material for a variety of film and musical compositions between 2010 and 2018.[15] Nonetheless, these are recent developments in the almost two-thousand-year history of the cultural narrative and iconology of Mary Magdalene; rather early Christian and medieval devotional and legendary texts including Jacobus de Voragine's *The Golden Legend* have been the more effective sourcebooks for the symbolism and imagery of the Magdalene mosaic.[16]

[14]Readers should refer to the catalogue *Mary Magdalene: Chief Witness, Sinner, Feminist* edited by Lieke Wijnia for the special exhibition *Mary Magdalene: The Exhibition* on view from June 25, 2021 to January 9, 2022 at the Museum Catharijneconvent, Utrecht, for the most recent consideration of the Gnostic Gospels on visual depictions of Mary Magdalene by contemporary feminist artists, most especially in Wijnia's contributions "Her body as battlefield: Femininity in the conceptualization of Mary Magdalene" and "A seated powerhouse: Is this the Mary Magdalene of the twenty-first century?" on pages 90–9 and 126–31 respectively. The earlier exhibition *Codex Magdalene: Towards a New Iconography and Re-imaging the Mythology and Legends of Mary Magdalene* featured the works of Majak Bredell and was on view in varied sites in South Africa from May 6, 2016 to May 3, 2017.

[15]See the discussion of Peeter Vähi's oratorio, Garth Davis's film, and Mark Adamo's opera on page 89 of this volume.

[16]See the detailed discussions on page xviii n.6 and pages 88–90 of this volume.

2

Patristic Sources

The scriptural quandary over the Magdalene's identity persisted throughout the formative texts of the church fathers and beyond the sixth-century proclamation of Pope Saint Gregory the Great (*c.* 590–604).[1] Perhaps the earliest and most influential of these was Tertullian's (*c.* 160–220) determination that the otherwise unnamed woman taken in adultery and "Mary" were one and the same woman, for *both* anointed Jesus' feet and dried them with their hair (Lk. 7:36–50; Jn 12:1–8).[2] Neither Tertullian's contemporaries nor later church fathers were in complete agreement with his analysis that Mary Magdalene was the same as Mary of Bethany, the unnamed sinner, and the woman taken in adultery. For example, Ambrose of Milan (*c.* 340–97) was not clear in his discussion of the "muddle of Marys" as to either independent or composite identities of these women. Jerome (*c.* 340–420) was precise in his opinion that the unnamed adulteress and the anonymous sinful anointer were two different women. Augustine (354–430), although he saw "merit" in the composite Magdalene of Tertullian's text, determined that the scriptural ambiguity left her identification open to question.

Mary Magdalene's identity became even more muddied when she was included in the list of invocations known as the *Litany of the Saints* (the first Western written version dates from the seventh century).[3] Her name appeared at the beginning of the list of the holy virgins and widows.[4] There is no scriptural or legendary evidence that she may have been a widow who might have attained the state of

[1] For the classic discussions of the Magdalene's identity in patristic sources, see Victor Saxer, *La Culte du Marie Madeleine en Occident, des origins à le fin du moyen âge* (Paris: Librarie Claveuil, 1959) 1:1–31; 2:327–50.

[2] See Tertullian, *De pudicitia*, 11.2.

[3] The list of petitions in the *Litany of the Saints* is contemporary to the lives of the martyrs. The first Western text of the invocations was written in Greek in Rome and dates from the seventh century. Earlier texts existed in the Eastern Mediterranean.

[4] My original source for this information was Peter Ketter, *The Magdalene Question* (Milwaukee: The Bruce Publishing Company, 1935), 83. See also *Brevarium Romanium* (1952): "*Sancta María Magdaléna, ora . . . Omnes sanctae Vírgines et Víduae . . .*" (251); the *Roman Breviary* (1950): "St. Mary Magdalen, . . . All ye holy Virgins and Widows . . ." (209). The *Litany of All Saints* of *The Roman Calendar: Text and Commentary* (1976) reflects the 1969 canonical changes so that Saint Mary Magdalene is the last-named entry for the "Prophets and Fathers of our Faith" (129–30). I am grateful to Joseph N. Tylenda, S.J., for our discussion on this liturgical conundrum. More recent documents issued by authority of Pope Francis have further clarified the separate identities of Mary Magdalene and Mary of Bethany; see pages 21–2 of this volume.

"virginity" upon her spouse's death; in such an instance, virginity was synonymous with chastity and monogamy. Nor are there any theological or liturgical grounds to interpret the title "virgin" or the delineation of "all ye holy virgins and widows" as simply an honorific. Given the Christian moral climate contemporary with the issuing of the *Litany of the Saints*, the designation of the Magdalene as either a "holy widow" or a "holy virgin" could only have had a sexual connotation appropriate to the authoritative writings of Augustine and Jerome.[5] Thereby this text serves as liturgical testimony for the continuing confusion over her identity. Ambrose of Milan and Modestus of Jerusalem (d.634) employed the title "Virgin" when discussing Mary Magdalene in their texts.

Nonetheless, Gregory the Great concluded that a multiform Magdalene who was both sinful and penitent would prove more salutary to then contemporary Christendom for his was a time of loose morality and other forms of immoral behavior. He appropriated the common actions in the scriptural unction scenes and conflated the "seven devils" with immorality and sinfulness to proclaim that Mary Magdalene was all of these biblical women in his *Homily 25.1.10*.[6] After all, he instructed his fellow Christians,

> The considerable time it took for the disciples to believe in the Lord's Resurrection may have been a weakness on their part; nevertheless, it served to our strength. In response to their doubts, they received numerous proofs of the Resurrection: when we become aware of them, we can say that the apostles' doubts are the opportunity for us to affirm our faith. *Mary Magdalene, who believed immediately, is less useful to us than Thomas, who doubted for some time.*[7]

Following Gregory, the Western Christian tradition acknowledged the multiform Magdalene as one woman who was sinner, penitent, anointer, and follower as well as witness to the Resurrection. However, the theological debate about her identity did not end with this series of papal pronouncements. Albertus Magnus (d. 1280), Bernard of Clairvaux (1080–1153), and Thomas Aquinas (*c.* 1225–74), among other theologians, disputed her identity on scriptural, devotional or spiritual grounds.

On the eve of the Reformation, however, perhaps the most controversial discussion of "the Magdalene question" was the declaration by the French humanist Jacques Lefèvre d'Étaples (1455–1536). The Queen Mother, Louise de Savoy (1476–1531), commissioned the Franciscan François

[5]The early Christian categories of "virgin" and "widow" as shaped by the Church Fathers are discussed by several scholars including Ute E. Eisen, Katharine Ludwig Jansen, and Victor Saxer. In classical Mediterranean culture a virgin was an "independent woman," that is, one who stood without the financial or societal support of a man be he husband, brother, or father. This "independence" was not related to any form of sexual knowledge or experience. For example, the epithet "virgin goddess" was employed for Hera, Aphrodite, and Athena; and in point of fact, Hera annually underwent a "ritual bath" to restore her "virgin powers." See my entry "Virgin/Virginity" in the *Encyclopedia of Comparative Iconography* (Chicago: Fitzroy Dearborn, 1998), II: 899–906.

[6]Gregory's homiletic texts were dependent upon his reading of Tertullian's *De pudicitia* 11.2.

[7]Gregory the Great, *Homily 29*. The emphasis is mine.

Demoulins de Rochefort (*c.* 1470/80–1526) to write an illustrated life of Saint Mary Magdalene with the Flemish illustrator Godefroy le Batave (fl. 1516–26) to commemorate the official 1516 pilgrimage of the court of Francis I of France (1494–1547) to La-Sainte-Baume and Saint Maximin La-Sainte-Baume.[8] Demoulins asked his friend Lefèvre about the Magdalene, her story, and her role in the Christian narratives.

In his treatises, *De Maria Magdalena* (1517) and *De tribus et unica Magdalena* (1510), Lefèvre sought to distinguish between Mary Magdalene and Mary of Bethany and promoted his conviction that the beloved medieval saint was an erroneous composition of three biblical women—Mary Magdalene, Mary of Bethany, and the unnamed anointer—and that the Magdalene mosaic was the result of exaggerated medieval claims and legends which sparked vigorous theological and spiritual debates. He argued that a careful reading of scripture advocated that she was neither the unnamed adulteress nor the sinful anointer but was rather one of Jesus's original followers faithful unto his death and was the witness to his Resurrection.[9] While scripturally sound, Lefèvre's *dictum* provoked controversy at every level of the Christian collective including the esoteric public debates between himself and John Fisher, then Bishop of Rochester.

Demoulins published his *Vie de la Magdaléne* (*The Life of Mary Magdalene*) in 1517, following the established biographical details of the many medieval *vitae* and *The Golden Legend*. Embellished with seventy-two grisaille miniatures by le Batave which formed the largest cycle of images documenting the saint's life, Demoulins's text encompassed a visual defense of the Magdalene mosaic. Further this cycle of images led to a redefinition of her iconography by northern artists including Lucas van Leyden (1494–1522) and the Master of the Magdalene Legend (fl.1483–1527), whose detailed images of the Magdalene dancing, hunting, and preaching as well as of her reliquaries might be interpreted as a visual defense of the Magdalene mosaic.

In 1969 under the aegis of Pope Saint Paul VI (1897–1978), the Roman Catholic Church formally revised the canonical definition of Mary Magdalene in the *Calendarium Romanum*. She was returned to the early Christian description of faithful follower and first witness, and not the unnamed adulteress or sister of Lazarus and Martha.[10] However, stronger affirmations of the Roman Catholic revisionist

[8]Martha Mel Edmunds, "La Sainte-Baume and the Iconography of Mary Magdalene," *Gazette des Beaux-Arts* CXIV (1989): 16–39.

[9]For a comprehensive discussion of this theological controversy, see Anselm Hufstader, "Lefevre d'Étaples and the Magdalene," *Studies in the Renaissance* 16 (1969): 31–60. See also Robin Waugh, "Mary Magdalene, II. Christianity, B, Medieval Times and Reformation Era," *Encyclopedia of the Bible and its Reception*, Volume 17 (Berlin: Verlag De Gruyter, 2019): 1210–12, especially 1212. The recent study is Margaret Arnold, *The Magdalene in the Reformation* (Cambridge, MA: Harvard University Press, 2018).

[10]The entry for July 22 under *Variationes in Calendarium Romanum Inductae* reads as follows:

Nil mutatur in titulo memoriae huius diei, sed agitur tantummodo de S. Maria Magdalena cui Christus post suam resurrectionem apparuit, non vero de sorore S. Marthae neque de peccatrice cui Dominus remisit peccata (Lc 7, 36–50).

Calendarium Romanum (Vatican: Typis Polyglottis Vaticanis, 1969), 131.

attitude toward Mary Magdalene were evidenced when the Congregation for Divine Worship and the Discipline of the Sacraments issued two documents at the expressed wish of Pope Francis (b.1936) on June 3, 2016. The more significant text is identified as *Apostolorum Apostola* (Latin for "*Apostle of the Apostles*") that proclaimed that the July 22 celebration was elevated from a memorial to a feast in the General Roman Calendar. The designation of feast signified major events, such as the Annunciation to the Virgin Mary or the Baptism of Christ, and those saints of greatest significance like the twelve (male) Apostles.

In Section 16 of his Encyclical "On the Dignity and Vocation of Women on the Occasion of the Marian Year" (*Mulieris dignitem*) issued on August 15, 1988, Pope Saint John Paul II (1920–2005) advised that there was a "special emphasis on the particular role of Mary Magdalene as the first witness who saw the risen Christ, and as the first messenger who announced the Lord's resurrection to the Apostles."[11]

The second document issued under the authority of Pope Francis on June 3, 2016 was *The New Preface of Saint Mary Magdalene* that enriches the earlier prefaces in the *Missale Romanorum* for July 22 by replacing Lk. 7:36–50 with Jn 20:2–1, 11–18, thereby emphasizing that the Risen Christ appeared to her first and charged her as the Apostle to the Apostles. Throughout this document, the appearance of the Risen Christ to Mary Magdalene is identified as "being in the garden" as a harbinger of new life, and thereby in contrast to Eve in the Garden of Eden as a signifier of death.[12] During his homily for the morning meditation on April 2, 2013 in the chapel at Domus Sanctae Marthae, Pope Francis I said that Christ's mercy was extended to this woman who was "exploited and despised by those who believed they were righteous" and that her tears at the Empty Tomb reminded us that "sometimes in our lives, tears are the lenses we need to see Jesus."[13] During his general audience on May 17, 2017, Pope Francis spoke further about the nature of Christian Hope and directed attention to the figure of Mary Magdalene at the tomb, "So that woman, before encountering Jesus, had been at the mercy of evil (cf. Lk. 8:2) now becomes the *Apostle of the new and greatest hope*."[14]

[11]The formal English translation of this papal document can be accessed online at https://w2.vatican.va/content/john-paul-ii/en/apost_letters/1988/documents/hf_jp-ii_apl_19880815_mulieris-dignitatem.html (accessed February 15, 2020).

[12]The official English translation of this document *Apostle to the Apostles!* was issued under the signature Arthur Roche Archbishop Secretary of the Congregation for Divine Worship and the Discipline of the Sacraments on June 3, 2016 and is available online at http://www.vatican.va/roman_curia/congregations/ccdds/documents/articolo-roche-maddalena_en.pdf (accessed January 15, 2020).

[13]The formal English translation of this papal homily can be accessed online at http://www.vatican.va/content/francesco/en/cotidie/2013/documents/papa-francesco-cotidie_20130402_tears.html (accessed January 15, 2020).

[14]The formal English translation of the Pope's General Audience can be accessed online at http://www.vatican.va/content/francesco/en/audiences/2017/documents/papa-francesco_20170517_udienza-generale.html (accessed January 15, 2020).

3

Eastern Christian Narratives and Traditions

Alternatively, distinctive patristic interpretations and cultural traditions of Mary Magdalene were followed in Eastern Orthodox Christianity.[1] The Hellenistic scholar and theologian Origen of Alexandria (*c*. 185–254) defined Mary Magdalene as the faithful follower of Christ and the first witness to the Resurrection. He distinguished clearly between the female anointers in the scriptural unction narratives.[2] As a result, the three women who were often confused or conflated with each other either in oral tradition or theological debates within the Western churches came to be honored officially as three distinct individual women in the Eastern practice, which affirmed them with separate feast days: the Converted Sinner on March 21; Mary of Bethany and sister of Lazarus on March 18; and Mary Magdalene on July 22. However, the three Marys known as the *Myrrhophores* or Myrrh-Bearing Women who attempted to anoint the body of the crucified Jesus are recognized on the third Sunday of Easter.[3] Although named as one of the myrrhophores, Mary Magdalene is honored as the "The Holy

[1] Vassiliki A. Foskolou, "Mary Magdalene between East and West," *Dumbarton Oaks Papers* 65 and 66 (Washington, DC: Dumbarton Oaks, Trustees for Harvard University, 2011–12), 271–96. See also Désirée Krikhaar, "Mary of Magdala—Mary Magdalene: Image of a Saint between East and West," and Diane Apostolos-Cappadona, "Mary Magdalene's Left Hand," in Wijinia, *Mary Magdalene: Chief Witness, Sinner, Feminist* (2021), 105–13 and 118–21 respectively.

[2] See *In Matthaeum*, series 77.

[3] This feast is known as the Sunday of the Myrrh-Bearing Women. As Lent and Easter are moveable feasts in Eastern Orthodox Christianity, the date of this feast is set as the Third Sunday of Easter. The iconography of the Myrrh-Bearing Women, or *Myrrhophores*, is the "most ancient depiction of Pascha" and is understood to have first appeared on an early-third-century fresco at Dura-Europos. See Michel Quenot, *The Resurrection and the Icon* (Crestwood, NY: Saint Vladimir's Seminary Press, 1997), 93. More recently, however, Michael Peppard has presented a strong argument for these images not being associated with Mary Magdalene but rather the Virgin Mary; see his *The World's Oldest Church: Bible, Art, and Ritual at Dura-Europos, Syria* (New Haven, CT: Yale University Press, 2016).

Illustration 7 Icon of Saint Mary Magdalene *(Monastery of Simonpetra, Mount Athos).*

Myrrh-Bearer and Holy Equal-unto-the-Apostles" on July 22.[4] The text for the week of the Saint Myrrh-Bearers reads:

> Many were the Myrrh-Bearers, but the Evangelists mentioned only the important ones, leaving the others aside. First of them all was Mary Magdalene, from whom Christ cast out seven demons; after the Ascension of Christ, she went to Rome, as the story has it, and delivered Pilate and the High Priests to an evil death. After relating to the Emperor Tiberius the events surrounding Christ; she later reposed in Ephesus and was buried by Saint John the Theologian; her holy relics were translated to Constantinople by Emperor Leo the Wise.

[4]See the *Synaxarion of the Eastern Orthodox Church.* The Synaxarion is a listing of the Feast Days and Saints of the Eastern Orthodox Church. Given the autocephalous nature of Eastern Orthodox Christianity, the Synaxarion will have regional and national differences but the major feast days and saints will remain universal.

Continuing to observe Origen's formula and in coordination with the spiritual and theological praise of the Cappadocian father Gregory of Nyssa (*c.* 335–94), and conscientious readings of the Christian Scriptures, the female saint identified as Mary Magdalene is esteemed in the Eastern Orthodox Christian traditions as the woman healed of demoniac possession who was recognized as one of the pious women who, along with Joanna and Susanna, supported Jesus and his ministry and shared evangelic tasks with the (male) Apostles (Lk. 8:1–3). She was a faithful follower of Jesus, bore witness at the foot of his cross, lamented with his Mother, endeavored to anoint his crucified body, and received the initial angelic pronouncement of the Resurrection. The first to see the Risen Christ, Mary Magdalene received his proclamation of the Resurrection and his Ascension. By sending her to announce this to his (male) disciples, the Risen Christ transformed her into the "Apostle to the Apostles." As such, she plays a significant role in the liturgical services for the Passion Week, and especially in the morning and afternoon liturgies of Easter Sunday.

The Matins for Holy Wednesday incorporate multiple references to Mary Magdalene as "the fallen woman," as Myrrh-Bearer, and as witness. The most notable of these testimonials is found in the liturgical chants of the Byzantine Abbess and hymnographer Saint Kassiani (*c.* 805/20–65). Liturgically the *Troparion of Kassiani* is chanted only once a year late in the evening of the Holy Tuesday service in anticipation of the next morning. This hymn begins,

> The woman who had fallen into many sins recognizes Thy Godhead, O Lord. She takes upon herself the duty of myrrh-bearer and makes ready the myrrh of mourning, before Thy entombment.[5]

Of particular note beyond her more formal scriptural role in the Easter liturgy, pious tradition recounts that following the Pentecost, Mary Magdalene traveled to Rome where she preached the kerygma, related the teachings of Christ, and supported the initial Christian community there. It came to pass that she was invited to a banquet at which Tiberius Caesar (42 BCE–37 CE) was present. After explaining the story of Jesus as the Christ including his miracles and his mission, Mary Magdalene lectured Caesar as to the shortcomings of Pontius Pilate and his mishandling of the trial. She then confirmed that she had seen the Risen Christ and signified his Resurrection by holding up a universal symbol for new life—an egg. Caesar rebuked her with the challenge that he would not recognize the Resurrection unless the egg turned red. Mary Magdalene then proffered the egg that had turned red in her hand as both the sign and symbol of the Resurrection and proclaimed "*Christos Anesti!*" ("Christ

[5]The *Hymn of Kassiani* was written by the ninth-century Abbess Kassia (also transliterated in English as Kassiane). The translation quoted here is from the *Greek Orthodox Holy Week and Easter Services* compiled by George L. Papadeas (Daytona Beach, FL: Patmos Press, 1979), 104. For an alternative translation, see *The Services for Holy Week and Easter* trans. Leonidas Contos (Northridge, CA: Narthex Press, 1999), 138. The Matins for Holy Wednesday are often sung in anticipation on Holy Tuesday evening. However, it is important to note that the Holy Wednesday evening service includes Holy Unction for all believers.

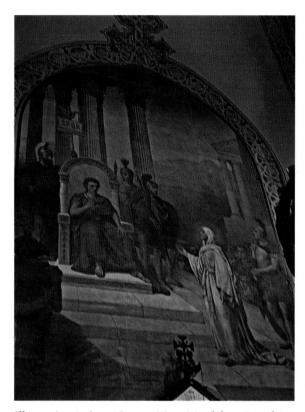

Illustration 8 *Sergei Ivanov,* Mary Magdalene Preaching to Emperor Tiberius *(c. 1886: Russian Orthodox Church of Saint Mary Magdalene, Gethsemane).*

is Risen"). This episode is depicted in the nineteenth-century paintings by the famed Russian artist Sergei Ivanov (1864–1910) (Illustration 8) in the Russian Orthodox Church of Mary Magdalene on the Mount of Olives in Jerusalem.[6]

Red-colored eggs continue to be the symbol of *Pascha* in Eastern Orthodox Christianity and are exchanged when the Lenten fast is broken. The established prayer for the Paschal blessing of the eggs and cheese is retained from a prayer transcribed on parchment from the Library of the Monastery of Saint Athanasius near Thessalonika.

[6]Note that the formal title of this complex is The Russian Ecclesiastical Mission in Jerusalem. The Church of Mary Magdalene was built in 1886 as a memorial to the Empress Maria Alexandrovna (1824–80) by her son the Russian Tsar Alexander III (1845–94), and his brother the Grand-Duke Sergei Alexandrovich (1857–1905) and his wife Grand-Duchess Elizabeth (1864–1918). The Grand Duchess commissioned Sergei Ivanov to paint the murals depicting the life of Mary Magdalene and she brought the finished works with her

Thus, have we received from the holy Fathers, who preserved this custom from the very time of the holy Apostles, wherefore the holy Equal-unto-the-Apostles Mary Magdalene first showed believers the example of this joyful offering.

Testimony abounds within Eastern Orthodox Christian traditions as to Mary Magdalene's many post-Pentecost activities of teaching and preaching. According to one of these traditions, it is believed that on her way to Rome in 34 CE the boat transporting her and her companion Mary Cleophas anchored at Porto Vromi on the Greek island of Zakynthos.

Accordingly, her footprint remains visible on the landing rock on which she stepped as she began her evangelization of this part of Greece. The nearby village known as "Maries" has been named in memory of this visit as is the Church of Panagia Mariesotissa that houses an icon with miraculous properties and that sponsors a major festival in honor of the Magdalene every July. One of the walls inside this church is decorated with a mural painting of the two holy women stepping out of their boat onto the rocky landing of the island (Illustration 9).

Building on the scriptural foundation of Paul's Epistle to the Romans 16:6 to "Salute Mary, who hath laboured much among you" as referencing Mary Magdalene, Eastern Orthodoxy affirms her evangelic mission to Rome and thereby her confrontation with Tiberius Caesar. She is reputed to have remained in Rome for two years following Paul's arrival until the first court judgment against him. Her return to Jerusalem was preceded by a major missionary journey throughout the Mediterranean as she traversed Italy, France, Egypt, Phoenicia, Syria, and Pamphylia.

when she travelled to Jerusalem for the consecration ceremonies in 1886. After the assassination of her husband in 1905, the Grand Duchess Elizabeth founded the Convent of Saints Martha and Mary (Magdalene) in Moscow. This order of nuns was dedicated to the care of the poor, the nursing of the sick, and the education of young girls. Elizabeth became Abbess until March 13, 1918 when along with the then five surviving male Romanovs, she and her companion Sister Barbara were arrested and transferred to Alapaesvk where on the morning of July 5, 1918 they were pushed down a mine shaft, tortured with water, grenades, and fire until they eventually died from their injuries. To avoid desecration by the Bolsheviks, the bodies of Mother Elizabeth and Sister Barbara were identified and smuggled through Shanghai to Jerusalem. By 1920, the bodies of the two saintly women were laid to rest in the crypt of the Church of Mary Magdalene in Gethsemane. Between October 19 and November 1, 1981, along with many others who died for their Orthodox faith at the hands of the Communists, Mother Elizabeth and Sister Barbara were declared to be Holy New Martyrs and Saints. As a result, the Archimandrite Anthony (Grabbe) followed the instructive issued by the Council of Bishops of the Russian Orthodox Church Outside of Russia and opened the five tiers of their coffins in preparation for the canonization ceremonies. In particular, when Mother Elizabeth's ultimate coffin was opened "a strong aroma like jasmine and honey mixed together" filled the room. Despite the arid conditions of the Gethsemane Convent, the garments of these was moist and thereby her remains were determined to be emitting myrrh. The uncorrupt remains of these saints were carefully dressed in new garments and reverenced as the Archimandrite removed the right hand of Mother Elizabeth and placed it in a reliquary. The remains of these two new saints were laid to rest in newly sealed coffins and moved to the upper church. The reliquary containing the Grand Duchess' right hand was translated to the Synodal Cathedral of Our Lady of the Sign in New York City and visited Russia in May 2017. For additional detailed information on the Grand Duchess Elizabeth the New Martyr, see http://www.russianorthodoxchurch.ws/synod/engdocuments/enart_stselizabethbarbara.html (accessed January 16, 2020), https://www.russianorthodoxchurch.ws/synod/engrocor/enser_metanastassystelizabethfeodorovna.html (accessed January 16, 2020), and http://orthochristian.com/103248.html (accessed January 16, 2020).

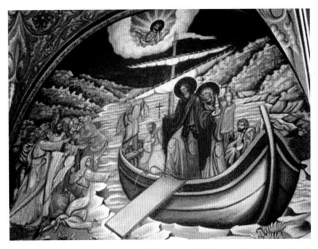

Illustration 9 Mary Magdalene and Mary Cleophas land at Porto Vromi *(Church of Panagia Mariesotissa, Zakynthos).*

From Jerusalem, she accompanied the Theotokos and Saint John the Evangelist to Ephesus where they spent the remainder of their lives in what is now identified as the House of the Virgin Mary.[7] According to pious tradition, Mary Magdalene wrote her Gospel and worked with Saint John on the first twenty chapters of his Gospel. These examples of Magdalenian authorship may be the foundations for the later Western medieval depictions of her as a writer. Following the Koimesis (Dormition) of the Theotokos, Mary Magdalene remained in Ephesus until her own peaceful death and the eventual burial of her earthly remains in a nearby cemetery cave where it is reputed that the Seven Sleeper Saints of Ephesus were later placed.[8]

[7]Known in Turkish as the *Merema Ana Evi*, this small stone house on the Mountain of Nightingale (*Koressos* in Greek) some 9 km. from the ancient city of Ephesus, was erected on a site located by Lazarists Fathers in 1891 and identified from the description of a vision of Blessed Anne Catherine Emmerich (1774–1824) as the location of the building in which the Theotokos, Saint John, and Mary Magdalene lived. It is positioned between a miraculous salt water stream and the site of the second-century ecclesial building in which the Council of Ephesus was held and during which the Bishops pronounced the Virgin Mary to be *Theotokos* ("God-Bearer") in 431 CE. From the eighth to the fifteenth centuries, this same site was referred to as the *Panagia Kapulu* (Virgin's Door or Doorway to the Virgin). The significance of this present site was enhanced by Pope Leo XIII (1810–1903) in his 1898 Encyclical *Magnae Dei Matris*. Later affirmations by Pope Pius X (1835–1914) identified this as the first Christian church dedicated to Mary while Pope Pius XII (1876–1958) made a pilgrimage there as a youth in 1896 and later as Pope he granted this edifice the status of a Holy Place in 1951 that was confirmed by Pope Saint John XXIII (1881–1963). Pope Saint Paul VI (1897–1978) was the second Pope to visit this site in 1967. In 1980, Pope Saint John Paul II (1920–2005) declared this site to be a Marian Shrine and celebrated Mass on what was believed to be the adjoining site of the Council of Ephesus. Most recently, Pope Emeritus Benedict XVI (b. 1927) visited this Marian Shrine in 2006.

[8]Archaeologists discovered the Cave of the Seven Sleepers in the grounds of a fourth-century cemetery that included a two-story monumental tomb positioned above ten underground chambers. A church with an extensive cemetery containing seven hundred tombs was later constructed on this site.

The Patriarch of Jerusalem, Modestus (*c.* 537–634) provided the first detailed account of the life, death, and burial of Mary Magdalene in Ephesus noting that

> After the death of Our Lord, the Mother of God and Mary Magdalene joined John, the well-beloved disciple, at Ephesus. It is there that the myrrophore ended her apostolic career through her martyrdom, not wishing to the very end to be separated from John the Apostle and the Virgin.[9]

He characterized Mary Magdalene as being totally pure and virginal, and thereby capable of instructing other women about a life of holy chastity. Further, Modestus affirmed that before her death, Mary Magdalene appeared to all as a "pure crystal" because of her "very great virginity and purity."

Additional affirmations that Mary Magdalene ended her days in Ephesus are found ironically in the writings of two of the leading Western Christian chroniclers: Gregory Bishop of Tours (538–94) and Willibald Bishop of Eichstatt (700–89). Renowned as both a theologian and a historian for his *Historia Francorum* (*History of the Franks*), Gregory was the initial contemporary source for the narrative of the Merovingians in what would become France.[10] In his *De Gloria martyrum (Glory of the Martyrs)*, Gregory identified Ephesus "is in this town that Mary Magdalene rests, with nothing to cover her."[11] Gregory makes no reference in any of his writings to the Provençal narrative of Mary Magdalene and her burial in Saint-Maximin-la-Sainte-Baume.

Famed for his successful efforts on behalf of the Church in Franconia, the Anglo-Saxon Willibald had a special devotion to Saint Mary Magdalene. During a pilgrimage to the Holy Land in 721, he paid a long visit to the traditional site of her tomb in Ephesus followed by a visit to the somewhat ambiguously identified tomb of Saint John the Evangelist and the Cave of the Seven Sleepers. Although he lived during the translation of the Magdalene's relics from Provence in the south of France to Vézelay in Burgundy, Willibald like Gregory makes no mention of the Provençal tradition.

Rather these two Western chroniclers appear to affirm the traditional narrative of the life, death, and burial of Mary Magdalene in Ephesus at least until 899 when the Byzantine Emperor Leo VI the

[9]Clive Foss, *Ephesus after Antiquity: A late antique, Byzantine, and Turkish City* (Cambridge: Cambridge University Press, 1979), 33, especially n. 10.

[10]*Decem Libri Historiarum (Ten Books of Histories)* also related miracles of the saints, especially those of Saint Martin of Tours whose devotion Gregory promoted.

[11]For a more recent translation, see Raymond Van Dam, *Gregory of Tours: Glory of the Martyrs* (Liverpool: Liverpool University Press, 1988), #29: "John the Evangelist," 47. "Mary Magdalene is buried in Ephesus, although there is no building over her."

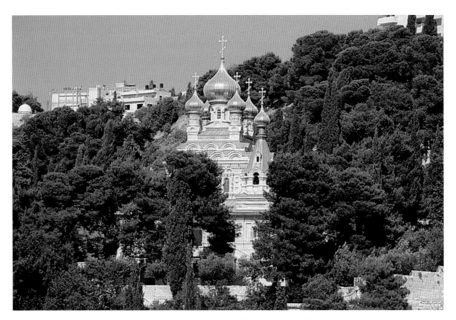

Illustration 10 *Russian Orthodox Church of Saint Mary Magdalene (Gethsemane).*

Philosopher (886–912) had her relics translated to the Monastery of Lazarus on the Bosphorus near the Imperial Palace in Constantinople. Western Christian tradition attests that during the Crusader campaigns, most significantly after the infamous Fourth Crusade in 1204, the Magdalene's relics were taken to the Basilica of Saint John Lateran in Rome from whence fragments were moved to France, especially to Marseilles and Vézelay.

However, according to the Eastern Christian tradition, fragments of her relics remain in Orthodox churches, convents, and monasteries including in the Church of the Holy Sepulchre in Jerusalem, the Russian Orthodox Church of Saint Mary Magdalene on the Mount of Olives (Illustration 10) and most especially in the Monastery of Simonpetra (Illustration 11) on the Holy Mountain (known also as Mount Athos).

While pious traditions and devotion suggest an earlier arrival for the left hand of Mary Magdalene at the Monastery of Simonpetra, factual documentation affirms its presence from 1644, or perhaps no earlier than 1580. There is no mention of this relic in the *Vita of Saint Simon* and tragically the Byzantine and post-Byzantine archives of the monastery were destroyed in a major fire in 1580. Thereby, any earlier history of this relic at Simonpetra cannot be authenticated. Nonetheless the saint's

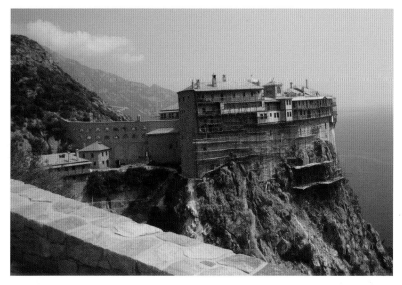

Illustration 11 *Monastery of Simonpetra (Mount Athos).*

left hand is enshrined in a silver reliquary[12] (Illustration 12) in the katholicon (church) of the Monastery and is easily recognized by the faithful from the heavenly fragrance it exudes and the emitting of a constant aura of bodily warmth. Further, given the spiritual significance of Mary Magdalene and the many miracles she has performed at Simonpetra, she is revered as the second foundress of this Holy Monastery.

Recent traditions promote several miracles of intercession including the rescue of the peoples in the Galatista region of Thessaloniki from the blight of plant-eating worms in 1911 and those in the Epanomis region of Thessaloniki from a plague of locusts in 1912. Perhaps most significantly for Mount Athos, the presentation of the relic of Mary Magdalene in coordination with the Holy Water Service and a Supplication Service to the saint led to the preservation of several monasteries during

[12]The inscription on the reliquary container reads:

[ΤΗΣ] ΜΥΡΟΦΟΡΟΥ ΚΑΙ ΙΣΑΠΟΣΤΟΛΟΥ
Μ(Α)Ρ(Ι)ΑΣ [ΤΗΣ] ΜΑΓΔΑΛΗΝΗΣ ΥΠΑΡΧΕΙ
ΤΗС ΜΟΝΗС ΤΟΥ ΑΓΙΟΥ СΙΜΟΝΟС
ΠΕΤΡΑС ΕΝ ΕΤΕΙ ͵ΖΡΝΑ:
That means:
IT IS OF THE MYRRH BEARER AND EQUAL OF THE APOSTLES
MARY MAGDALENE
OF THE MONASTERY OF SAINT SIMON'S
ROCK, IN THE YEAR 7151 (1644 CE)
(E-mail correspondence with Fr. Kosmas Petrides of Simonpetra Monastery, February 26, 2018).

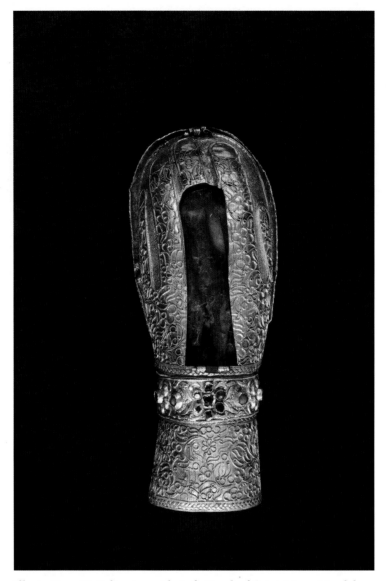

Illustration 12 Reliquary with Left Hand of Saint Mary Magdalene *(Katholion, Monastery of Simonpetra, Mount Athos).*

dangerous fires first in 1945 in the forest of the Holy Monastery of Iveron that endangered the Holy Monasteries of Iveron, Philotheou, Xeropotamou, and Simonpetra, and later in 1947 specifically in the forest of the Holy Monastery of Simonpetra. Encased in a larger silver and golden reliquary container along with a fragment of the True Cross and another precious relic from Simonpetra, and accompanied by a monastic entourage, Mary Magdalene's incorrupt left hand has traveled to offer blessings and solace to the Orthodox faithful in Russia (1888 and 2006), Zakynthos (2010), and most recently Warsaw and the Holy Mountain of Grabarka (2014) (Illustration 13).

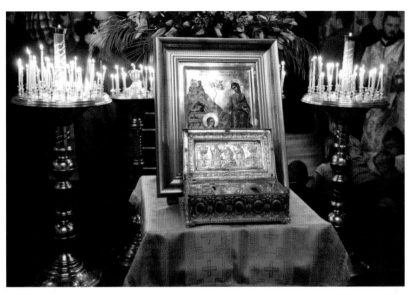

Illustration 13 *Reliquary displaying relics of Saint Mary Magdalene and a Fragment of the True Cross during Holy Visit to the Saint Mary Magdalene Orthodox Cathedral, Warsaw, Poland, in 2014.*

4

Western Christian Narratives and Traditions

Discussions of the Magdalene's "afterlife" following the events in the scriptural narratives were also of much concern to believers in the Western Christian tradition. Her popularity among believers was signified by the pious legends and traditions that completed, or attempted to complete, her earthly biography. Various sources, including the Roman martyrology, detailed versions of her evangelical missions to France in what might be deemed a curious series of parallels to the Eastern Christian tradition of her scriptural afterlife. The Western narrative of the Magdalene's journey from Jerusalem echoed the earlier narratives with the twists and turns that brought her and her larger entourage of early Christian companions across the sea to the south of France.

Although the initiation of this Western sojourn is dated 47 CE, the legendary episodes and liturgical dramas that relate her narrative form a series of texts credited from the ninth century forward. Further, these written texts endorsed the "Magdalene mosaic" established as a result of interpretations of Gregory's homily beginning with the *vita evangelica Mariae Magdalenae* attributed to a homily by Saint Odo of Cluny (*c.* 878/880–942).[1] Although modern scholarship does not favor identifying the author of this text as Saint Odo, it is nonetheless clearly a product of the Cluniac monastic tradition. The *vita evaneglica Mariae Magdalenae* was the initial attempt to amalgamate all the Gospel and patristic passages about Mary Magdalene, Mary of Bethany, and Luke's anonymous sinner into one coherent personality and narrative.

Moreover, two other early texts the ninth-century *vita eremetica Mariae Magdalenae* and the tenth-century *vita apostolica Mariae Magdalenae* provided simultaneously written substantiation of the Magdalene's historicity and identity. Although often credited to either a Cassianite monk, the Jewish

[1]See for example, Katherine Ludwig Jansen, *The Making of the Magdalen: Preaching and Popular Devotion in the Late Middle Ages* (Princeton: Princeton University Press, 2000), especially page 38, note 65.

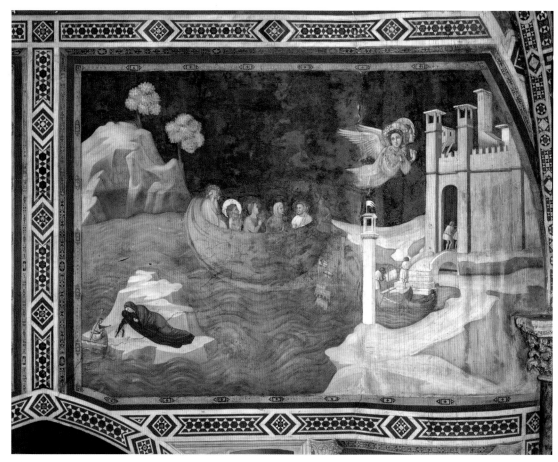

Illustration 14 *Credited to Giotto di Bondone, Detail of the* Voyage of the Magdalene to Marseilles *from the Eastern Wall (c. 1307–8: Cappella Maddalena, Basilica di San Francesco, Assisi).*

historian Flavius Josephus (37–*c.* 100), or an Eastern Christian source (a Greek monk or monks fleeing Byzantium), this otherwise anonymous source is significant for the commingling of the legend of Saint Mary of Egypt with that of Mary Magdalene.

The historical source for information about Saint Mary of Egypt (*c.* 344–*c.* 421) is Saint Sophronius who was Patriarch of Jerusalem (634–638). He is reputed to have recorded the narrative of her life which she told to Saint Zosimas of Palestine.[2] At the age of twelve, Mary left her parents for a life of sexual perversities in the Egyptian port city of Alexandria. Ruled by a voracious female sexual appetite, she was renowned for her freely bestowing her favors and for earning a living by begging and spinning

[2]Although Saint Mary of Egypt's official feast day is April 1 which is acknowledged as the day of her repose in Eastern Orthodox Christianity, she is commemorated further on the Fifth Sunday of Lent with a Great Vespers offered the Saturday evening before. A third commemoration is offered on the Thursday before the Fifth Sunday of Lent when her life, i.e., Sophronius' full text, is read during the Great Canon of Saint Andrew of Crete.

flax. After seventeen years in Alexandria, Mary set out on a non-religious pilgrimage in search of new sexual partners among those celebrating the Exaltation of the Holy Cross in Jerusalem. Initially she continued her depravities in Jerusalem until one day an invisible force restricted her access to the Church of the Holy Sepulchre. Recognizing that her impurity made her unworthy to enter the sacred place, she was filled with remorse and repented of her lifestyle. She prayed for forgiveness before an icon of the *Theotokos* which was placed outside of the church and vowed to lead an ascetic life. Granted entry into the church, she venerated a relic of the true cross and returned to give thanks before the icon of the *Theotokos*.

During her prayer, she heard a voice directing her to cross the River Jordan for a glorious rest. At the Monastery of Saint John the Baptist, she received absolution and Holy Communion. Crossing the River Jordan the next morning with only three loaves of bread, she took refuge in the desert for the remainder of her life as a penitent. She existed on the foods she found in the wilderness and when her clothes disintegrated, her hair grew long enough to cover her nakedness (Illustration 15). She is

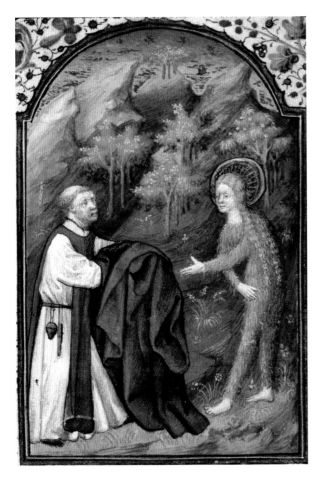

Illustration 15 Saint Mary of Egypt, covered with hair, stretches out her hand to Zosimas, the priest, *Hours of Jean Dunois, Yates Thompson 3. F.287 (1436–50: British Library, London).*

characterized in Christian art as an emaciated old woman whose nakedness is covered either by her long hair or the mantle of Saint Zosimas.[3]

The common threads in the "biographies" of Mary of Egypt and Mary Magdalene, as well as those of other reformed prostitutes including Thaïs, resulted in conflations of their stories and iconography throughout the Middle Ages. As with the lives of the Christian martyrs and saints, a common structure emerged for the narratives of these reformed prostitutes who renounced a life of pleasure for a life of chastity, poverty, and prayer. Similarities in these structures can also be found in comparison with the last years in the life of Mary Magdalene when she retreated to the wilderness of La Sainte-Baume.

The *vita apostolica Mariae Magdalenae* incorporated the episodes of her voyage to Marseilles, emphasized her preaching vocation in Gaul, and related her years of solitude and contemplation in a mountainous cave. Promulgated by the Benedictines of Vézelay, this chronicle was circulated widely throughout the eleventh century. Significantly, however, neither of these *vitae* related the Magdalene's encounter with the prince (count) of Marseilles or the fertility miracle for which she is renown within the history of the Merovingian dynasty of France.

Later in the eleventh century, these two *vitae* were unified into the *vita apostolico-eremetica* which accentuated the Magdalene's preaching career, her role in saving pagan souls in Gaul, and her time at La-Sainte-Baume. Further expansions to her legend included her encounters with the prince and princess of Marseilles, and the fertility miracles were the result of "collaboration" between hagiographers, Provençal romance writers, and her devotees. Ultimately her medieval tradition was an obvious integration of these early medieval *vitae*, the homily credited to Saint Odo, and the legend of Mary of Egypt which formed the foundation for the Magdalene's story as related in the *Golden Legend* with expanded discussions of the miracles credited to her.

Further, multiple French legends related the episodes of her perilous sea journey from the Holy Land to the south of France, her ministry of teaching and healing, her years of penance in either the French woods or a cave, and the ministry of angels at her death. What is definitive here is her significance to the Western Christian collective even into the thirteenth/fourteenth-century dramatic encounters between the Benedictines of Vézelay and the Dominicans of Saint Maximin-La-Sainte-Baume as to the historicity and location of her relics.

While there are variants in what becomes the fundamental narration of the Provençal legend and the Magdalene's consequential place in French history, the basic elements of the story begin with the persecution of the early Christians in the Holy Land. Customarily associated with Provençal religious beliefs was the voyage of the frail craft from the Holy Land to the coastal town known today as Les-Saintes-Maries-de-la-Mer sometime after 33 CE and most likely before 47 CE. This "small bateau"

[3]For a discussion of Saint Zosimas and his role in the last years of Mary of Egypt, and his eventual entry into the iconography of Mary Magdalene, see pages 46–7 of this volume.

that may or may not have had rudders or sails on the perilous journey across the Mediterranean toward Gaul,[4] miraculously carried not only Mary Magdalene but those identified as her brother Lazarus and her sister Martha. Additional passengers included her companions Mary Salomé and Mary Jacobé as well as Bishop Maximin, Sidoine, and the Holy Innocents all of whom fled the Holy Land to avoid persecution.

According to pious lore, the dark-skinned Sarah joined the small group after a miracle allowed her to walk on the waters over the cape of Mary Salomé. As with most religious legends, there are many versions of these events including the size and type of boat used and the itinerary across the Mediterranean as well as the identification of Sarah as an Egyptian, an abbess of a Libyan convent, a servant, or even as a survivor of Atlantis.

Their boat comes ashore at the then known village of Notre-Dame-de-la-Mer a site dedicated to the Virgin Mary but which had previously been sacred to three significant classical water goddesses: Isis, Artemis, and Cybele.[5] So as with other early Christian and medieval sites dedicated to the Virgin Mary, the legacy of a sacred feminine cult morphed from classical goddesses to Christianity's leading holy woman. This seashore area had both a Christian presence beginning in the first century and also a Jewish comportment following the destruction of the Temple in Jerusalem in 70 CE.

After landing at the port now known as Saintes-Maries-de-la-Mer and initiating a Christian identity there, the little group of Christians disbanded with Mary Jacobé and Mary Salomé staying with this new community and establishing the foundation for the fortress which would protect this area and lead to the building of the present church structure sometime between the ninth/ twelfth century. As time passed and the tradition of the "three Marys" landing on this shore became more established both the village and the church were renamed Les-Saintes-Maries-de-la-Mer.

Returning to the historical narrative, Martha ventured north toward Avignon to become the missionary to Tarascon (where she fought the demon monster [or dragon] identified as the tarasque) while Lazarus and Mary Magdalene travelled east to Aix and Marseilles. Later versions of this legend included additional companions such as Bishop Maximin, Sidoine (also identified as Cedonius) the man born blind, and the Holy Innocents among others. Lazarus remained in Marseilles to evangelize and eventually become the Bishop of Marseilles while the Magdalene after her time of preaching and evangelizing ended travelled further east-northeast until she reached the cave in the midst of a massif eventually identified as La-Sainte-Baume (or Holy Cave in the dialect of medieval Provençal) and depicted in multiple manuscript illuminations, prints and engravings, and paintings (Illustration 16).

[4] According to variants of this narrative, either as their frail craft docked on the Egyptian shore or closer to Carthage, the woman identified as Sarah joined the entourage on its voyage. The crypt chapel in the Church of Les-Saintes-Maries-de-la-Mer is dedicated to this elusive female figure who is oftentimes identified as the "Black (read also as the Dark) Sarah" and is the patron of the Roma.

[5] These classical female deities are oftentimes represented with dark, or black, skin but with Caucasian facial features and physiognomy as is also typical of the figures of the Black Madonna.

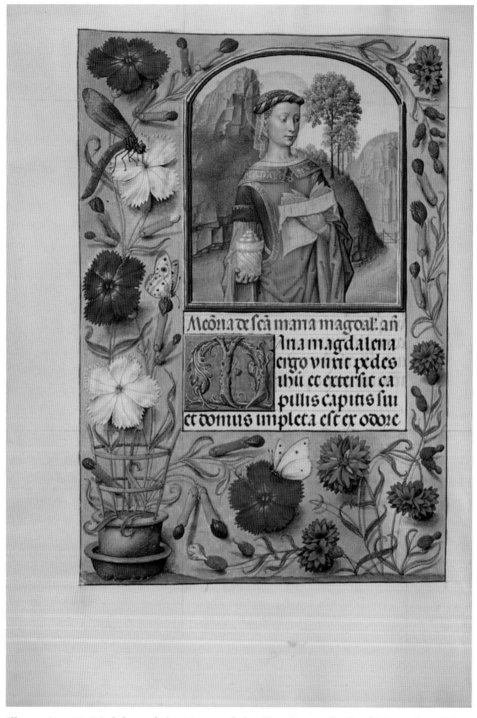

Illustration 16 *Workshop of the Master of the First Prayer Book of Maximilian*, Mary Magdalene with a Book and Ointment Jar, *Ms. Ludwig IX, 18.fol. 264v. (c. 1510–20: J. Paul Getty Museum, Los Angeles).*

Her reported thirty or, more appropriately—following the medieval tradition of Jesus's lifespan—thirty-three years of prayer, contemplation, and penance at La-Sainte-Baume included her daily elevation at the seven canonical hours by angel choirs (Illustration 17) to receive Holy Communion at the top of the massif in a small, sheltered altar known today as the Chapel of Saint Pilon.[6]

Eventually as her end grew near, she ventured, oftentimes described as being transported by angels down the massif to the small town known as Saint-Maximin-La-Sainte-Baume, where Bishop Maximin offered her Last Communion just before the Risen Christ descended to transport her soul

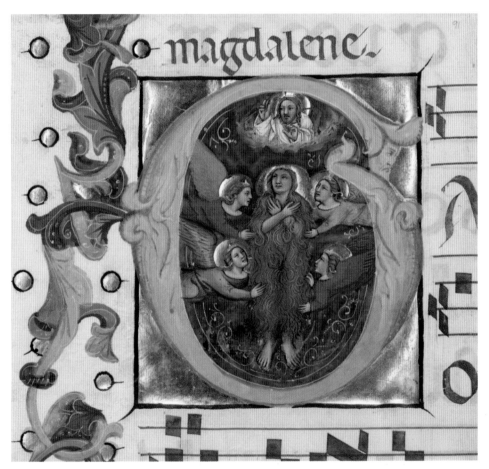

Illustration 17 *Niccolò di Giacomo da Bologna,* Initial G with the Assumption of Saint Mary Magdalene, *Ms. 115, leaf 4 v. (c. 1392–1402: J. Paul Getty Museum, Los Angeles).*

[6]This is the site of the Chapel of Saint Pilon whose sculptural group of the Magdalene and her celestial companions was smashed in August 2020. It is physically located over 3,000 feet above La Sainte-Baume at the top of the massif.

to heaven (Illustration 18). Alternative versions of this legend include an episode in which Bishop Maximin either ventured up to La-Sainte-Baume or meeting her halfway between La-Sainte-Baume and the town to offer the Magdalene a Last Communion. Medieval artists and dramatists portrayed these multiple variations oftentimes simply dependent upon their own spiritual attitude toward the Magdalene or their geographic or cultural milieu as evidenced in the altarpieces found as far south as the Iberian Peninsula and as far north as the Alps.[7]

Sanctuaries and shrines for her relics are found in Les Saintes-Maries-de-la Mer, Sainte Baume, Vézelay, and Aix-en-Provence as well as the many medieval French cathedrals dedicated to

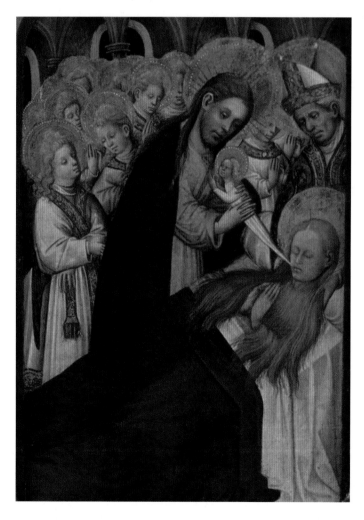

Illustration 18 *Bernat Martorell, Detail of the* Death of Saint Mary Magdalene *from Illustration 4.*

[7]See, for example, Joanne W. Anderson, *Moving with the Magdalen: Late Medieval Art and Devotion in the Alps* (London: Bloomsbury Visual Arts, 2019).

La Madeleine.[8] While earlier legends as well as Egyptian gnostic texts account for her last days being spent with Thomas in India, with the Risen Christ in the desert, or with the Virgin Mary and John the Evangelist in Ephesus.

The complex nature of the Magdalene's symbolic significance in the Middle Ages is highlighted by the intertwined tales of her journey to and throughout the south of France, and gave rise to the even more convoluted history of her relics. As was the case for other saints' relics and many religious objects, especially in France, those of the Magdalene were desecrated or destroyed either during the Reformation or in the late eighteenth century as a result of the French Revolution and the Reign of Terror.

Nonetheless, many fingers, fragments of arms or legs, endless locks of her hair, fragments of her penitential hair shirt and of the stones on which she knelt or prostrated herself in penance, her alabaster vase and spikenard, and even her tears have been located in diverse and distant lands from the Church of Saint John the Baptist of the Florentines in Rome even unto the Cathedral of the Madeleine in Salt Lake City, Utah. The reality of these tales, and of the extraordinarily long but endlessly incomplete list of her relics—including how they survived, were translated, and dispersed throughout the Mediterranean basin and the European mainland—prove the ubiquity of the interest of the Christian collective in her narrative(s), her existence, and her importance as an exemplar of Christian faith and devotion.

Beyond the accounts of her remains being found, revered, and translated to/from Ephesus, Constantinople, and Mount Athos in the Eastern Christian tradition; there are testimonials that her relics, whether large or fragmentary, can be found in Vézelay, Saint Maximin-La-Sainte-Baume, Senigallia (near Ancona), Rome (San Giovanni in Laterano), and Venice, to identify a few privileged sites. While she lived and may have died within the geographic borders of Eastern Christianity thereby making those claims to her relics more historically plausible, the detailed accounts of her journey to as well as her life and death in the south of France support the better-known accounts and dispositions of her relics.

Following the tradition that Mary Magdalene traveled, ostensibly carried by angels, to receive Last Communion from Bishop Maximin in or near the town of Saint-Maximin-La-Sainte-Baume, it is accepted that she was buried in the crypt of the cathedral which has been a pilgrimage site since the twelfth century. However, the exact location of her relics has had an equally convoluted history given the debates as to who are the caretakers of the Magdalene between the Benedictines established in Vézelay and the Dominicans in Saint-Maximin-La-Sainte-Baume.

[8]Perhaps the most famous of the cathedrals dedicated to her in France is the *Église de la Madeleine* in Paris. This is "the church" of such legendary women as the couturier Gabrielle Chanel and the actress Marlena (Maria Maddalena) Dietrich as well as other couturiers, actresses, models, seamstresses, songstresses, and dancers for whom the Magdalene was patron.

According to the tradition, to ensure their safety from the invading Saracens in 710, the Magdalene's holy remains were translated from Provence to Benedictine Abbey in Vézelay which began a centuries long dispute as to the authenticity and ownership of these relics. Pope Leo IX (1002–54) issued a Papal Bull naming Mary Magdalene as one of the major patrons of the Abbey in Vézelay on April 27, 1050. Later in 1058, Pope Stephen IX (*c.* 1020–58) identified as the official relics of Mary Magdalene as being housed in Vézelay, thereby clearly affirming its position as the fourth most popular pilgrimage destination after Rome, Jerusalem, and Santiago del Compostela. To add to the significance of both this abbey and the relics of Mary Magdalene, Pope Urban II (*c.* 1035–99) declared the First Crusade from Vézelay in 1096. By the early twelfth century, a new Romanesque basilica dedicated to the Virgin Mary was built on this site. On Easter Sunday 1146, Saint Bernard of Clairvaux (*c.* 1090–1153) declared the Second Crusade from the steps of this new basilica. Multiple literary accounts of the significance of Vézelay, especially as the location of the Magdalene's relics, can be found in medieval manuscripts as well as the *Legenda Aurea*.

However during the latter half of the thirteenth century, the fortunes of Vézelay began to decline while those of Saint Maximin La-Sainte-Baume rose under the rule of the Anjou Dynasty. On April 24, 1267, Charles II (1254–1309), then the Count of Provence, and later King of Naples and Duke of Anjou (1254–1309), exhumed some of the Magdalene's bones at Vézelay, specifically her left foot, and translated her relics from Vézelay back to Saint Maximin La-Sainte-Baume. Later in mid-December, 1279, Charles II supervised the opening of the marble crypt in Saint Maximin La-Sainte-Baume and the reported aroma of "sweet scent" identified the burial site of a female skeleton as belonging to Mary Magdalene given that the so-called *noli me tangere* spot of living skin was evident on her forehead while a fennel or palm plant was growing on her tongue signifying the gift of her elegant sermons. Further positioned near her remains was the *Sainte Ampoule* which was the glass sphere containing earth or stones soaked with the blood of the crucified Christ that Mary Magdalene had collected at the foot of the cross. Her relics were reverenced and then placed into varied reliquaries for display to the faithful in May 1280, although the *noli me tangere* was not secured in a glass vase until 1789.

Devoted to the Magdalene, Charles II later commissioned extravagant reliquaries of gold and precious stones, especially for her arm and skull in 1293. By April 6, 1295, he was able to insure the reunion of her otherwise missing jawbone housed in San Giovanni in Laterano with her skull. That same year in a papal bull issued by Boniface VIII (1230-1303) declared the authenticity of the relics of Mary Magdalene at Saint Maximin La-Sainte-Baume and entrusted their supervision to the Dominicans for whom Charles built a convent/abbey adjoining the basilica. Boniface strengthened this identification and consequence of the Magdalene's relics later in 1295 by granting indulgences to pilgrims who ventured forth on her feast day, the day of her translation, or during the octave of those feasts. Throughout his reign and his realm, Charles II commissioned and/or dedicated churches,

basilicas, convents, monasteries, and shrines to Mary Magdalene. The new Gothic basilica in Vézelay would not be completed until 1532 because of interruptions by the Black Death and other catastrophes, whereas the crypt in Saint Maximin La-Saint-Baume in which the Magdalene's relics and the sarcophagi containing the remains of Sidoine, the Holy Innocents, and others was dedicated in 1316.

In December 1448, King René (1409–80), Count of Provence, ordered excavations in search of the relics of at least two of the three Marys in the original ninth-century church of Les-Saints-Maries-de-

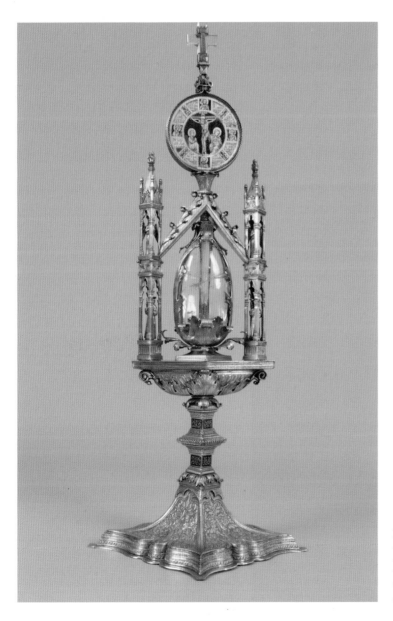

Illustration 19 Reliquary with the Tooth of Saint Mary Magdalene *(fourteenth/fifteenth century: Metropolitan Museum of Art, New York).*

la-Mer. These archaeological digs resulted in the discovery of several human heads arranged in the form of a cross along with the bodies of two women. These bodily remains were identified as belonging to Mary Jacobé and Mary Salomé as they were positioned by a smooth marble stone identified as "the Saints pillow." The nearby altar of compacted earth further established their identities as it was the custom of the early church to celebrate liturgy above saintly relics. As a result of these discoveries, Les-Saintes-Maries-de-la-Mer became a pilgrimage site in its own right and a stage on the route to Compostela. After 1449, an enlarged new church built to accommodate all Christians on their spiritual travels as well as the heavily populated May and October pilgrimages of the Roma people. In 1948, the then Papal Nuncio to Paris, Angelo Cardinal Roncalli (later Pope Saint John XXIII) marked the 500th anniversary of the discovery of these relics by celebrating a special mass in Les-Saintes-Maries-de-la-Mer.

Medieval legendary and devotional texts continued and embellished the varied traditions of Mary Magdalene's life. A series of devotional *vitae* continue her metamorphoses by conflating her with Mary of Egypt (ninth century); the "other" scriptural Marys (tenth century); and the Desert Mothers (eleventh century), and expanding her iconography as for example with the addition of the figure of Zosimas from her conflation with Mary of Egypt.

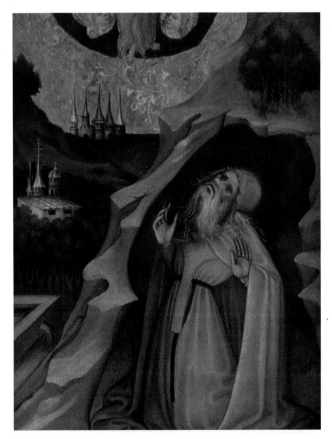

Illustration 20 *Bernat Martorell, Detail of Zosimas from Illustration 4.*

According to Saint Sophronius, Patriarch of Jerusalem (*c.* 560–638), and author of the *Vita of Saint Mary of Egypt*, the desert monk, Saint Zosimas of Palestine (*c.* 460–560) (Illustration 20) met her during his Lenten fast in the Egyptian desert.[9] After he covered her naked body with his monastic mantle, the emaciated desert mother related the story of her life and conversion. She asked him to return the following year and to bring her Holy Communion on Holy Thursday. When Zosimas arrived at the banks of the Jordan, Mary of Egypt walked across the water to receive Holy Communion. At her request, Zosimas again returned the following year, but this time he found her incorrupt body on the site of their original meeting where an inscription in the sand indicated she had died the previous year immediately following their last meeting. With the assistance of a passing lion, the monk solemnly buried her body.

As the medieval Magdalene became conflated with Mary of Egypt the motif of a haggard female ascetic dressed either in animal skins or her own lengthy tresses and posed in prayer emerged. Zosimas was inserted into the scenes of her days on La Sainte Baume in Provence until he became identified as Bishop Maximin. Several medieval authors incorporated this episode into her narrative foremost among whom was Jacobus de Voragine (*c.* 1230–98) whose popular medieval text *Legenda Aurea* (*The Golden Legend*) related the Magdalene's "pre-conversion" life as a wealthy proprietor in Magdala; her role as the bride at the marriage at Cana; and her pilgrimage to Rome.

Regional variations in customs, traditions, and language acknowledged the expanding spheres of the Magdalene's influence by means of what the medievalist Victor Saxer (1918–2004) referred to as "medieval bestsellers" from the legendary French verses, Old and Middle English texts, varied German prose pieces, Irish homilies, and Scottish legendary chronicles, and Spanish texts by female monastics to the pre-fourteenth-century Welsh variants of the *Life of Saint Mary Magdalene and Her Sister Martha*. No matter the language, the basic structure of these literary and performative accounts was established in the eleventh-century narratives about the Magdalene which were composed of five parts: her pre-ascension life; her voyage to Marseilles; her encounter with the Prince of Marseilles; her thirty-year solitude, death, and burial; and her post-burial miracles and the translation of her relics.

These medieval liturgical plays related the biblical message to the audience as the performances made the scripture come alive. For the story of the Magdalene, the Easter liturgical plays such as *Quem quaeritis* (*Whom do you seek?*) premised on the scriptural episode of the "Three Marys and the Angel at the Tomb" (Mt. 28:1–7, Mk 16:1–7) were the most significant. However as her cult and popularity increased, individual plays about her were performed, the most important drama cycle being the fifteenth-century East Anglian *Digby Magdalene*. The structure of this popular traveling play which was to be performed in the round was taken from *Legenda Aurea* (*The Golden Legend*) and was

[9] See note 2 and the discusssion on pages 36–8 of this volume.

composed of three major parts: Simon the Leper's House emphasizing her exorcism; her Mission to Marseilles; and her Death and Elevation.

The Magdalene continued her pilgrimage through the canons of Western literature from drama to poetry to prose. While she began her theatrical employment as the supporting actress in early Christian liturgical plays to become a star of medieval dramas, she has maintained a stage presence in both secular and sacred theater even into the twentieth century. Her poetic pilgrimage which began in the scriptural and apocryphal texts of the earliest Christian communities and flourished in the courtly "love" poetry of the Middle Ages. The devotional poetry of the baroque period found inspiration in Mary Magdalene, as in the verses of Richard Crashaw (*c.* 1613–49) and John Donne (1572–1631). The nineteenth-century infatuation with the *femme fatale* discerned her in Samuel Taylor Coleridge's (1792–1834) "Christabel" and John Keats's (1795–1821) "La Belle Dame Sans Merci" and "Lamia."

The Magdalene was transformed from the "heroine" of popular legends and medieval devotional literature into the protagonist of modern biblical fiction. She has been featured as the central or a leading character in late-nineteenth- and twentieth-century novels, novellas, and short stories including the vastly popular *The Road from Olivet* (1946) and *The Scarlet Lily* (1944) by Edward F. Murphy, *The Galileans: A Novel of Mary Magdalene* (1953) by Frank G. Slaughter (1918–2001), and the controversial *The Last Temptation of Christ* (1955) by Nikos Kazantzakis (1883–1957). Predicated upon the seventh-century Gregorian model, the Magdalene of popular biblical fiction is the well-known female apostate transformed into apostle. However, it was the cult of and devotions to the Magdalene codified in the High Middle Ages that gave formal voice to her role in the hearts and minds of the Christian collective resulting in visual transformations throughout the ensuing centuries and the global expansion of Christianity.

5

Symbols and Devotions

Traditionally in Christian art, saints were represented by identifiable attributes or symbols which delineated their "martyrdom" in the most fundamental sense of the term, that is, the witnessing of their faith. For example, Catherine of Alexandria (*c.* 287–*c.* 305) and Catherine of Siena (1347–80) are distinguished by their individual attributes: the spiked wheel and the cross surmounted by a lily or a heart respectively. Controversies and debates about her identity aside, Mary Magdalene was recognizable by her fundamental attributes: an ointment jar, long flowing hair, tears, and her gestures and postures. These visual connectors reference the Magdalene as the woman who anointed Jesus of Nazareth—either his feet, his head, or his crucified body. She is the indispensable conduit between the Christian ritual action of healing and protection, and human frailty.

The Magdalene's renowned jar is itself a symbol of metamorphosis. It transmogrifies into a diversity of shapes including alabaster containers, elegant perfume bottles, clear glass carafes, and golden liturgical vessels (Illustrations 20, 21, and 22). As the protector of these precious and consecrated anointing oils, her jar signifies the unction which cleanses, preserves, and seals the anointed from evil, disease, and sin.[1] When its classical mythological referents are commingled with its role in the scriptural anointment episodes, the jar connotes metanoia.[2]

When depicted as a beautiful perfume bottle, the Magdalene's jar signifies both her former life of pleasure and a link to her Hebraic scriptural foretypes, Susanna and Bathsheba, whose luxurious flagons held fragrant bath oils. Just as the jar portends metanoia, unction, and metamorphosis, it

[1] Early Christians recognized the linguistic relationship between salvation and redemption through the anointing oils as the Hebrew *messiah* became the Greek *christos* which translates as "the anointed one."

[2] The symbolic links between the Magdalene's jar and Pandora's box have been carefully delineated by several commentators including Marjorie Malvern and Susan Haskins. However, the more interesting connection may be that between the iconography of the repentant Magdalene to the Cretan tradition which relates that the bodies of dead children were arranged in the fetal position and placed within amphorae as the source of physical and intellectual life, i.e., the mother's womb. For the Cretan tradition, see Jean Chevalier and Alain Gheerbrandt, eds., *A Dictionary of Symbols* (Oxford: Blackwell Reference, 1994 [1982]), 552.

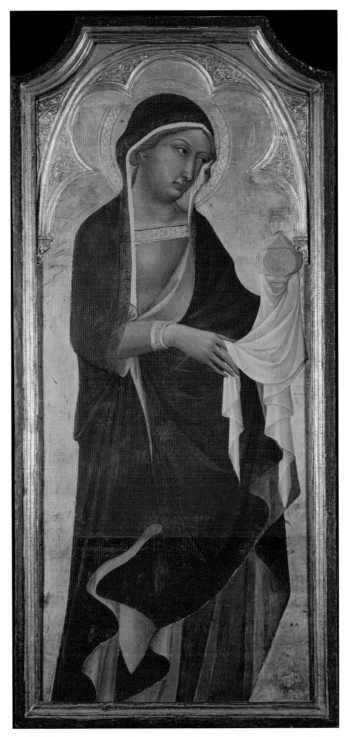

Illustration 21 *Bartolomeo Bulgarini,* Saint Mary Magdalene *(c. 1350–60: Columbia Museum of Art, Columbia, SC). Gift of the Samuel H. Kress Foundation, CMA 1954.22.*

Illustration 22 *Workshop of the Master of the Magdalen Legend,* Saint Mary Magdalene (*c. 1520: Harvard Art Museum/ Fogg Museum, Cambridge*).

serves as a reminder that at the very bottom of Pandora's box lay Hope. Pandora's curiosity overwhelmed her restraint so that she opened the "forbidden" box and released evil, disease, and suffering into the world. However, she shut the lid quickly enough to retain Hope.

Mary Magdalene's long-flowing hair references her roles as anointer and repentant adulteress. Hair in its condition, color, and style emblematized physical, spiritual, and societal characteristics, especially in classical and early Christian culture.[3] Hair typified energy and fertility; a full head of hair embodied *joie de vivre, élan vital,* and resolution to succeed. As the head signified the most spiritual part of the human body, being the closest to the heavens, hair on the head connoted spiritual energy. Healthy, abundant hair such as the Magdalene's exemplified her spiritual development following upon her healing or conversion.

[3]See J. Duncan M. Derrett, *Glimpses of the Legal and Social Presuppositions of the Authors,* Studies in the New Testament, 1 (Leiden: Brill, 1977), see especially "Religious Hair," 170–175. Also see Penny Howell Jolly, *Hair: Untangling a Social History* (Saratoga Springs: Francis Young Tang Teaching Museum and Art Gallery at Skidmore College, 2004).

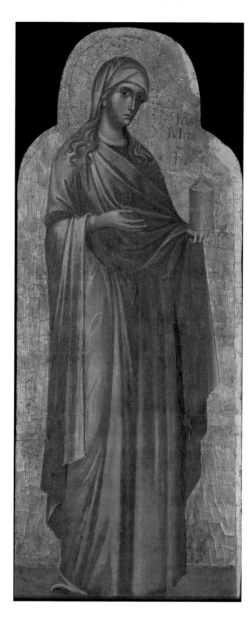

Illustration 23 *Paolo Veneziano,* Saint Mary Magdalene (c. *1350: Yale University Art Gallery, New Haven, CT).*

Hair styles had significance in the classical world.[4] Typically, young unmarried women allowed their abundant tresses to flow freely down their necks and over their shoulders in a style synonymous with that of the female personifications of sacred love. Proper married women covered their heads in public as both a sign of their social station and of the preservation of their "energy" for their husbands. Courtesans braided their hair, piling it high atop their heads. They decorated these styles with

[4]Diane Apostolos-Cappadona, *A Guide to Christian Art* (London: Bloomsbury T&T Clark, 2020), 212.

bejeweled or floral ornaments alluding to the female personifications of profane love. If she embodied the "sinful" side of her complex persona, the Magdalene's hair is elegantly coiffed and decorated with jewels, flowers, and ribbons. Her long flowing hair signifies the invocation to her as a "holy virgin" in the texts of the early church fathers and in the *Litany of the Saints*.

Given its relation to the planet Venus, copper- or red-colored hair implied a venereal character and thereby was associated with sexuality. As the residents in the classical Mediterranean were predisposed

Illustration 24 *Master of the Chronique scandaleuse,* Saint Mary Magdalene and the Virgin, *Ms. 109, fol. 137. (c. 1500: J. Paul Getty Museum, Los Angeles).*

to olive skin with dark hair and eyes, any person with fairer skin and hair tones was immediately noticeable. During the Middle Ages and Renaissance, Mary Magdalene was depicted with beautifully braided and arranged red hair to connote her fundamental lascivious nature prior to her healing or conversion.

Tears, especially the large pearl-shaped ones dripping slowly from her eyes, signified that Mary Magdalene had been granted the *donum lacrimorum*, "the gift of tears," as espoused by the church fathers and the medieval mystics. Shed in repentance, the Magdalene's tears symbolized her self-knowledge and recognition of her own finitude and guilt. Her tears were the external expression of the spiritual action of the purification of the soul. Therefore, silent penitential tears—not the physical contortions of sobbing or hysteria—became a visual attribute of the Magdalene.

Other well-received depictions include the Magdalene engaged in contemplative penance. Her bodily posture and the attributes of skull, scourge, or crucifix, signify that she is lost in her thoughts about the transitory nature of human existence. She may be pictured deep in contemplation gazing into a mirror—not in reversion to her former narcissism but rather in spiritual introspection. She was rendered as a disheveled, haggard, and wan figure with a prayerful gesture denoting either penance or preparation for death.

During the medieval and Renaissance periods, she was the spiritual advocate of confraternities dedicated to the penitential discipline of self-flagellation, and of cloistered nuns devoted to the contemplative life of silent prayer. She is credited with many miracles including spectacular cures, the liberation of prisoners, the raising of the dead, fertility, and successful childbirths. Mary Magdalene has played multiple roles in Christian spirituality and devotions as the patroness of penitents and flagellants, vintners and coiffeurs, weavers and couturiers, perfumers as well as perfumiers[5] and jewelers, nuns and monks, caregivers and healers.

[5]A perfumer is also identified as *le nez* as she/he has a an exceptionally sensitive nose and olfactory senses which allow the creation of scents whereas the perfumier is the expert sales personnel in the marketing of perfumes.

6

Mary Magdalene through Christian Art

Historically, Christian art especially in the early Christian periods, focused on a saint's role not on the scriptural or theological debates as to her/his identity. So, in the instance of Mary Magdalene as *the* witness to the Resurrection of Jesus as the Christ, for early Christians, then, her "dignity lies in her proximity to the mystery of salvation,"[1] not in her personal story. Early Christian art was concerned with the visualization of faith either as a form of devotion or of pedagogy. Any search for individual representations of Mary Magdalene would most likely prove fruitless. Rather as with other saintly figures, she should be included within the context of those miracles and scriptural episodes in which she played a part, such as in the narrative of the Passion-Death-and-Resurrection of Jesus Christ. Perhaps as witnesses at a baptism or a presentation of the Wise and Foolish Virgins, a fragment from the procession of the holy women holding torches in the extended right hands and jars in the left hands from the walls of a Christian chamber at Dura-Europos (Illustration 25) has often been identified as the earliest representation of Mary Magdalene in Christian art.[2]

During the evolution from early Christian and Byzantine art into medieval art, the composite image of the Magdalene was defined by Gregory the Great and his conflation of her with the converted sinner, repentant adulteress, and Mary of Bethany took universal form. While she can be identified in visual narratives of scriptural stories which featured the anonymous women like the Anointing at Bethany and the Woman Taken in Adultery, Mary Magdalene is portrayed most clearly in scenes of the Passion, Death, and Resurrection. In particular, she is identifiable in representations of the Apparition of the Risen Christ presaging the *Noli Me Tangere* which appears first in the Western

[1] Johannes H. Emminghaus, *Mary Magdalene: The Saints in Legend and Art* (Recklinghausen, West Germany: Aurel Bongers Publications, 1964), 5:15.

[2] Michael Peppard has persuasively argued for a complete reassessment of these female figures in favor of the Virgin Mary in his *The World's Oldest Church: Bible, Art, and Ritual at Dura-Europos, Syria* (New Haven, CT: Yale University Press, 2016).

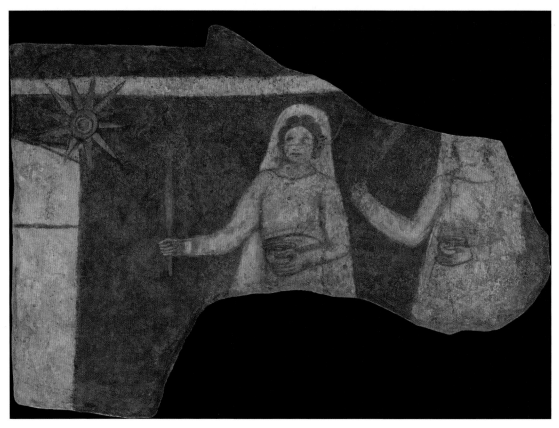

Illustration 25 Baptistery, Wall: Procession of Women, *Dura-Europos (c. AD 240–5: Yale University Art Gallery, New Haven, CT).*

Christian art of the late Middle Ages and early Renaissance.[3] Thereby, she transitioned from an element as a traditional saintly female figures in early Christian and Byzantine art, especially in manuscript illuminations, to become a unique and independent topic on cathedral archways, portals, and walls.

Characterized as an era of faith and an awareness of the power of sin, the Middle Ages venerated the Magdalene as a penitential saint. The periods of the "great plague" (*c.* 1348–99) highlighted the recognition of human suffering, misery, and the fragility of human life. As the eminent female sinner who experienced the healing love and forgiveness of Jesus of Nazareth, she symbolized spiritual encouragement for her fellow human sinners as proclaimed on her scroll—*Ne Desperetis Vos Qui Peccare Soletis, Exemploque Meo Vos Reparate*, "Do not despair you who are accustomed to sin but do penance following my example"—in the presentation by the Master of the Magdalene Legend in his in *La Maddalena e storie*

[3]Note the evolution from the Early Christian/Byzantine motif of the *chairete* see page 116 in this volume.

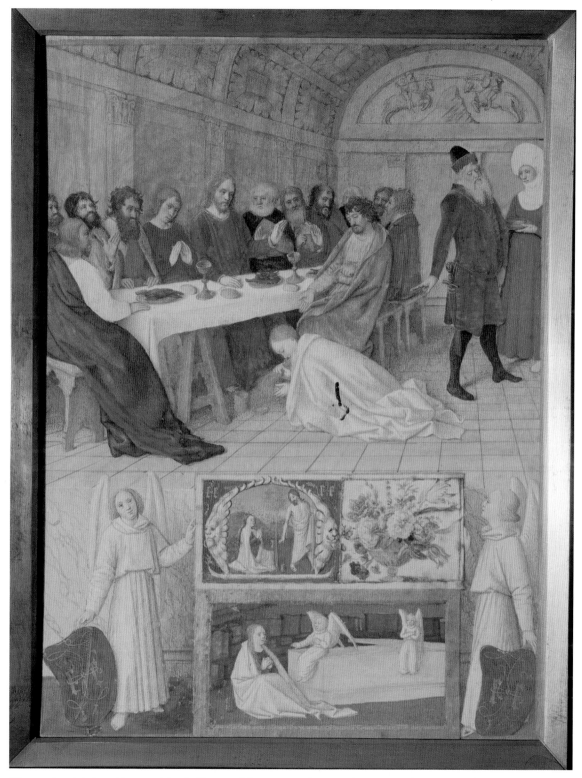

Illustration 26 *Jean Fouquet*, The Suffering of the Saints: Christ in the House of Simon the Pharisee *from* Hours of Etienne Chavelier, *Ms. Fr. 71 Fol. 37 (1445: Musée Condé, Chantilly).*

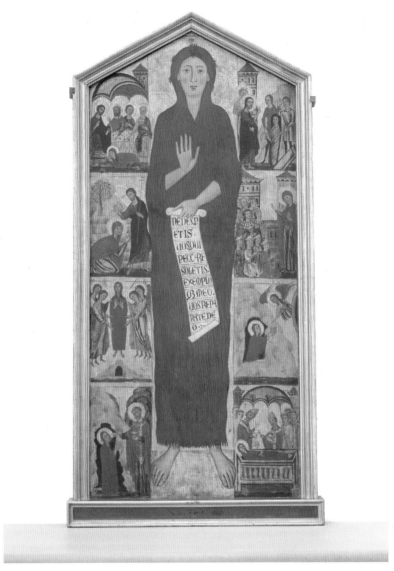

Illustration 27 *Magdalene Master,* La Maddalena e storie della sua vita *(1280–5: Galleria dell'Accademia, Firenze).*

della sua vita (Illustration 27).[4] This early-thirteenth-century visual testimony to the importance of her cult includes scriptural episodes—the Anointing at Bethany, the Raising of Lazarus, the *Noli Me Tangere,* and her preaching mission—in the upper registers; and pious traditions surrounding her penitential life in France in the lower registers. Her monumental central figure affirms the fusion of the Magdalene with the other reformed prostitute saint of early Christianity: Mary of Egypt.

[4]This translation from the original Latin inscription is mine.

Liturgical dramas and Passion plays flourished during the Middle Ages. Mary Magdalene was a featured character in the traveling plays, especially in the Lamentation and Resurrection episodes. With the emergence of Franciscan spirituality in the thirteenth century, the saintly and matronly Magdalene was "humanized" on the stage and in Christian art. Her hair was no longer covered by a mantle or veil. Similarly, the illustrations of her found in the mysteries of salvation, which had been located on the facades and portals were repositioned inside the cathedrals on the interior windows, walls, carpets, and altar tableaux. This transition allowed the faithful a new proximity to the Magdalene inside the church.

Beginning in medieval art and throughout the Renaissance, artists positioned her under the cross and within the scriptural sequences related clearly to the fusion of the converted sinner with the unnamed adulteress. Such placements, along with that in the *Noli Me Tangere* episodes, were embedded with the emotive, subdued, or erotic qualities that emanated throughout her postures, gestures, and facial expressions and that can be identified as prime examples of a form of body politics with which artists invested Mary Magdalene.[5] Artistically and spiritually, this conflation had practical and profound motives: devotional empathy in the viewer for the expiatory sacrifice of Jesus of Nazareth. For as the Magdalene empathized with him, so too could we, through the vividness and immediacy of her eye-witness vision.

The hapticity of the distraught and "fallen" woman at the foot of the cross provided a visual association for the Christian believer, whether through the dedicated devotion of Bernardo Daddi (*c.* 1280–1348), the meditative aura of Masaccio (1401–28), or the contorted drama of Sandro Botticelli (1445–1510). These images of the Magdalene fuse two scriptural motifs: the woman kneeling at Jesus' feet, the same feet she earlier anointed and wiped with her own hair in anticipation of his death and burial; and the etymology of her epithet, for she stands as the sentry of the watchtower as his body hangs on the cross.

Daddi expands the boundaries of the Magdalene as a common intercessory figure (Illustration 28). She becomes a physical channel between the Virgin Mary, who has collapsed from sorrowful grieving, and her son who has suffered unto exhaustion. This artistic vision of Mary Magdalene is that of the mediator between both the Virgin Mary as Mother Church and her son as the sacrament; between the Christian collective and the sacraments. In an extraordinary presentation of the visual parallels between the Virgin

[5]This phrase, although not perhaps this concept, was coined by Joanne W. Anderson who organized and chaired a special symposium at the Warburg Institute entitled "The Body Politics of Mary Magdalen" in November 2017. I am grateful to my colleague Professor Anderson for the clarity of this phrasing and its vibrant associations for the study of Mary Magdalene.

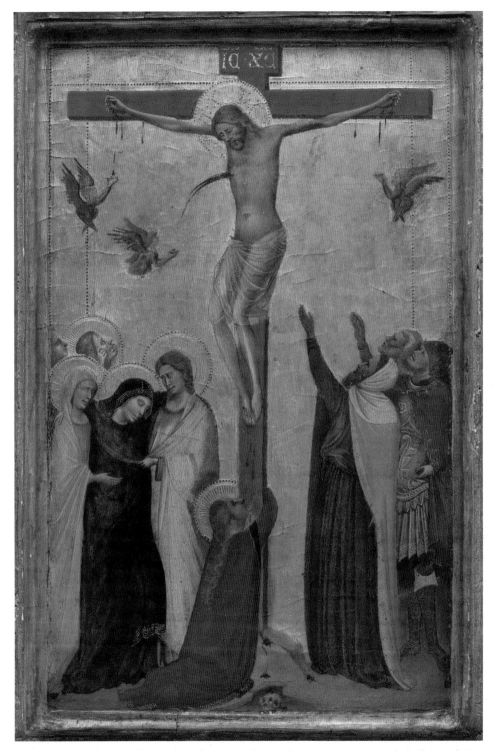

Illustration 28 *Bernardo Daddi,* The Crucifixion *(c. 1320–5: National Gallery of Art, Washington, DC). Samuel H. Kress Collection.*

Mary's *compassion* and the Magdalene's *empathos*,[6] Daddi places the Magdalene at the foot of the cross as she becomes the physical support of the Crucified Jesus and the spiritual support of his mother. Further she acts as if she were the traditional interlocutor figure in a classical work of art who welcomes us, the viewers, into the action of the painting as we look with her upward toward the salvific sacrifice of Jesus as the Christ.

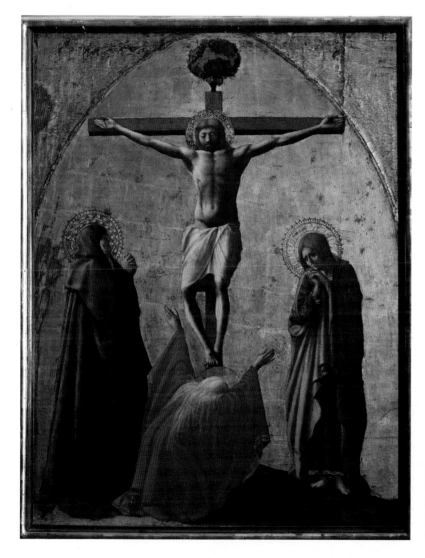

Illustration 29 *Massacio, Crucifixion with Mary, Mary Magdalene and St. John (1426: Museo di Capodimonte, Napoli).*

[6]The classic interpretation of the iconographic and theological meaning in the parallel formations of the bodies of the Crucified Jesus and the Virgin Mary in Rogier's masterpiece is Otto von Simson, "*Compassio* and *Co-Redemptio* in Roger van der Weyden's *Descent from the Cross*," *The Art Bulletin* 35 (1959): 9–16. For an interpretation of the *empathos* exhibited by Mary Magdalene in this same masterwork see Diane Apostolos-Cappadona, "The Space Between Image and Word: The Journey from Rogier van der Weyden's *Descent from the Cross* to Walter Verdin's *Sliding Time*," *CrossCurrents* 63.1 (2013): 26–43. The latter essay first appeared as "Lo spazio tra imagine e parola: il viaggaio dalla *Deposizione* di Rogier van der Weyden a *Sliding Time* di Walter Verdin," in *La promessa immaginata. Proposre per una teleogia estetica fundamentale* ed. Stefanie Knauss and Davide Zordan (Edizione Dehoniane Scienze Religiose Nuova Serie, 2011), 239–57.

Masaccio clearly exemplifies the powerful vocabulary of the body in his depiction of Mary Magdalene (Illustration 29). She kneels at the foot of the cross. Her elegant hands extended toward the crucified savior, her arms expanded forward as if to encase his body *if* they could be stretched fully upward to grasp his open hands, their fingers forming gestural parallels. Her haloed head bent down below his wounded feet completing the major vertical line from his haloed heads as their bodily postures form a series of intersecting triangles. Her legs although bent at the knees mimic the posturing of his in a total display of haptic *empathos*.

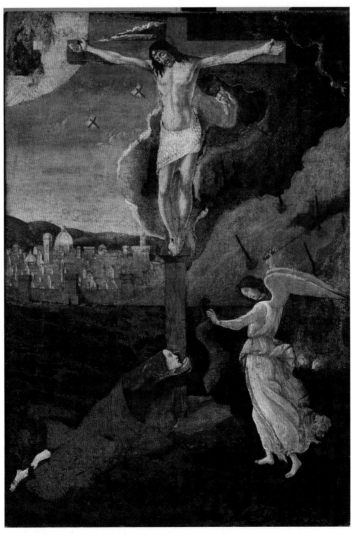

Illustration 30 *Sandro Botticelli (Alessandro Filipepi)*, Mystic Crucifixion *(c. 1500: Harvard Art Museum/Fogg Museum, Cambridge).*

Botticelli exemplifies the medieval art historian Millard Meiss' statement that the "desperate Magdalen makes an appearance at the foot of the cross" (Illustration 30).[7] The exaggerated and contorted posture of her body simultaneously evokes the depth of her otherwise silent grief and her role as mediator between the earth and the heavens as she wraps her arms around the base of the cross. The diagonal posturing of her body extends the viewers' eye upward toward the crucified body of Christ. Her glorious long flowing red hair "crowns" the elongation of her distress in a visual metaphor of the rebirth of faith that will follow upon this grievous event. Created within the milieu of the reformist spirituality of the Dominican friar Girolamo Savonarola (1452–98), Botticelli has created a devotional picture of the highest order. The immediacy of the Magdalene's eyewitness account evokes the viewer's emotive response.

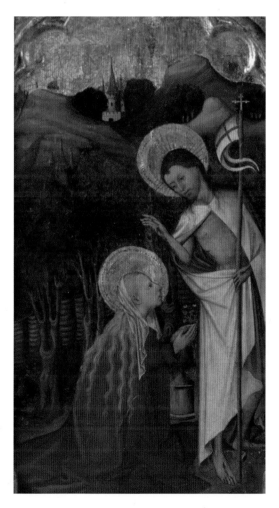

Illustration 31 *Bernat Martorell, Detail of* Noli me tangere *from Illustration 4.*

[7]Millard Meiss, *Painting in Florence and Siena After the Black Death* (New York: Harper Torchbooks, 1951), 127.

The theme of the *Noli Me Tangere* representing the Appearance of the Risen Christ to Mary Magdalene, originates in the West in late medieval and early Renaissance art, and promotes her increasing significance as depicted in Bernat Martorell's altar panel painting (Illustration 31). She has become *the* feminine symbol of penitence, humility, and love as communicated through her kneeling posture at the Risen Christ's feet and her eloquent gestures of prayer in relation to his right hand—both positioned directly above her golden unguent jar. The dramatic intention of his *dictum* is expressed in the poignant but empty spaces between the paralleling of their heads and their hands.

The spirituality preached through the mendicant orders, particularly through the writings of Bonaventure (1221–72) and the Dominican Jacobus de Voragine (1228/30–1298), Blessed Archibishop of Genoa, in southern Europe; and the devotionalism of the Rhineland mystics including Mechthild of Magdeburg (c. 1207–1282/1294) and Gertrude the Great (1256–c. 1302), and lay movements such as the *Devotio Moderna* in the north, cemented this theological symbolism for the Magdalene.[8] Her popularity as a devotional and spiritual figure waxes with the needs of the Christian believer to understand and experience the otherwise abstract concepts of forgiveness and salvation/redemption. She was the great sinner who repented and was forgiven, who became the devoted disciple and the first witness to the Resurrection. As the liturgical dramas emphasized the Magdalene's past as a sinner and a penitent, and her role in salvation history prompted artists like Martorell to give visual expression to her position by depicting her long flowing hair, her extraordinary kneeling posture, and her elegant prayerful hand gestures in relation to those of the Risen Christ.

She "was one of the favorite subjects of Renaissance paintings, and pictures of her abound. Some are devotional, but many show scenes from the Gospel and her legendary life."[9] Renaissance representations of Mary Magdalene evidence both her prominence in Christian spirituality and her popularity among believers. She has become a clear and distinct individual—no longer an "element" within a larger narrative (Illustration 32). The Magdalene's story is never linear; her identity, symbolism, and imagery are never simple. Her complexity is a critical element in her appeal to believers.

Devotional, legendary, and theological books were crucial resources for these medieval and Renaissance metamorphoses of Mary Magdalene. Pseudo-Bonaventura included significant references to her in his fourteenth-century *Meditations on the Life of Christ* which was an essential source for Christian art. Medieval commentators affirmed that the bridal couple at Cana were to have been Mary Magdalene and John the Evangelist, an association which originated in Jerome. Following Origen, the medieval champion of the "scripturally real" Mary of Magdala, Bernard of Clairvaux (1090–1153)

[8] See Katherine Ludwig Jansen's now classic study *The Making of the Magdalen: Preaching and Popular Devotion in the Late Middle Ages* (Princeton: Princeton University Press, 2000).

[9] George Ferguson, *Signs and Symbols in Christian Art* (New York: Oxford University Press, 1980 [1966]), 135.

Illustration 32 *Piedmont Master,* The Sermon of Saint Mary Magdalene in Marseille *from* The Life of Saint Mary Magdalene *(1451: Chapelle de Saint-Erigne-Auron).*

linked the bride of the *Song of Songs* with the anointer of Jesus of Nazareth and thereby signified the fusion of *eros* with *agape*, earthly love with divine love.[10]

The Magdalene was transformed from saintly matron to a heroine of Christian virtues as communicated in images of her as reader. Although the motif of a holy woman reading was not unknown in Christian art, Rogier van der Weyden (1400–64) painted the first known image of *The Magdalene Reading* in 1436. (Illustration 61). The collective acceptance of Rogier's presentation of the contemplative reader was affirmed in its "mass production" in fifteenth- and sixteenth-century northern European art by several leading artists including Ambrosius Benson (*c.* 1495–1550) (Illustration 33), Pieter Coecke van Aelst (1502–50), Adriaen Isenbrandt (1490–1551), and the otherwise unnamed Master of the Female Half-Lengths (active early sixteenth century) and the Master of the Parrot (fl. 1520–40) .

Many of these same northern artists created other mass-produced images of the Magdalene as a musician, especially playing her lute. The Magdalene's interconnections with music are premised upon the devotional legend of her daily elevations at each of the seven canonical hours while she resided at La-Sainte-Baume. She was believed to have listened to the chants of the celestial choir. Western

[10]See Origen, *Commentary on the Canticle of Canticles*; Bernard of Clairvaux, *Sermons on the Song of Songs*, especially Sermon #57. Another "link" in this tradition is the text of the Matins for Holy Wednesday in Eastern Orthodox Christianity and Kassia's *Hymn of the "Fallen Woman,"* see page 25 of this volume.

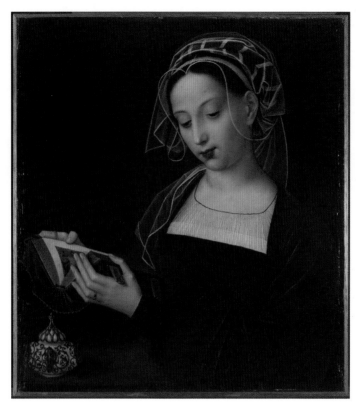

Illustration 33 *Ambrosius Benson,* Mary Magdalene Reading *(c. 1520: The National Gallery, London).*

liturgical music was dedicated to the Magdalene, especially for Lenten and Paschal services, including the Gregorian chants known as the *Offices of St. Mary Magdalen*, the sixteenth-century *Missa Maria Magdalena* by Alonso Lobo (1555–1617), and the French baroque laments of the *Magdalena lugens* by Marc-Antoine Charpentier (1642–1704) for his *Salve Regina.*

Depictions of her playing the lute or the clavichord—instruments previously reserved for the angels—flourished in northern medieval paintings and paralleled the composing of secular *basse* dances and love songs in her honor (Illustration 34). Again the female subject of these works was identifiable by her ever-present jar, often ornately decorated in gold and enamel.

Early Modern Europe—that is from the time of the Reformation and the Counter-Reformation[11] until the nineteenth century—was a period of profound spirituality and devotionalism. The Magdalene

[11]Leading church historians, most notably John O'Malley, have replaced the label "Counter-Reformation" with that of "Early Modern Europe" to signify the larger cultural, political, and social permutations from 1517 into the nineteenth century in Europe. For example, see *Early Modern Catholicism: Essays in Honour of John W. O'Malley, S.J.* ed. Kathleen M. Comerford and Hilmar M. Pabel (Toronto: University of Toronto Press, 2001).

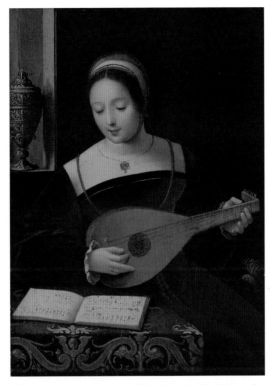

Illustration 34 *Master of the Female Half-Lengths,* Mary Magdalene Playing the Lute *(c. 1530: Hamburger Kunsthalle, Hamburg).*

found a renewed and expanded audience among the Christian collective, especially within Roman Catholicism while Northern European artists re-inserted her into the biblical narratives or emphasized her role as a model for penitence as evidenced in popular prints and engraving by Lucas Cranach the Elder (1472–1553), Albrecht Dürer (1471– 1528), and Lucas van Leyden (1491–1533) (Illustration 35).

Alternatively, she became a visual model for the proper Christian women in the many illustrated "behavior manuals" identified, for example, as the *Heroines of the New Testament* (Illustration 36) authored by Protestant ministers and theologians from the sixteenth to the twentieth centuries.

Leading Italian and Spanish baroque artists exalted her as a defender of the faith. With Peter, she became the guardian of the sacrament of penance as her tears shed in expiation of her "sins" paralleled his shed in contrition for his denial. She became a symbolic crusader for the Roman Catholic tradition, which promised salvation through the sacramental mysteries of the church.

Artists found a new kinship with theologians and liturgists as a Roman Catholic iconography developed to elucidate that tradition and to encourage the faithful. Representations of the *Penitent Magdalene* (Illustration 37), of her Last Communion, and of the Contemplative Magdalene flourished.

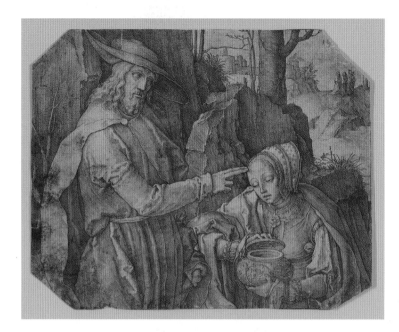

Illustration 35 *Lucas van Leyden,* Christ Appearing to Saint Mary Magdalene as a Gardener *(1519: Cleveland Museum of Art, Cleveland, OH).*

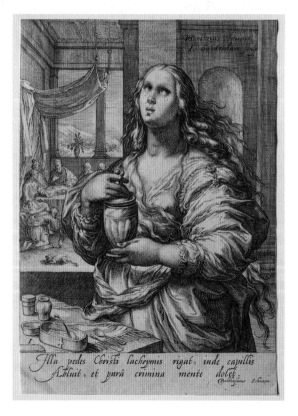

Illustration 36 *Jan Saenredam,* Heroines of the New Testament: Mary Magdalene *(1519: Cleveland Museum of Art, Cleveland, OH).*

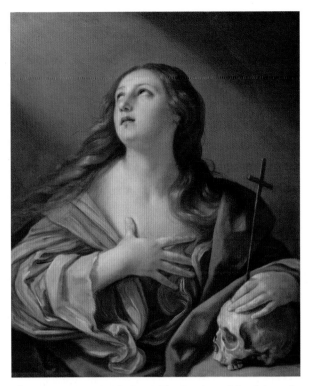

Illustration 37 *Guido Reni,* The Penitent Magdalene *(c. 1635: The Walters Art Gallery, Baltimore).*

Although baroque artists accentuated her sensual nature and voluptuousness through color, dramatic lighting, flowing drapery, and provocative poses, the spiritual and devotional motivation effected by the Magdalene remained strong. Southern baroque artists portrayed her as a beautiful young woman dressed in revealing attire, her hair cascading over her shoulders, as she tearfully contemplates her fate. Whether totally or only partially in a state of undress, her nakedness personified not wantonness, but rather her "new life" in the spiritual purity born of repentance and forgiveness. The Magdalene as subject of art, devotions, and spirituality was esteemed at this time of sacramental intensity.

Michelangelo Merisi da Caravaggio (1571–1610) painted several versions of Mary Magdalene including his singular *Penitent Magdalene* (Illustration 38).[12] Her long red hair flowed down her back and her left shoulder as she crouched in a fetal position, visualizing the depth of her remorse and guilt and emphasizing her body politics. She lowered her head to her left and clasped her womb with her hands as her body language conveyed a tragic figure internalizing her emotions. She became a formal

[12]See also his figuration of the Magdalene in his *Entombment* and in his *Death of the Virgin*. His *The Magdalene in Ecstasy* is a unique vision of the merging of *eros* with *agape* as it was understood in sixteenth/seventeenth-century Roman Catholic theology and spirituality.

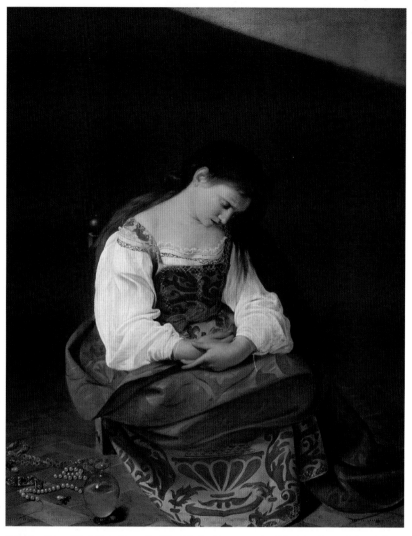

Illustration 38 *Michelangelo Merisi da Caravaggio,* The Penitent Magdalene
(c. 1594–7: Galleria Doria Pamphili, Roma).

vision of concentric circles composed of her bodily posture, her gestures, her billowing sleeves, her encircling mantle, and her capacious skirt which overflowed her body and her chair.

On the floor to her right lie her discarded jewels, signifying the old life she has cast off. A clear glass jar, ostensibly containing perfume or aromatic oils, is strategically placed between her pearls and herself. Large pearl-shaped tears drip slowly from her right eye down her cheek. She is the visual epitome of metanoia. Her repentance will result in a new life—a metamorphosis if you will—as the Magdalene moves from sinner to penitent to saint.

As art, theology, and society moved from the High Renaissance into the milieu of the Early Modern, the names, biographies, and works of women artists were recognized as individuals independent from

their artist fathers from whom they garnered their earliest training in painting, sculpture, and prints and engravings.[13] These women were creating art after the Council of Trent which met in three sessions between 1545 and 1563 as a critical element in Roman Catholic Church's formal response to the questions and concerns of the Reformers. At the 25th and final conciliar session in December 1563, the last document issued by the council was concerned with the role of saints, relics, and art. While the so-called definition of art was imprecise, there was a clear mandate for restraint in religious imagery noting that "all lasciviousness" was to be avoided and works must be approved by the appropriate bishop before installation in a church.[14] This document and its interpretation would become significant for many of these Early Modern women artists.

First among these was the Bolognese painter, Lavinia Fontana (1552–1614), who was the first woman to achieve professional status and public recognition equal to that earned by her male colleagues even unto the highest levels of patronage including her appointment as official painter to the papal court of Clement VIII in 1603. Because of her professional success, she became the main financial support of her family which included her eleven children. Among her more technically skilled canvases was her rendition of the *Noli Me Tangere* (1581) (Illustration 39) within which the Magdalene played a central and pivotal role.

Positioned in the middle foreground of the painting, the kneeling figure of Mary Magdalene comes to dominate the canvas as much from her placement as from the coloring of her garments from her rose dress to the yellow and white underdress. She is enveloped in a swirling mantle of shades of orange and her blue sandals highlight the lower left corner of the canvas and begin a diagonal that crosses her outstretched right hand and the lapis lazuli and golden vessel in her left hand across to the Risen Christ's belt upward to the blue scarf that rests on his left shoulder. Following this line allows for the sight of the very slight wound marks on the hands and feet of the Risen Christ signifying his crucifixion.

The Magdalene's colorful garment further highlights her presence as the first of the group of the "Three Marys" at the upper left as they stand before the entrance to the Empty Tomb which is placed within a cave. The glowing white garment and halo of the angel resting atop the vacant sarcophagus fulfills the earlier scriptural passage when the Holy Women found that the body of the crucified Jesus was missing and in fear and wonder returned to tell Peter and the other disciples. However, this is the background to the critical activity in the foreground in which Lavinia presents her viewers with her

[13]Although depictions of Mary Magdalene are not discussed in this text the following women artists from this same period include among others, the nun painter Orsola Maddalena Caccia (1596–1676); printmakers Diana Scultori (1547–1612), Anna Maria Vaini (fl. 1627–55), and Maria Felice Tibaldi Sulbyeras (1707–90); sculptor Luisa Roldán (1652–1706); and wax tableau maker Caterina De Juliana (1670–1743). The interest of these women artists in depicting Mary Magdalene is occasioned not simply by common gender correspondences but also by the interest in patrons and collectors in her iconography and devotionalism.

[14]This conciliar document is available online https://history.hanover.edu/texts/trent/ct25.html (accessed October 17, 2021).

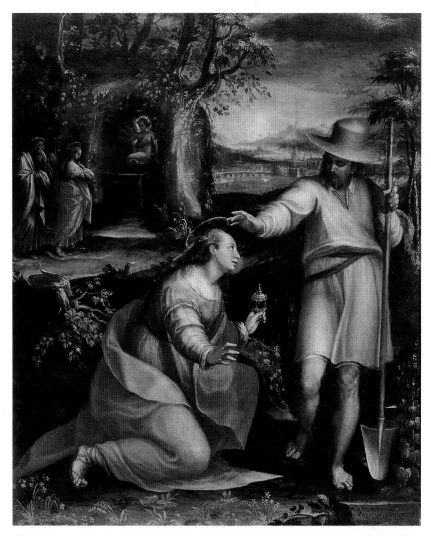

Illustration 39 *Lavinia Fontana,* Noli Me Tangere *(1581: Galleria degli Uffizi, Firenze).*

interpretation of the moment when the otherwise distraught Magdalene realizes that the male figure before her is not a gardener but the Risen Christ.

Building as much upon her own artistry as on her recognition of the significance of the meaning of "the gardener" in the then contemporary scriptural exegesis and popular preaching that Jesus was the gardener of the human soul,[15] Lavinia accurately depicts the costume and implements of a

[15]The motif of Jesus as the gardener of the human soul found in the sermons of Saint Gregory the Great continued as a theological metaphor into the Early Modern period in such authoritative texts as Ludolph of Saxony's (*c.* 1295–1378) *Vita Christi* which was formative for Saint Ignatius of Loyola (1491–1556) and his *Spiritual Exercises* (1470s) with which the erudite Lavinia would have been familiar.

practicing gardener from his wide-brimmed hat and smock to the large shovel in his left hand. By so doing, the artist validates the Magdalene's confusion when she first sees the stranger in the garden as if to indicate that she is neither delusional nor given to female hysteria. The realism in Fontana's painting promotes a positive and powerful image of the Magdalene.

Trained by her father, Nunzio, the Milanese painter Fede Galizia (1578–1630) acquired an artistic reputation for the intricate and naturalistic details in her still life works. However, she also received major commissions for religious paintings including her version of the *Noli Me Tangere* (1616) (Illustration 40) as an element in an altarpiece for the major altar in the Church of Santa Maria Maddalena in Milan.[16]

Although Fede respects the traditional composition with the placement of the Risen Christ and the Magdalene, she might be said to take a step back from Lavinia's introduction of accurate and obvious horticultural dress and implements by incorporating her own iconographic innovations. Most noticeably, her Christ figure wears only a glowing white shroud as he displays all five wounds he suffered during the crucifixion (both on his feet and hands, and his pierced side). The presence of a glowing aura around his head highlights his blonde tresses and facial hair. His bare feet draw attention to the sense of movement throughout Fede's presentation as his upturned left foot suggests his movement away from the kneeling Magdalene in rhythm with his upraised palms that gesture her to stop.

The open cave housing the empty tomb on the upper left, just above the head of the kneeling Magdalene, is occupied by two small cherubs as opposed to the more traditional adult angels. The innermost cherub is hidden in the shadows as he kneels in prayer and the outermost cherub stands within the open sarcophagus as he points toward the Risen Christ. Fede carefully manipulates the light so that it is the Risen Christ who is its source as a visual metaphor for Plato's cave, i.e., when the teacher brings the light (knowledge) and leads the people out from the darkness (ignorance) of the cave. This garden is filled with wonderful botanical details and symbolism all positioned within the frame of the wooden fence with its shut gate in the background as the Heavenly Jerusalem is imaged in the far distance.

Fede's presentation of the Magdalene fills the lower left portion of the canvas as she kneels in her now familiar pose with her unguent jar in the foreground by her knees. Her hands are positioned above her heart as she signals either that she is in a moment of internal conversation or primal recognition of what she beholds. She is elegantly dressed, perhaps to indicate that she has not yet surrendered her worldly vanities, although no elegant jewelry is present either on her person or in her hair. The soft folds of her pink robe suggest it is made of fine silk with a soft white underdress revealed by the ruffled sleeves and collar. A stylist golden brocade mantle has dropped from her shoulders to cover her lower body and legs as it displays a teal silk lining. Her sandaled left foot completes her

[16]Unfortunately, this monastery and eventually this church were destroyed in the late eighteenth/early nineteenth century along with the majority of Galizia's altarpiece except for the *Noli Me Tangere* canvas which is now in the Pinacoteca Brera, Milano.

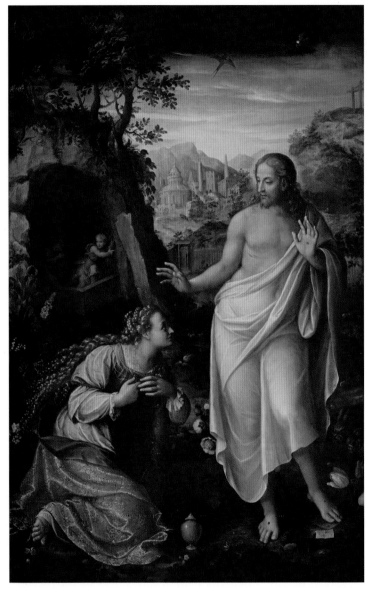

Illustration 40 *Fede Galizia,* Noli Me Tangere *(1616: Pinacoteca Brera, Milano).*

costume while her long golden hair is partial coiffed in braids piled on her head and flowing curls down her back. Despite the richness of her costume, ostensibly in the manner of a well-kept courtesan, and the lack of obvious signs of Jesus as a gardener, it is the intensity of the Magdalene's attention to him—the turn of her head, the composed inward turning of her hands over her heart, and her sightline concentrating on his glowing face—that commands the attention of viewers of Fede's painting.

Perhaps the most well-known of these Early Modern women artists was Artemisia Gentileschi (1593–1656), celebrated for her innovative interpretations in the iconography of the female hero, especially those from scriptural and legendary narratives. As with her variations of the image of Judith, Artemisia painted at least eight to twelve variants of Mary Magdalene in her many guises from penitent to spiritual ecstatic, often on commission.[17]

This depiction identified as *The Magdalene as Melancholy* (Illustration 41) is an intriguing adaptation of the saint's iconography. Typical of Artemisia, there is an emphasis on the jewelry being worn by her subject which in this case includes pearl drop earrings and a gold bracelet between her upraised right wrist and her bent elbow. Following Mediterranean tradition, pearls are understood to be gemological symbols for tears as the natural pearl is formed from the irritating grains of sand encased in the shell of an oyster. The Magdalene's bracelet is difficult to decipher without a careful review of the actual painting(s); however, Artemisia customarily includes some form of decorative elements, either as cameos or decorative flourishes, which reference the attribute of the sitter or else her story. While it would not have been untoward for a woman of Artemisia's time to wear a bracelet, it is not an accident that she has placed it in such a prominent position on the bent lower right arm upon which the Magdalene rests her head in a classic posture of melancholy. On the small table to Magdalene's right, almost parallel to the bracelet, the artist has positioned a small and shiny metallic pot ostensibly for the anointing ointment.

Although she is often portrayed in a seated position in the guises of the penitent Magdalene or the conversion of the Magdalene, her identification as "melancholy" is innovative even if melancholy here is simply understood as a pensive or deep sadness. However, Albrecht Dürer's (1471–1528) celebrated print entitled *Melancholia* (1514) was a visualization of the Renaissance consideration of artistic genius, and thereby a "pause" such as this was characterized as a state of waiting for inspiration to strike. There is no doubt that Artemisia knew both this work and others by Dürer. So, then, is the "inspiration that is about to strike" the Magdalene one of spiritual conversation or if she is an alter ago for the artist herself, then, a burst of creative energy?

[17]The count of Artemisia's Magdalenes varies not simply from expert to expert or generation to generation but in recent times almost from day to day. Two recently discovered paintings by Artemisia, including another variant of her *Conversion of the Magdalene*, have been identified in the collection of the Sursock Palace in Beirut. Despite the damage suffered in the Beirut bombings in August 2020, the "Wounded Lebanese Artemisia Gentileschi Arrives in Milan" for inclusion in the special exhibition *Le signore dell'arte: storie di donne tra '500 e '600* at the Palazzo Reale (Spring 2021). Further, as I was completing this manuscript an article appeared in the online edition of *Apollo* (September 29, 2021) entitled "Has a long-lost painting by Artemisia finally come to light?" The painting in question which has yet to be authenticated by the leading scholars of Artemisia's work may in fact be the original version of Illustration 41 and is entitled *Penitent Magdalene*. Replica copies of this variant may have been made by Artemisia herself or members of her studio and are entitled *Conversion of the Magdalene* (Seville Cathedral, Seville, Spain) and *Mary Magdalene as Melancholy* (Museo Soumaya, Mexico City, Mexico). I decided not to omit my analysis of Illustration 41 as it is the iconography of this motif which is significant even if it had been only known to us from a copy.

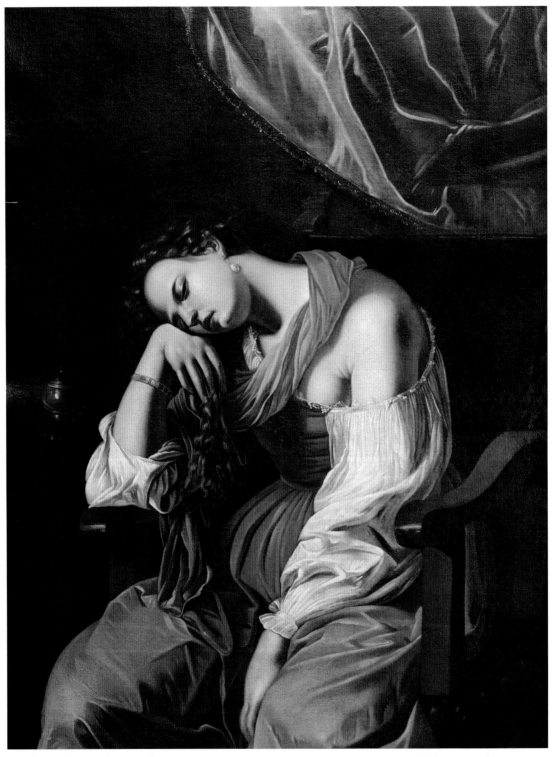

Illustration 41 *Artemisia Gentileschi, Mary Magdalene as Melancholy (c. 1622–5: Museo Soumaya, Mexico City).*

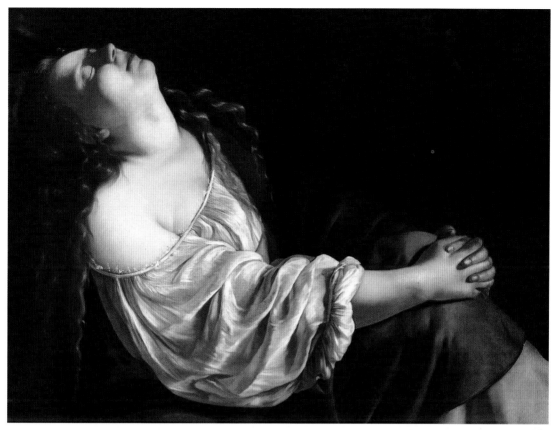

Illustration 42 *Artemisia Gentileschi,* The Magdalene in Ecstasy *(c. 1620–5: Private Collection / Alamy).*

For example, Artemisia Gentileschi's powerful painting *Mary Magdalene in Ecstasy* (Illustration 42) captured critical acclaim and public attention once it was included in two recent special exhibitions *Artemisia* (London: The National Gallery, 2020) and *By Her Hand: Artemisia Gentileschi and Women Artists in Italy, 1500–1800* (Hartford: Wadsworth Atheneum Museum of Art, 2021–2022; Detroit: Detroit Institute of Arts, 2022).

Throughout her oeuvre, Artemisia reformulated the imagery of the female hero, especially biblical and mythological women such as Judith and Mary Magdalene. Her interest in representing female strength and fortitude was coordinated with visual innovations and complex emotions. Her works were popular especially for those themes that supported the tenets of the Counter-Reformation, her own persona and biography influenced her art. She was an independent woman who lived and had a successful career in a patriarchal society; further, she had the moral fortitude and stamina not only to publicly accuse her rapist but to testify at his trial. She understood that feminine frailty and

empowerment were not concepts but realities, and her female heroes were reflections of her own life experiences.

Art historian Letizia Treves has characterized *Mary Magdalene in Ecstasy* as a "significant keystone in Artemisia Gentileschi's interpretive and visual repertoire."[18] Although life-size, the compactness of the horizontal posturing of Mary Magdalene combined with the constricted frame simultaneously permits an aura of intimacy and personal contact with the viewer. Captured in that form of bodily sacramentality so well known among southern baroque artists, Artemisia's Magdalene is lost in a moment of religious ecstasy which can only be visualized by means of the bodily characteristics of human sexual encounter.[19] However, for someone like Artemisia, passionate as she was as a wife and a lover, the term "ecstasy" had a specific religious definition intending that state of mystical rapture when the body had become incapable of sensuality while the soul was engaged in the contemplation of divine things.[20]

Often described as a being in a state of mystic or prophetic trance, ecstasy was distinguished often by a swoon such as that evidenced in the Magdalene's sloped shoulders, backward inclined head and neck, and her closed eyes. Perhaps Artemisia's most striking innovation in this rendition of the Magdalene was not her posturing or the dramatic closeness between viewer and subject but rather that here the saint is depicted without any of her traditional attributes such as an ointment jar or a skull, and yet is immediately recognizable in her solitude.

Adding further to the visual history of Mary Magdalene are three recently authenticated paintings of Mary Magdalene, most notably two more by Artemisia and one by the nun-artist Orsola Maddalena Caccia (1596–1676) depicting an elegantly garbed Magdalene postured in contemplation before her conversion.[21]

Despite the unnatural brevity of her life, the Bolognese artist Elisabetta Sirani (1638–65) had an impact and influence with her oeuvre of over two hundred paintings, thirteen public altarpieces, and several hundred drawings as well as the academy that she established for women artists in her native city. Trained by her father Giovanni Andrea who had been a pupil of Guido Reni, Elisabetta received public acclaim and royal patrons for her art even after 1660 when she concentrated her efforts on

[18]Letizia Treves, "Entry 24: *Mary Magdalene in Ecstasy*" in *Artemisia* edited by Letizia Treves (London: The National Gallery Company, 2020), 182. Exhibition catalogue.

[19]Predominant among those southern baroque artists who emphasized the Roman Catholic tenet of love as *agape* was Gian Lorenzo Bernini (1598–1680); for example, see either his *Ecstasy of Saint Teresa* (1647–52: Santa Maria della Vittoria, Rome) or *Death of the Blessed Ludovica Albertoni* (1671–4: San Francesco à Ripa, Rome).

[20]The classic study on the levels of spiritual love is Denis de Rougemont, *Love in the Western World* (Princeton: Princeton University Press, 1956; rev. ed. 1983), translated and revised from the original French edition *L'Amour et l'Occident* (Paris: Plon, 1939).

[21]This painting entitled *Mary Magdalen* (*c.* 1620–30: private collection, Italy) was auctioned in 2020 by Galerie Canesso, Paris, and as of my writing of this volume, has not yet been included in any major exhibitions.

small scale devotional pictures featuring either the Madonna and Child or saints, including Jerome and Mary Magdalene. Identified as a virtuosa in her own day, she was a trendsetter for women artists even unto her practice of clearly signing every one of her works, whether painted or drawn.

Her *Mary Magdalene in Penitence* (1663) (Illustration 43) was influenced by the Provençal tradition of the saint's years of prayer in La Sainte-Baume. Although Elisabetta favored the theatrical style and rhetorical visual language of Baroque art, she added her own personal perception in this painting as she introduced the drama of a night scene into this moment of a contemplative swoon. The softness of the Magdalene's flesh and the silkiness of her rosy mantle contrasts with the cold and rough hardness of the interior of the rocky cave/grotto.

The recognizable attributes of Mary Magdalene, except her unguent jar, can be found scattered throughout this interior setting with her rope scourge prominently displayed in her right hand and nestled near her left nipple. The symbol of a *memento mori* (that is, a remembrance of human finitude) rests on her lap underneath her left hand. On the left side of the canvas, an open Bible is positioned next to a lit candlestick and just below a crucifix bearing the infamous titulus of INRI reflecting the Magdalene's role in the scriptural narratives, especially her presence at the foot of the cross. Her long hair flows downward as if to cover her otherwise bare shoulders and back, and strategically emphasizes her naked breasts in a fashion like the Venetian master Titian's (*c.* 1488/1490–1576) earlier and eroticized depictions (1530–65) of this same theme.[22]

Emblematic of other renditions of a penitential saint, Elisabetta's Magdalene is seated and appears to be lost in a swoon as her head tilts to her left and her eyes are closed. Perhaps she is lost in a dreamworld or a spiritual vision. The Magdalene's nudity could have been interpreted as problematic, especially given the rubrics stated at the Council of Trent and by later Roman Catholic theologians such as Gabriele Cardinal Paleotti (1522–97), Joannes Molanus (1533–85), and Charles Cardinal Borromeo (1538–84), especially as this artist was a woman. However Roman Catholicism also espoused distinctive definitions and characters of love with the highest level of love being that between God and the human person, i.e., *agape*, and a foretaste of which was described as the finest expressions of love between husband and wife, and differentiated as the sacramentality of the body. This is the form of mystical love visualized by the sculptor Gian Lorenzo Bernini (1598–1680) in his masterful *Ecstasy of St. Teresa* (1652). Elisabetta would have been familiar with both this theological tenet and the art of Bernini. Although her *Penitent Magdalene* is in a state of undress, at least her upper body as her mantle has fallen off her shoulders, she was not necessarily understood to be depicted in a

[22]Popular with his patrons and favored by the artist himself, Titian painted multiple versions of this theme over thirty years. Most notable among these are the following: *The Penitent. Magdalene* (1531–35: Galleria Palatina, Palazzo Pitti, Firenze), *The Penitent. Magdalene* (1555–65: The Getty Museum, Los Angeles), and *The Penitent Magdalene* (1565: The Hermitage, St. Petersburg, Russia).

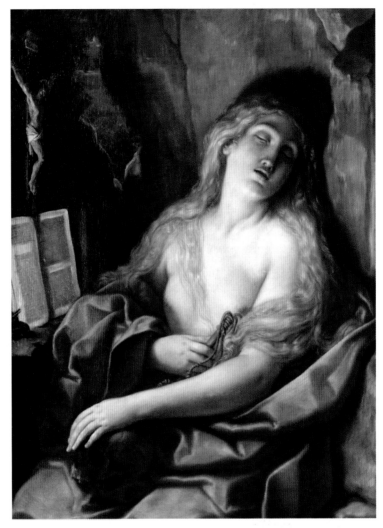

Illustration 43 *Elisabetta Sirani*, Mary Magdalene Penitent *(1663: Musée des Beaux Arts et Archéologie, Besançon).*

lascivious or erotic state. As a forgiven sinner, she has re-entered a state of innocence similar to that of Adam and Eve before the Fall, so to paraphrase Kenneth Clark she is nude not naked.[23]

Similarly, the cult and the image of the Magdalene as a model of penitence travelled with Roman Catholicism into the New World as depicted by the Bolivian painter Leonardo Flores (active 1665–83)

[23]In his classic study *The Nude: A Study in Ideal Form* (Princeton: Princeton University Press, 1984 [1956]), Kenneth Clark distinguished between the naked and nude from Classical art into the Modern period. He was careful to advise his readers that what one individual sees (experiences) as erotic, another sees (experiences) as innocent. His interest was in delineating the presentations of bodily form as a visualization of ideal beauty or as amoral indignity. While his text made be dated and read by some as misogynistic or patriarchal, the distinguishing ideas between the naked and the nude, and their cultural, historical, and philosophical contexts can prove valuable in analyses of gender and stereotypes of human sexuality.

Illustration 44 *Leonardo Flores,* Saint Mary Magdalen Relinquishing Her Worldly Possessions *(1680s: Portland Art Museum, Portland, OR).*

(Illustration 44). Kneeling, perhaps in prayer or in remorse, Mary Magdalene is positioned discarding her elegant finery as she turns her head toward the angel who mediates between the saint and the light coming from the heavens. Her penitential tears are highlighted by the pearls cascading down from the broken necklace in her right hand. Her left hand underscores the perfumed liquid dripping from the overturned glass jar in front of her jewelry falling from the multi-compartment *vargueno* common in Spanish colonial homes. Flores has combined all the essential elements of both the Magdalene's traditional iconography and her place in Early Modern Roman Catholicism in the New World.

The eighteenth-century rise of modern science, politics, and economics brought about the secularization of Western culture. The repercussions for the arts, especially for Christian art, were profound. Although the Magdalene continued to effect religious devotions, she initiated a "new life" as a secular symbol for the reformed prostitute in art, literature, and common parlance.[24]

[24] According to the *Oxford English Dictionary*, the use of *magdalene* for "a reformed prostitute" began in 1697 and for "a home for reformed prostitutes" in 1766.

Various nineteenth-century art and religious movements are credited with the renewal of European interest in Mary Magdalene.[25] The restoration of her cult at Sainte Baume in 1822 and the re-establishment of the Bourbon monarchy in France are cited as the initial impetus for public re-awareness of this saint. Romantic poets and artists were attracted to legendary and fictionalized figurations drawn from the Christian scriptures and fused with pious traditions. The revival of interest in Christianity, whether identified as the Catholic Revival, the (Anglican) Oxford Movement or similar groups, were empowered by the identifications with those art movements such as the Academy of Saint Luke in Rome, the Nazarenes in Germany, and the Pre-Raphaelite Brotherhood in England, that claimed a privileged connection to the dramatic spirituality of the "Magdalene mosaic." Composed from a variety of named and anonymous biblical women, early Christian saints and legendary figures, this assemblage is typified by Frederick Sandys's (1829–1904) painting *Mary Magdalene* (Illustration 45).

Sandys creates an artistic study in tonality and color relationships. The flowing auburn-red hair, red cape trimmed in green with a leaf-strewn green and pink collar, and pink gown are all set off by this Magdalene's pale skin tones and the emerald-green brocaded wallpaper emulating a garden, perhaps to signify both the renewal of vegetation in the spring and the garden setting of the *Noli Me Tangere* motif. Beyond the red hair which had faded from depictions of Mary Magdalene in late medieval and Renaissance art, the only visual clue that this is Mary Magdalene is the prominent position of her unguent jar. This woman is not proffering the luminescent alabaster jar to us to witness but rather clasps it tightly over her heart. She is not simply a Pre-Raphaelite "stunner," for her heavenward vision, half-closed eyes and quiet but heartfelt piety belies that secular possibility. Rather, Sandys's Magdalene is simultaneously "everywoman" and all of those biblical women—named and anonymous—known by their actions of anointing and being redeemed.

For other nineteenth-century artists including the French painters Jules-Joseph Lefèbvre (1836–1911) and Marius Vasselon (1841–1924), she was the biblical pretext for the presentation of the female nude. The British painter William Etty (1787–1849) was well known for his depictions of the nude figure, both male and female, especially within the context of history paintings. A practicing Methodist, he had strong admiration for Roman Catholicism; however, his attraction to the figure of Mary Magdalene was most probably linked to the contemporary reformist, political, and evangelical concerns for the "fallen woman" during the early Victorian era. The focus of sentimental poetry as

[25]See Diane Apostolos-Cappadona, *In Search of Mary Magdalene: Images and Traditions* (New York: The Gallery of the American Bible Society, 2002); "Revisiting *The Scarlet Lily*: Mary Magdalene in Western Art and Culture," *Secrets of Mary Magdalene*, edited by Daniel Burstein and Arne de Keijzer (New York: Perseus Books/Squibnocket Press, September 2006), 200–11; and, Barbara Baert, *Maria Magdalena: Zondares van de Middeleeuwen tot vandag* (Gent: Museum voor Schone Kunsten, 2002), English translation of essays and entries, pp. 74–82.

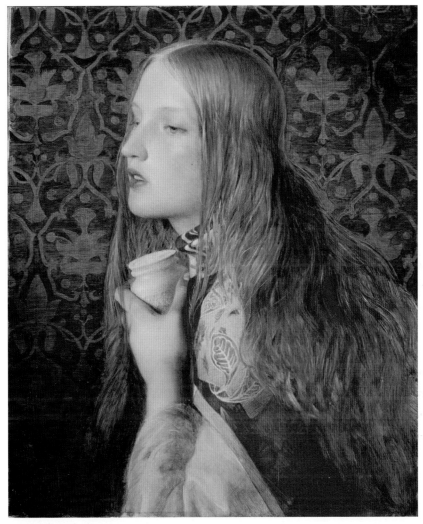

Illustration 45 *Frederick Sandys,* Mary Magdalene *(c. 1858–60: Delaware Art Museum, Wilmington, DL).*

well as sermons and novels, the penitent Magdalene was the theme of several of Etty's canvases between *c.* 1834 and 1845.

This version of his *Penitent Magdalen* (*c.* 1842) (Illustration 46) incorporates both traditional and new aspects of her iconography. Her hair is both flowing down her shoulders toward her almost naked breasts but coiffed into a neat bun in the back of her head. Her open palms are clasped to her chest as if both protecting her near nudity and also signifying her internalization of her sense of finitude and guilt. Her upward gaze toward the heavens is not directed toward either the viewer or the material objects before her—book, crucifix, and skull. However the large size of the illuminated pages attract

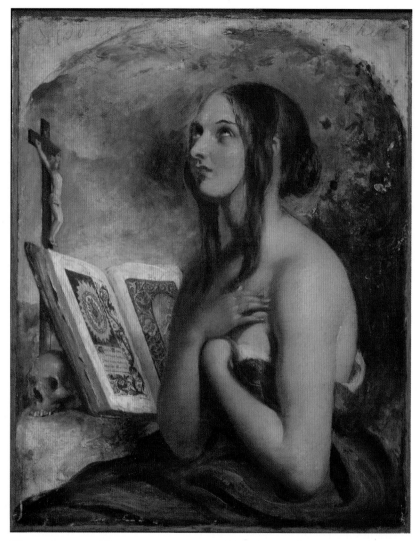

Illustration 46 *William Etty,* Penitent Magdalen *(c. 1842: Tate Britain, London).*

the viewer's attention both to its placement at the feet of the crucified savior and to the elaborate borders and designs which may reference Etty's attraction to the Roman Catholic liturgy. However the absence of the Magdalene's chief attribute of her unguent jar is a curious omission which Etty may have intended for his Anglican audience.

Both her name and her artistic image were transformed by the end of the nineteenth century into flashpoints for morality tales, social ethics, and eroticism. With the growing cultural recognition in the ambience of the Victorian worldview of the need for a society premised on a public Christian morality,

attention was given to the needs of women who could be described as exiled from or abused by society—unwed mothers, battered wives, abandoned daughters, and prostitutes, in particular. The word *magdalene* became synonymous with prostitution, and Magdalene houses were organized initially as shelters for unwed mothers with their (illegitimate) children and for wives seeking shelter from their abusers.

Established around 1758 under the auspices of Protestant church leadership, these houses required that the women they were sheltering performed laundry services as partial payment for their board. Eventually, however, as with other well-intended social organizations, these so-called Magdalene Asylums, or Laundries, became centers of forced female labor in contradiction of their original purposes. Beginning in the nineteenth century, these laundries were established in Sweden, Canada, United States, and Australia, becoming identified with Roman Catholic nunneries dedicated to Mary Magdalene.

However, the most egregious of these laundries were located in Ireland, as highlighted in 1993 when a mass grave of 155 women was located on land owned by the Sisters of Our Lady of Charity and which they had intended to sell. The indignities that women suffered in the Magdalene Asylums became the focus of media attention, documentaries, and books charting their history, and resulted in the shuttering of the last Irish location in 1996.[26] Raising the social and feminist consciousness of contemporary artists resulted in the composition of several songs including "The Magdalene Laundries" (1994) by singer-songwriter Joni Mitchell, the film *The Magdalene Sisters* (2002) by Peter Mullan, and the inclusion of the *Magdalen Laundry Shrine* in the installation artwork *Shrine for Girls* by Patricia Cronin for the 2015 Venice Biennale with subsequent displays in Dublin (2017) and Utrecht (2021). Despite the best of intentions, these laundries, and their laborers, like the Magdalene, reflected the ambiguities of being female in a patriarchal society.

Simultaneously, salon painters such as Jean Béraud (1849–1935) and Alfred Stevens (1823–1906) focused on Magdalene themes as a visual form of social and cultural critique. Yet, this same world of art and religion would produce the extraordinarily influential illustrations for Bibles by Gustave Doré (1832–88) and James Jacques Tissot (1836–1902). Premised on classical Christian art, these illustrated books—Doré's *Bible* (1865–66) and Tissot's *The Life of Our Saviour Jesus Christ* (1890–1900)—were popular among middle-class families in Europe and the United States, issued at an affordable price. In many ways, they can be seen as the nineteenth-century equivalents of the profusely illustrated yet accessible *Michelangelo Bibles* and *Rembrandt Bibles* issued in the 1950s and 1960s.

Alternatively, a more "delicate" figuration remains in the crypto-religious art of the Pre-Raphaelite Brotherhood and the Nazarenes extending into the works of Academy painters such as Jean Béraud,

[26]For example, see James Smith, *Ireland's Magdalen Laundries and the Nation's Architecture of Containment* (Manchester: Manchester University Press, 2007).

La Madeleine chez le Pharisien (Illustration 4). This painting of the anointing in the home of the Pharisee portrays Mary Magdalene resplendent in contemporary evening clothes and elegantly coiffed copper-colored hair. She is dramatically prostrate at Jesus's feet. More of an exquisite period painting than a spiritual vision, Béraud's canvas was renowned for the then identifiable portrait of the author of the controversial *Story of Jesus*, Joseph Ernest Renan (1823–92), on the face of Jesus of Nazareth.[27]

Mary Magdalene served as the feminine *exempla* of the Protestant emphasis on the experience of conversion and the embodiment of inward grace. Culturally, this biblical heroine also functioned once again as a visual affirmation of women's literacy, especially through her multiple reinterpretations in the illustrations in gift books and annuals. As the century progressed, Mary Magdalene became the model of faith and piety in the illustrated manuals for young women authored by ministers and theologians. This particular motif of Mary Magdalene moved away from public displays of sexuality and sensuality, preferring rather to advocate a positive model of feminine modesty for young Christian women to follow.

The arts and spirituality of the nineteenth century were permeated with a "Magdalene revival" from her secularized images of such operatic female heroes as "a courtesan with a heart of gold" as Violetta in Giuseppe Verdi's (1813–1901) *La Traviata* (1853) and as Thaïs and Tosca in Jules Massenet (1842–1912) and Giacomo Puccini's (1858–1924) respective eponymous operas,[28] and to the spiritualized visions in nineteenth-century Roman Catholic revival of interest in the medieval. The Romantics were attracted to the "heroine" of the Christian story.[29] The Symbolists were fascinated with her as *femme fatale*.[30] Transformed along with Cleopatra, Judith, and Salomé, the Magdalene was characterized by her abundant flowing hair, androgynous body, and blatant sexuality.

Yet by the end of the century, as the Bible and Christianity came under new scrutiny with the emergence of Liberal Protestantism, the "quest for the historical Jesus," and new biblical scholarship, there was a commensurate move as artists turned away from the biblical emphasis on Mary Magdalene as penitent and witness, to a revisionist typology in which she was simultaneously the Second Eve, the Second Pandora, and the archetypal female sinner.

Elihu Vedder (1836–1923) made a series of over fifty drawings as illustrations for the 1894 edition of the *Rubaiyat of Omar Khayyam*. In quatrains 79 through 91, the poet voiced the lament of the

[27]Renan, a French Orientalist and essayist, scandalized Paris when as Professor of Hebrew at the Collège de France he pronounced that Jesus was an "incomparable man." His emphasis on the humanity of Jesus in the *Vie de Jésus* was consistent with the then emerging "quest for the historical Jesus."

[28]These latter operas are dated 1893 and 1900 respectively. Ironically, Tosca's beloved Mario Cavaradossi is painting a portrait of Mary Magdalene for the Church of Sant'Andrea della Valle in Rome in the opening scene of the opera.

[29]See Samuel Taylor Coleridge, *Christabel* (*c.* 1797–1801); and John Keats, *La Belle Dame Sans Merci* (1819), and *Lamia* (1819).

[30]For a succinct history of the *femme fatale* see Patrick Bade, *Femme Fatale: Images of Evil and Fascinating Women* (New York: Mayflower Books, 1979); and Bram Dijkstra, *Idols of Perversity: Fantasies of Feminine Evil in Fin-de-Siécle Culture* (New York: Oxford University Press, 1986).

archetypal penitent lured by temptation into sin and now in guilt-ridden despair searching for hope. Vedder parallels his lamenting Magdalene (Illustration 47) to a stunning presentation of Eve as potential sinner across a two-page spread. Eve's flowing tresses frame her beautiful face as she stands with regal grace offering the apple with her extended right hand. Her right arm is entwined simultaneously with her exuberant hair and the almost invisible serpent who extends his body behind and below Eve as his tail wraps around the tree. The lushness of Eden contrasts sharply with the desolation of the Magdalene's environment while the spider's web is positioned between her hand and the poetic verse that presages the doom to come.

This Magdalene's landscape, distinctively different from Eve's Eden, is a desolate environment highlighted by the leafless tress, barren mountains and rocks strewn across the foreground. Crouched in an almost fetal position, Vedder's Magdalene is poignantly naked, her nudity highlighted by the swirling drapery that merely encircles her body, neither covering nor protecting her. Similarly, her hair is not cascading down her shoulders and her back but rather piled on her head, offering again no protection, no cover either to the viewer's eye or the dangers of the barren landscape.

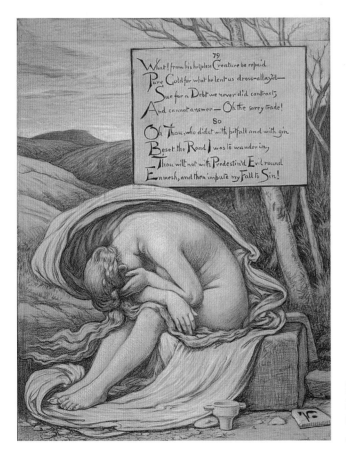

Illustration 47 *Elihu Vedder,* The Magdalen. Illustration for the Rubáiyát of Omar Khayyam *(1883–4: Smithsonian American Art Museum, Washington, DC).*

Her dramatic posture, however, recalls the tradition of penitent Magdalenes in Christian art, who have been overcome by their shame and grief, and who have denied their previous lives by flinging their jewels to the ground.[31] Vedder's figure has only stones to cast, in a visual pun on Jn 8:7. Lamenting her past and perhaps fearing her future, this Magdalene is reminiscent of Pandora—whose opened box simultaneously unleashed evil into the world while nonetheless retaining Hope. Vedder's Magdalene has an open unguent jar—releasing the aroma of sweet myrrh into the world and perhaps suggesting hope in the face of despair and the recognition that even with death, love never dies.

However, Doré's and Tissot's imagery had a wider impact and lasting influence, not only on their nineteenth-century readers but specifically on twentieth-century film and television producers and directors such as Cecil B. DeMille (1881–1959) and Franco Zeffirelli (1923–2019).[32] Further, Vedder's erotic illustration of a penitent Magdalene and the then contemporary fascination with the Orientalist imaging of the biblical figure of Salomé resulted in DeMille's formative cinematic figure of the scantily clad Jacqueline Logan (1904–83) in *King of Kings* (1927). As the nineteenth century ended and the twentieth century began, Mary Magdalene had been transformed once again into that mysterious and enigmatic dichotomy of being simultaneously sinner and saint.

She has waxed and waned as both a spiritual and as a secular image in the multi-media world of the "modern" arts. Haunting but puzzling images of the contemplative penitent have vacillated with depictions of the immoral seductress and the terrified suffering sinner in the competing styles of the secular century from abstraction to cubism through expressionism into post-modernism. Most significantly in the twenty-first century, she has been the topic of television documentaries and popular movies. She has appeared in cinematic biblical epics from the original the *King of Kings* to Martin Scorsese's controversial *The Last Temptation of Christ* (1988) and most recently in Garth Davis's *Mary Magdalene* (2019) as the star of her own movie.

The Magdalene has been the inspiration for twentieth- and twenty-first-century music about lost loves, betrayed wives, jilting vixens, and faithful lovers. She inspired sacred and secular music throughout the twentieth century from Kris Kristofferson's haunting "Magdalene" (1981) to Andrew Lloyd Weber's mournful "I don't know how to love him" from *Jesus Christ Superstar* (1970) to the Legendary Pink Dots' "Casting the Runes" (1988). Several female singer-songwriters promoted the Magdalene theme in their music, whether as individual recordings or in albums or music videos, including Sandra's "Maria Magdalena" (1985), MeShell Ndegeocello's "Mary Magdalene" (1996), Tori

[31]For example, Caravaggio's *Repentant Magdalene* (Galleria Doria Pamphili, Roma) on pages 69–70 of this present volume.

[32]For further discussion of this relationship, see Diane Apostolos-Cappadona, "From Vamp to Saint: Mary Magdalene on the Silver Screen," *Secrets of Mary Magdalene*, edited by Daniel Burstein and Arne de Keijzer (New York: Perseus Books/Squibnocket Press, 2006): 252–59.

Amos's "Marys of the Sea" (2005), and FKA Twigs' "Magdalene" (2018 album). With perhaps the most infamous being Lady Gaga's portrayal of Mary Magdalene in her music video "Judas" (2011).

The inventory of twenty-first-century Magdalene materials also includes Garth Davis's film, *Mary Magdalene* (2018) which offered a distinctive feminist narration of her story clearly influenced as much by Gnostic texts as by recent feminist biblical and theological scholarship as well as a reissued soundtrack celebrating the fiftieth anniversary of *Jesus Christ Superstar*. Moreover, two operas were commissioned to retell the Magdalene's story by Mark Adamo and at least peripherally by John Adams. Commissioned by the Los Angeles Philharmonic, Adams's *The Gospel According to the Other Mary* (2012), subtitled "A Passion Oratorio in two acts," related the final weeks of Jesus's life, including his passion, from the perspective of "the other Mary," that is Mary of Bethany and her siblings Martha and Lazarus. Emphasizing the distinction between Mary Magdalene and Mary of Bethany, Adams promotes his "other Mary" as a social activist who runs a women's shelter.

Adamo's two act opera, *The Gospel of Mary Magdalene* (2013), commissioned by the San Francisco Opera Company, was influenced by the so-called *Gospel of Mary Magdalene*.[33] His opera opens as five modern-day seekers begin a journey to find the truth and voice their negative thoughts about contemporary Christian attitudes toward sex and the subservient place of women in the Church. This Mary Magdalene is not a reformed prostitute but an independent, intensely intelligent, and sensual woman. The Estonian composer Peeter Vähl wrote an oratorio *Mary Magdalene's Gospel* (2010–2011) whose music was to be played in unison with the original Coptic text.

Mary Magdalene has been fictionalized as heroine, victim, and seductress in novels, magazines, and theatrical productions. While the list of novels, even on amazon.com, is fundamentally endless, these have played significant roles in the popular consciousness especially from the mid-twentieth century with the publication of *The Galileans: The Story of Mary Magdalene* (1953) by the American novelist and physician Frank G. Slaughter, and several works of the Greek novelist and philosopher Nikos Kazantzakis including *The Greek Passion* (1954) and *The Last Temptation of Christ* (1960).[34] The explosion of novels about Mary Magdalene began in the early twenty-first-century with the almost simultaneous publication of Margaret George's *Mary, called Magdalene* (2003) and Dan Brown's *The Da Vinci Code* (2003).[35] Quickly followed by over one hundred other novels, the most significant of

[33]Scholars of Early Christianity and Biblical Studies continue to struggle as to the clear identity of the Mary cited in this text; see for example, Karen King, *The Gospel of Mary of Magdala. Jesus and the First Woman Apostle* (Santa Rosa, CA: Polebridge Press, 2003), who supports the attribution to Mary Magdalene; and Stephen J. Shoemaker, *Mary in Early Christian Faith and Devotion* (New Haven, CT: Yale University Press, 2016), who promotes Mary of Nazareth.

[34]*The Greek Passion* was originally published in Britain under the title *Christ Recrucified* in 1948 and made into the 1956 movie *Celui Qui Doit Mourir* (*He Who Must Die*) by Jules Dassin and starring Melina Mercouri as Mary Magdalene. The movie of *The Last Temptation of Christ* was released in 1988, directed by Martin Scorsese and starred Barbara Hershey as Mary Magdalene.

[35]The film version of *The Da Vinci Code* was released in 2006, directed by Ron Howard, and starred Audrey Tatou as the female descendent of Mary Magdalene and Jesus.

which were the four volumes of *The Maeve Chronicles* by Elizabeth Cunningham (2006–11), woven into a Celtic narrative, and most recently the four-volume contemporary thrillers set in the Vatican Secret Archives *The Magdalene Chronicles* by Gary McAvoy (2020–21).

Even in the secular century, the Magdalene cannot be ignored or diminished. She may wane as a devotional or spiritual figure but she never disappears from the human consciousness. Perhaps no twentieth-century artist appreciated her enduring power more than Pablo Picasso (1881–1973). For him, she was the metaphysical embodiment of human frailty tempered by indubitable faith. His numerous renderings of the *Weeping Woman* (Illustration 48) are recognizable descendants of the

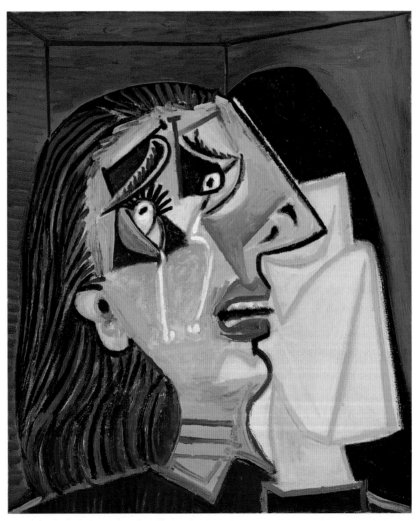

Illustration 48 *Pablo Picasso,* Weeping Woman *(1937: National Gallery of Victoria, Melbourne).*

Christian motif of the Magdalene as holy weeper.[36] Picasso's lamenting woman retrieves that crucial aspect of the Magdalene as the universal female metaphor for public as well as personal agony tempered by faith. Ambiguity and complexity, enigma and solution, injury and balm, sinner and saint—Mary Magdalene expresses and embodies the fullness of human experience. She is the living mirror of the virtue of mercy.

[36]For an in-depth discussion of the relationship between Mary Magdalene and Picasso's *Weeping Women*, see Diane Apostolos-Cappadona, "Pablo Picasso, *The Weeping Woman*," in *Beyond Belief: Modern Art and the Religious Imagination* ed. Rosemary Crumlin (Melbourne: National Gallery of Victoria, 1998): 66–7. Further discussion of Picasso's retrieval of Magdalene imagery can be found in Diane Apostolos-Cappadona, "The Essence of Agony: Grünewald's Influence on Picasso" in *Artibus et Historiae* 26 (1992): 31–48.

7

Coda

"But what," the art historian Erika Langmuir (1931–2015) writes, "of the imagery of that most problematic female saint, Mary Magdalene?"[1] Her image has vacillated between being the first Christian witness to salvation and an excuse for depictions of the female nude. Artists took their visual clues in her transformations from witness to agent as she vanquished a dubious, if not scandalous, past to emerge as the model female penitential saint. Throughout this journey, the Magdalene has exhibited a flexibility in image and definition unknown by other Christian saints.

Her imagery becomes a metaphor for the power of the gaze, for "the gaze," like the Magdalene, has an ambivalent nature. The contemporary emphasis on "the gaze" might sound as if there is a right *and* a wrong way to look; however, the reality is that within the shadows there are other possibilities waiting to emerge. Right and wrong are however culturally conditioned categories—for example, when the Magdalene's image is a visual metaphor for promiscuity or misogyny when seen through "the male gaze." Presentations of her as a beautiful young woman in a state of partial or total nudity are disconcerting to the modern eye as the spiritual and the sexual inhabit separate realms in contemporary culture. Our reactions to the female nude differ—from beauty to pornography to voyeurism.

Feminists, whether artists, writers, or scholars, have taken up the symbolism of the female body as central to their work on the premise that women have had either to surrender control of their bodies to patriarchal societies or have had their innate female sexuality severed from their identity. The latter clearly being the case for female saints and heroes, if not artists and writers in Christian cultures.[2] Kiki Smith, the prolific multi-media feminist artist perhaps best known for her sculptures, has emphasized the beauty, the desecration, and the restoration of the female body in her work. "Our bodies," she said, "are basically stolen from us, and my work is about trying to reclaim one's own turf."[3]

[1] Erika Langmuir, *Pocket Guides: Saints* (London: The National Gallery, 2001), 51.

[2] The constant attempts (as radical as physical disfigurement or simply eating disorders for women, whether in religious orders or lay society) to be like men to succeed or be saved. See, for example, Caroline Walker Bynum, *Holy Feast and Holy Fast: The Religious Significance of Food to Medieval Women* (Berkeley, CA: University of California Press, 1988).

[3] As quoted in Jo Anna Isaac, "Love Calls Us to the Things of this World" in *Kiki Smith* (London: Whitechapel Art Gallery, 1995), 22. Exhibition catalogue.

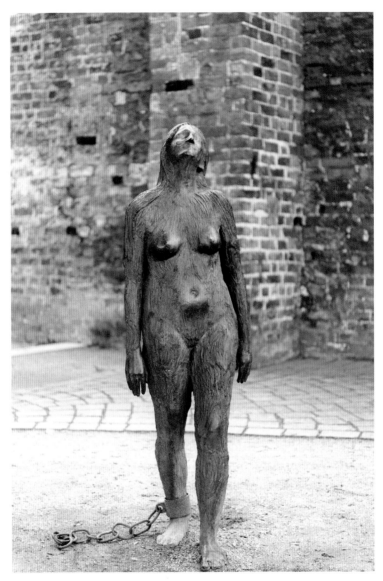

Illustration 49 *Kiki Smith,* Mary Magdalene *(1994: Lubeck, Germany).*

This artistic act of reclamation is especially evident in her *Mary Magdalene* (1994) (Illustration 49) which has often been compared or contrasted to Donatello's *Penitent Magdalene* (1453–55: Museo dell'Opera del Duomo, Firenze). Both sculptors promote the principles of authority and individuality despite the haggard physicality of these upright female figures. Although the upper body and thighs of Donatello's *Magdalene* is covered in animal skins, her arms and legs are bare. As if to emphasize the animal nature of the human, especially of women, Smith has covered her *Magdalene* with hair (also identified by some critics as flayed skin) while her female sexuality is highlighted by the nakedness of

her breasts and womb—as if to signify the female powers of creation and of sustenance of new life. Visually affirming the conflation of Mary Magdalene with Mary of Egypt, these two works—one by an early Renaissance male sculptor and the other by a twentieth-century female sculptor—raise the consciousness of viewers by asking silent questions about mortality, sexuality, and the body–spirit dichotomy.

Smith's sculpture expands the borders of how to see and experience the female body as both an artistic subject and a societal critique caught somewhere between a wild woman of medieval German folklore, an asexual female saint, and the formerly beautiful penitent sinner. The latter signified, perhaps, by the broken chain on her right ankle—symbolic of the Magdalene's continuing ambiguity as she is both trapped and free.

According to Smith, her image of Mary Magdalene was influenced by the French folk tales about the saint's life that she heard as a child. "It is one of many cautionary tales every culture tells to repress the sexuality of young girls: 'Mary Magdalene lives in the wilderness for seven years to atone for her sins. One day while drinking from a pool she sees her image reflected back to her and is condemned again for her narcissism. Her tears create the seven rivers of Provence.'"[4]

So how in the twenty-first century are we to learn from images of Mary Magdalene? How are we to relate not simply to contemporary works of art or societal concerns but to the fullness of her history as expressed in the Magdalene mosaic? What if we employ the wrong frame around her and thereby misinterpret not simply what we see but the intentionality and spirituality of the artist and her contemporary cultural milieu? If Christianity's central mystery of faith is the Incarnation of Jesus Christ—the enfleshment of his divine spirit—then why do Christians shun the significance of the human body? Re-visioning the Magdalene through "the religious gaze" may bring us closer to the believed reality that she was sign and symbol of the sacramentality of the body reborn through the redemptive love of Jesus Christ.

Representations of her body have been evident throughout her visual history as she engages and inspires artists, audiences, theologians, and writers. Learning to read the visual vocabulary of her body may result in the reception and response to the fundamental *empathos* of her witnessing of both the Christian teaching on forgiveness and the promise of the Resurrection. Her physicality transcends human limitations and flourishes in the assemblage of the sacred and the secular personae who bear her name.

[4]Smith is quoted in Isaac, "Love Calls Us to the Things of this World," pages 21–2. With Smith's recitation of these French folk tales, I am reminded once again of the endless task of studying and coming to terms with Mary Magdalene. Despite my many research visits to France, including time in Provençal villages and towns, I have neither read nor heard this tale of the Magdalene's tears creating the seven rivers of Provence.

Part Two

Motifs

As an initiation into a way of *seeing* the meanings and interpretations of the signs and symbols that have formed the Magdalene mosaic, this book is divided into two carefully constructed parts.

In Part One, I raised three central questions: what is the general perception of the woman identified through the centuries as Mary Magdalene? What do the Christian Scriptures reveal about Mary Magdalene? Who has Mary Magdalene become throughout her two-thousand-year journey in Christian art and cultural history?

Now in Part Two, I give attention to ten individual motifs through detailed analyses of works of art as these present the most familiar themes through which the Magdalene is generally characterized from Sinner and Penitent to the present-day Feminist Icon.

Mary Magdalene: A Visual History concludes with a reflective afterword surveying the major exhibitions dedicated to Mary Magdalene and the future of Magdalene studies as well as a select bibliography for continuing your explorations toward the visual history of Mary Magdalene from the earliest representations in Christian art into current times.[1]

[1] A special note that most recently scholars including Joanne Anderson and Penny Howell Jolly have begun careful examinations of the Magdalene's presence in Northern European art and theology.

8

Sinner/Seductress

The Old English *synne* means one who violates divine law, a transgressor against the law of God. The motif of sinner is the best-known characterization of Mary Magdalene although the nature of her sin is never depicted or disclosed. In the post-New Testament interpretations, hymns, sermons, and Christian art, the implication is that because she is a woman her "sin" is sexual in nature. So artistic portrayals of her as a beautiful desirable female figure whose elegant dress and coiffure combine with the sensual tactility of the perfumed ointments in her jar heightened the association of her "sin" with sexual licentiousness. Mark and Luke provide the only scriptural accounts for the identification of Mary of Magdala as sinner—the woman from whom the seven devils were cast out; all the other scriptural references are either to unnamed women or one of the other Marys. The confusion among the multiple "Marys" and several unnamed women in the scriptural narratives proceeded from similarities in their activities, the morals of their stories, or textual proximity. The realities of oral recitation exacerbated the situation by which Mary Magdalene became identified as the anonymous adulteress in the popular consciousness of believers.

The scriptural account of the woman taken in adultery (Jn 8:1–11) relates the Pharisees' unsuccessful maneuver to ensnare Jesus in an act of blasphemy that would effectively terminate his ministry. An unnamed woman, ostensibly apprehended in the act of adultery, was brought before him for judgment according to the Mosaic law (Lev. 20:10; Deut. 22:22–24). Cognizant of the double-edged sword—the punishment for adultery was death by stoning according to the religious code while Roman law permitted only Roman judges to sentence death—Jesus replied initially with silence as he bent down and with his finger began to write on the ground, the only scriptural reference to Jesus writing (Jn 8:6). He advised both the Pharisees and the surrounding crowd that the one among them without sin must cast the first stone.

Once he completed writing, he straightened up and saw only the woman. The absence of her accusers absolved the woman of the charge and the ensuing condemnation. Thereupon, Jesus announced that neither would he judge her and so he sent her home. John the Evangelist is not forthcoming as to what or why Jesus wrote on the ground. The accustomed interpretation is that he

spelled out either the names or the sins of her accusers while the artistic convention has him inscribing the scriptural dictum in Latin, "*Qui sine peccato est vestrum, primus in illam lapidem mittat*," "He that is without sin among you, let him first cast a stone at her."

In the early-fifteenth-century illumination for the Middle High German *Weltchroink* (*World Chronicle*) (Illustration 50), the artist has merged the traditional modes of depicting the episode of the woman taken in adultery in Christian art into one scene. The visual drama of the confrontation sequence on the left is heightened by the singularity of Jesus writing. To the right, the exoneration scene presents the Pharisees, distinguished by their headgear, leaving by the open wooden door as Jesus's gestures communicate the void being left by her accusers and his pardoning of her sin.

Whether correctly identified as images of the unnamed adulteress or implying Mary Magdalene, representations of this scriptural episode became a popular form of visual pedagogy for Christian morality. Book illustrations and prints were the most financially accessible artistic media to a wide audience given the economics of mass production. Lucas van Leyden's (1494–1533) engraving of the *Dance of the Magdalene* (Illustration 51) combined a secular genre scene with "religious art" by condensing three narrative episodes which were rarely depicted but popular in the then contemporary mystery plays. These motifs in this engraving were no doubt influenced by the grisaille miniatures by the Flemish illustrator Godefroy le Batave (fl. 1516–26) highlighting her imagery as a dancer, hunter, and penitent for François Demoulins de Rochefort's (*c.* 1470/80–1526) *Vie de la Magdaléne.*[1]

Just off center in the foreground amidst other couples in varying stages of embrace, the visual emphasis highlighted a stylishly garbed couple striding forward to the music of a drummer and a piper. As medieval and Renaissance courtship included *basse* dances and lute music which were often dedicated to the Magdalene, van Leyden characterizes her as a *mondaine courtesan* enjoying the pleasures of a "love garden" as dancing was a recognized metaphor for sexuality.[2]

The halo encircling her head calls the viewer's attention to the two scenes in the background. In the middle ground and identifiable by her halo, Mary Magdalene rides out ostensibly to hunt stag. In Christian art, however, the white stag symbolized Christ and the theme of the stag hunt was a traditional metaphor of "longing for Christ." Positioned higher above the haloed head of the "dancing Magdalene," van Leyden has placed a rocky mountain in the background to signify both La-Sainte-Baume, renowned site of the Magdalene's solitude and penance, and a small depiction of her daily elevations by four angels to receive celestial food on Mount Pilon.

[1]See note 8 on pages 20–1 of this volume.
[2]Craig Harbison, "Lucas van Leyden, the Magdalen and the Problem of Secularization in early Sixteenth Century Northern Art," *Oud Holland* 98 (1984): 119.

Illustration 50 *Brother Philipp,* Christ and the Woman Taken in Adultery, *Ms. 33, fol. 278. (c. 1400–10: J. Paul Getty Museum, Los Angeles).*

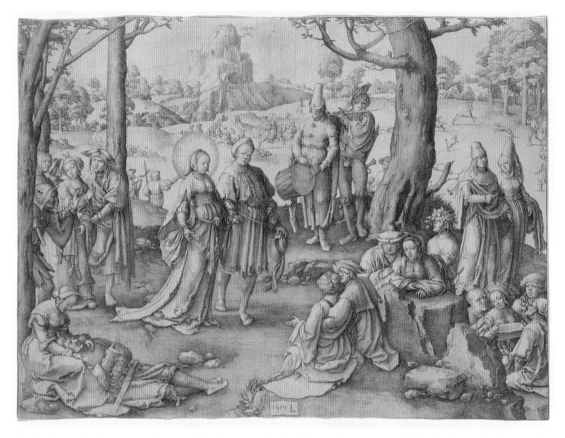

Illustration 51 *Lucas van Leyden,* The Dance of Saint Mary Magdalene *(1519: National Gallery of Art, Washington, DC). Rosenwald Collection.*

In all three episodes, a halo encases her head as van Leyden unites the Magdalene as sinner with the Magdalene as saint in one frame. These visual clues combined with the identification of the once demonically possessed Mary of Magdala as the anonymous adulteress and the unnamed sinful anointer substantiate the initial reading of this image as the drama of her conversion—her physical and spiritual move away from human fallibility to Christian salvation—that endeared her to believers. From that privileged preserve she captured the imagination and the devotion of the Christian faithful, and inspired their spiritual journeys.

9

Penitent

The Latin *paenitens* means one who feels pain or sorrow for sins or offense, thereby one who can be forgiven. While Luke and John provide the biblical basis for the forgiven female sinner neither offered a description of the female penitent. Matthew characterizes the male paradigm of penitence, Peter, as having "wept bitter tears" (Mt. 26:75). Nonetheless, post-New Testament believers and theologians alike understood that prior to the receipt of the gift of forgiveness the anonymous sinner of Luke and the nameless adulteress of John expressed remorse. Once Mary Magdalene was identified as both sinner and saint by Pope Gregory the Great in the sixth century, her penitence garnered spiritual significance. Pious legends and traditions, especially throughout the Middle Ages, affirmed her continuing acts of penitence even into the desert, the wilderness, the city of Ephesus, and the forests of France, or wherever the Christian collective identified her presence.

Mary Magdalene understood and articulated her Christian metanoia by means of the sign of her humanness—her body. Images of the penitent Magdalene instructed by example: her profound contrition warranted absolution. Metanoia led to metamorphosis as the sinner began her transformation into a saint—visually signaled as the elegantly attired and coiffed woman transformed into the contorted, tearful, and disheveled figure of anguished remorse.

Further supported by medieval textual and legendary sources such as Jacobus de Voragine's *The Golden Legend*, this motif of the post-scriptural life of the Magdalene continued her conflation with that other famed prostitute-turned-hermit saint, Mary of Egypt. Both women withdrew from active existence into the "wilderness"—the desert for the Egyptian and the South of France for the Magdalene. They maintained exemplary penitential lives—their days consumed in prayers, contemplation of their sins, and meditation on the meaning of salvation. The fashionable garments of the reformed Alexandrian deteriorated into nothingness as her previously styled tresses grew long enough to cover her "nakedness" before God. In a similar fashion, the penitent Magdalene was recognized both by the tragic posturing of her body, her unkempt hair, and her tattered or perhaps otherwise absent garments. Once her conflation with Mary of Egypt was solidified, Mary Magdalene was also characterized by an abundant mane flowing from her head until it covered her nakedness.

During her years of penitential withdrawal, the Magdalene was reported not to have eaten earthly food but to have survived from either the celestial music of the canonical hours or the heavenly manna offered by the angels. According to Provençal tradition, Mary Magdalene was elevated daily during each of the seven canonical hours by the angelic choirs who descended from the heavens to raise aloft and to serenade the woman identified previously as "fallen."

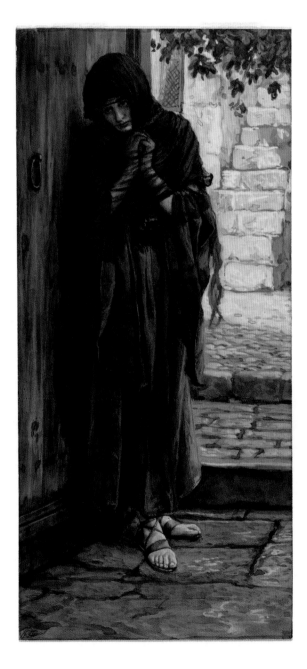

Illustration 52 *James Jacques Tissot,* The Repentant Magdalene *(1886–94: Brooklyn Museum of Art, Brooklyn, NY).*

Perhaps less dramatically postured than Caravaggio's baroque interpretation of female repentance, James Jacques Tissot's presentation of the *Repentant Magdalene* (Illustration 52) was no less effective. Distinct from his earlier stylizations of the fashionably dressed elegant ladies of the *belle epoque*, Tissot fostered a sorrowful and reflective female figuration that came to influence later cinematic and televised renditions of Mary Magdalene.

While she retained the same striped garment worn in the earlier and later episodes in Tissot's *The Life of Our Saviour Jesus Christ: Three-hundred-sixty-five compositions from the Four Gospels* (1899), it appears particularly altered as much by her upright posture as by the diaphanous black veil that covers her tilted head and hunched shoulders, and extends down her right side highlighted by a few loose tresses of her red hair. Huddled against a closed wooden door, the Magdalene appears to lower her head as if to hide both herself and her remorse evident from the lachrymose effluvia welling up in her eyes and her clenched hands, visible through the black veil, as they rest over her heart, reminding us that conversion is characterized as "a turning of the heart."

Tissot situates her in the shadowed side of his composition as the stone steps behind her lead the viewers' sightline upward toward a light-filled area. A lengthy lock of her red hair drops down her left side as if to function as an identifying marker between the darkness that she is about to leave behind her as she enters into the world of light. Further, her red hair is a signifier that this is a depiction of not just any female penitent but of the most significant of all female penitents—Mary Magdalene.

10

Anointer

The Middle English *enoynt* means "to smear with an unguent" and, when referencing religious ceremonies, "to consecrate with oil." Two separate groups of episodes in the New Testament narratives highlight the significance of anointing in the relationship of Mary Magdalene and Jesus of Nazareth. The four Gospels report in varied fashions the initial set of anointing scenes that corresponded with dinners (Mt. 26:6–13; Mk 14:3–9; Lk. 7:36–50; Jn 12:1–8) while only three of the Gospels recount the anointings that followed the Crucifixion (Mk 16:1; Lk. 24:1; Jn 20:39–40). The common threads between these anointings were, of course, the unguent identified fundamentally as spikenard and in the popular consciousness the anointer as Mary Magdalene.

The botanical basis of spikenard, also known as nard, is a flowering plant of the valerian family which originated in the Himalayan regions of Nepal, China, and India. Simultaneously sumptuous and expensive, spikenard was identified as a luxurious perfume in ancient Egypt and Imperial Rome. To secure it from evaporating and to preserve its singular woody and musky fragrance, it was carefully stored in alabaster jars. Botanists and herbalists know it as *nardostachys jatamansi* while homeopaths and aromatherapists mixed spikenard with cardamom and cinnamon either as a lotion to soothe pain and relax tired sore muscles, or as an inhalant to release physical trauma and prepare for transformation and metamorphoses. The use of spikenard either as an opulent perfume or for anointing the body of the dead is referenced in several classical works from Homer's *Iliad* and the *Song of Songs* to Dante's *Inferno*.[1]

The sixth-century apocryphal text known as the *Arabic Infancy Gospel* provides unique insights into the "precious ointment" for these scriptural anointings in its account of the Circumcision of the Infant Jesus in Chapter 5:

[1]With the help of his mother Thetis, Achilles anointed the dead body of Patroclus in *The Iliad*, Book 20; its aromatic and amorous references are found in the *Song of Songs* 1:11, 4:13–14 (Douai-Rheims); and as an element in the burial of the phoenix in *The Inferno*, Canto XXIV. Among the classical Greeks, spikenard, or nard, was also identified with a species of lavender indigenous to the Mediterranean coast.

And the time of circumcision, that is, the eighth day, being at hand, the child was to be circumcised according to the law. Wherefore they circumcised Him in the cave. And the old Hebrew woman took the piece of skin; but some say that she took the navel-string, and laid it past in a jar of old oil of nard. And she had a son, a dealer in unguents, and she gave it to him, saying: See that thou do not sell this jar of unguent of nard, even although three hundred denarii (Jn 12:5) should be offered thee for it. And this is that jar which Mary the sinner bought and poured upon the head and feet of our Lord Jesus Christ, which thereafter she wiped with the hair of her head.

<div align="right">

Lk. 7:37, 38[2]

</div>

This apocryphal episode was validated in the references to both the "precious nature of the ointment" in the alabaster box and its monetary value in Mk 14:3 and Jn 12:5. Legendary, theatrical, and visual depictions of the Magdalene, then, came to represent her in an apothecary shop purchasing this singular alabaster jar (or box) filled with both precious spikenard, the holy prepuce, and perhaps also Jesus' umbilical cord (Illustration 53). Thereby her act (or acts) of anointing him took on the

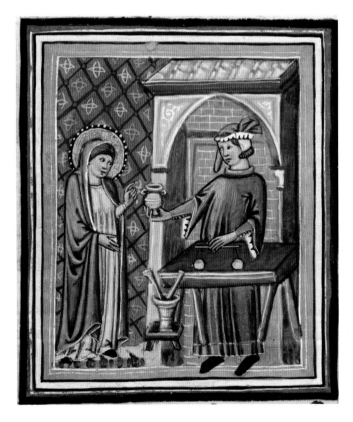

Illustration 53 Female Holy Figure making a purchase at a shop *from an illustrated copy of Saint Bonaventure's* Meditations on the Life of Christ *Ms. CCC 410 f.147 (mid-fourteenth century; Corpus Christi College, Oxford).*

[2]I am grateful to my former student, Daniel G. Callahan, for calling my attention to this episode in *The Arabic Gospel of the Infancy of the Saviour*.

connotation not only of consecration and ritual cleansing but also of a healing of body and spirit. In the classical world of Late Antiquity and Early Christianity to which the Medieval mystery plays, liturgical dramas, and manuscript illuminations was heir, a physical illness or trauma was a tangible sign of spiritual imbalance.

The customary cultural practice of mixing the spikenard with ostensibly "sweet spices" (Mk 16:1) to complement and enhance its woody aroma also had a scriptural basis (Lk. 24:1). Again, the two anointing narratives are brought together through the presence of Mary Magdalene represented by the sixteenth-century Milanese painter Bernardino Luini (1482–1532) (Illustration 54) as she transfers

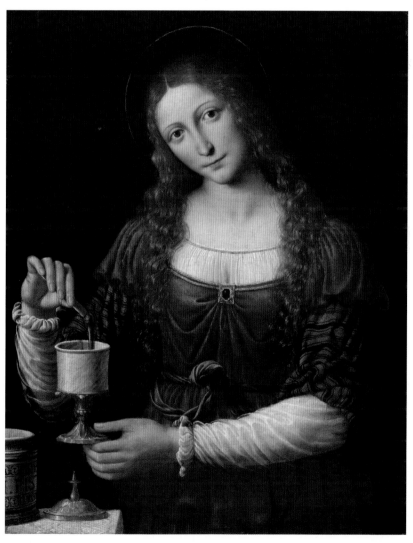

Illustration 54 *Bernardino Luini,* Saint Mary Magdalene (c. *1524: The Walters Art Gallery, Baltimore).*

some of the pure spikenard from the ceramic apothecary jar into the smaller alabaster chalice-like container. The medicinal properties and financial significance of the spikenard is noted by the lettering on the apothecary jar which spell out *pisticus* the Latin for pure or genuine.

In her right hand she deftly handles the precious unguent as it drips slowly from the small pestle into the alabaster receptacle which she holds in left hand to prepare the anointing balm. While this activity may be rarely depicted, the Magdalene is immediately identifiable by her flowing red hair, elegant garment, and the unguent jar as she prepares for her role as the anointer.

11

Weeper

The Old High German *wuofan* means to bewail or to lament. "To weep" connotes the otherwise passive condition of still silence or calmness in which the individual weeper softly and slowly releases the lachrymal effluvia from her eyes. Weeping denotes a self-transcending emotion characterized by a spiritual or internal emotional catharsis. The weeper is configured as sitting quietly with a composed balance of silent tears and measured breaths, so that an aura of stillness prevails: the sounds of silence. The position of the weeper's head may differentiate the salvific nature of her tears from the dignified stature of her erect head to the remorseful sorrow of her drooping head.

The scriptural tradition of tears that vacillated between effluvial expressions of sorrow, remorse, and pleasure in the Hebrew Scriptures was transformed in the Christian Scriptures into the symbol and sign of a person's integrity and honesty. Exemplary tears of entreaty are shed in the Christian Scriptures by Peter (Mt. 26:75; Mk 14:72; Lk. 22:62) and the woman identified as Mary of Magdala (Lk. 7:36–38). What will become an elaborate system of Christian tears begins with the *gratia lacrimarum* ("grace of tears" or "gift of tears") that developed both as a tribute to and a gift from God in the spirituality and texts of the Desert Fathers. This early Christian monastic theology of the *gratia lacrimarum* is confirmed in the Rule of St. Benedict which pronounced that to be pure prayer heartfelt prayer must be accompanied by tears.

The early Christian theology of tears espoused by Tertullian (155–220), Athanasius (*c.* 295–373), John Cassian (*c.* 360–*c.* 435), Ambrose of Milan (*c.* 340–397), Augustine (354–430), and most especially John Climacus (579–649) communicated the principle that tears were the visible but silent symbol of the purification of the soul. "Tears," Ambrose wrote, "are marks of devotion, not merely products of grief."[1] During the Middle Ages, spiritual weeping was revived with the emergence of lay spirituality and devotions which advocated personal experience as the cornerstone of faith. Bernard of Clairvaux (*c.* 1090–1153) affirmed tears as the visible sign of the love of God.

[1] As quoted in James Elkins, *Pictures and Tears* (New York: Routledge, 2001), 150.

The medieval cult of the piety of tears was influenced by the *imitatio Christi* of Thomas à Kempis while Francis of Assisi was described as having been "blinded" not by advancing age or illness but by too many tears. Medieval female mystics recognized weeping as critical to their religious experience. They produced a "literature of visions" which incorporated personal involvement in which tears were the central element. The mystic Mechtild von Magdeburg (*c.* 1209–*c.* 1282/94) voiced a metaphysical explanation of tears as the propagation of God's grace—for as the most human of liquids, tears were shed in repentance, born in recognition of sin, signified self-knowledge, and rejuvenated the soul through salvation.

From its earliest theological references, the Christian "gift of tears" has been referenced in the scriptural and visual motifs of the weeping woman. The female figure identified most often with tears was the *magna peccatrix* ("the great sinner")—Mary Magdalene—who shed penitential tears at her conversion, silent reflections, and throughout her solitude in the wilderness (or desert).[2] However she released copious tears as "the great mourner" at the foot of the cross, at the lamentation and anointing of Christ's body, and during the moments prior to her encounter with the Resurrected Christ (Jn 20:11–16). Only one among several significant scriptural figures who became Christian weepers including David and Peter, Mary Magdalene became *the* female weeper in the Christian religious imagination. Artistic depictions of her bodily contortions and facial expressions symbolized the human conditions of anguish, fear, terror, regret, and sorrow as well as the salvation of "the gift of tears."

The motif of the Magdalene's tears is exemplified in Enquerrand Quarton's *The Avignon Pieta* (Illustration 55). He has removed the mantle from the Magdalene's head so that her copper-colored hair cascades down her left shoulder and back over her russet silk mantle. This "unveiling" paralleled her presentations in medieval liturgical dramas and Passion plays. Her fundamental attributes—hair and ointment jar—are referenced within the motif of her tears as visual connectors of her role as anointer and as a sign of Christian healing in late medieval theology.

As she wipes away her tears with her right hand amid the billowing folds of the yellow silk lining of her mantle, her elaborately decorated blue-and-white apothecary jar is awkwardly positioned on her left hand as if the only support is from her extended fingers not from her open palm. However, the linear formation configured between her left hand and Jesus's left hand creates a plane on which this special container appears to have just been passed from him to her.

[2]Vibeke Olson, "'Woman, Why Weepest Thou?' Mary Magdalene, the Virgin Mary and the Transformative Power of Holy Tears in Late Medieval Devotional Painting" in *Mary Magdalene: Iconographic Studies from the Middle Ages to the Baroque* ed. Michelle A. Erhardt and Amy M. Morris (Leiden: Brill, 2012), 361–82; Diane Apostolos-Cappadona, "'Pray with Tears and Your Request Will Find A Hearing': On the iconology of Magdalene's Tears" in *Holy Tears: Weeping in the Religious Imagination* ed. Kimberley C. Patton and John Stratton Hawley (Princeton: Princeton University Press, 2005), 201–28.

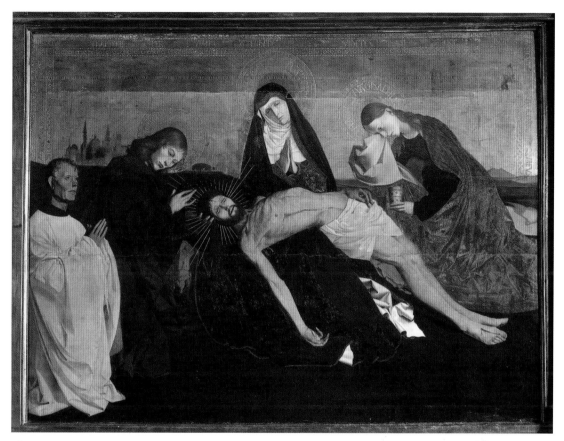

Illustration 55 *Enquerrand Quarton, Detail of Mary Magdalene from the* Pietà of Villeneuve-les-Avignon *(1455: Musée du Louvre, Paris).*

Further, the path of her tears from her left eye downward across her nose and cheek extends from her mantle onto the distorted fingers of Jesus's left hand over his loincloth, as if the tears are dripping into and about to be caught by his right hand—which is bent into the shape of a cup. Mary Magdalene's tears, then, are shed not simply in sorrow or remorse but are received as a liturgical or sacramental offering. She becomes then the vehicle for Quarton's visual endorsement of the Christian theology of tears.

As a mysterious form of expressive bodily effluvia, tears originate from the eye—the source of seeing which coordinates the early Christian metaphor of Jesus Christ as the illuminator who brings to those who are blind in spirit the light of faith. Mary Magdalene embodied the penitential, devotional, and spiritual significance of tears for, as the fourth-century ascetic and monk Evagrius Ponticus advised, "Pray with tears and your request will find a hearing."

12

Witness

The Greek *martyr* is one who beholds, or otherwise has personal knowledge of, something, and who attests to a fact, event, or testimony. Early Christians identified Mary Magdalene as the first witness of the Resurrection. With her singular flexibility, she performed the role of witness in a variety of capacities from her scriptural identity as the woman healed from demonic possession, faithful at the foot of the cross, the anointer, and the "apostle to the apostles." Given her later conflation with the anonymous women and the "other Marys," she testified as a reformed sinner, the forgiven anointer, the observer of Lazarus being raised, and the attentive student. In much of the popular consciousness and artistic representations, the common connective was that Mary Magdalene needed only to *see* to believe. Initially, the magnitude of her tears may have blinded her from seeing clearly and recognizing the stranger she identified as a gardener.[1] However, as she turned away in deep sorrow and despair, the Risen Christ called her name so as she turned, she saw him clearly in the "space between."[2] She is the interlocuter between the sacred mystery of belief and the Christian collective.

As one of "The Three Marys," the Magdalene entered into early Christian art and devotion as a witness to the Resurrection. The story of the holy women bearing aromatic ointments to anoint the body of the crucified Jesus but finding an empty tomb is related by all four Evangelists (Mt. 28:1–8; Mk 16:1–8; Lk. 24:1–11; Jn 20:1–9). From early-fifth-century carved ivories to the late-sixth-century *Rabbula Gospels*, the iconography of the Three Marys[3] gives visual witness to the reality of the biblical accounts.

[1]Depending upon the individual artist, the gardener may be identified by his spade, hoe, or sun hat.

[2]Diane Apostolos-Cappadona, "The Space Between Image and Word: The Journey from Rogier van der Weyden's *Descent from the Cross* to Walter Verdin's *Sliding Time*," *CrossCurrents* 63.1 (2013): 26–43. The latter essay first appeared as "Lo spazio tra imagine e parola: il viaggaio dalla *Deposizione* di Rogier van der Weyden a *Sliding Time* di Walter Verdin" in *La promessa immaginata. Proposre per una teleogia estetica fundamentale* ed. Stefanie Knauss and Davide Zordan (Edizione Dehoniane Scienze Religiose Nuova Serie, 2011), 239–57.

[3]The Evangelists and thereby Christian artists differ on the number of women—Matthew identifies two women (Mt. 28:1); Mark names three women (Mk 16:1); Luke employs the ambiguous "they" (Lk. 24:1); and John designates only Mary Magdalene (Jn 20:1).

Eastern Orthodox Christian tradition identifies the *Myrrophores* (Myrrh-Bearing Women) as the original icon of the historical event of *Pascha* (Easter) signifying he discovery of the empty tomb. Traditionally identified as Mary Magdalene, Mary the wife of Cleophas, and Mary Salome, these *Myrrophores* carry jars of aromatic ointments to anoint the body of Jesus. The acknowledged iconography of the *Anastasis* ("Resurrection") utilized during the Paschal liturgies had two biblical elements: the *Myrrophores* that identified the historic event of the Resurrection and the Descent into Hell its salvific effects.

This iconographic motif identified as the χαίρετώ ("All hail" and transliterated in English as *chairete*) as a greeting of welcome was evidenced by the hand gestures of both the Risen Christ and the two women, ostensibly the Theotokos and the Magdalene, and clearly following Mt. 28:9. The lower register of the illustration for the Crucifixion in the *Rabbula Gospel* (Illustration 56) depicts a three-part visual sequence as the two women encounter the angel, the Empty Tomb is central, and the Risen Christ gestures greeting to his Mother and the Magdalene who kneel at his feet. This motif of the χαίρετώ is the visual foretype for Western Christianity's visual motif of the *Noli Me Tangere* which will emphasize the sense of distancing evident in Jn 20:17.[4]

One of the more intriguing versions of what becomes a popular theme in Western art is by the early-sixteenth-century northern Netherlandish painter, Jacob Cornelisz van Oostsanen

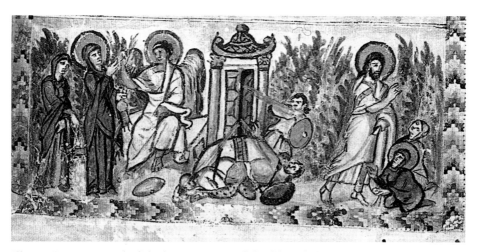

Illustration 56 *Detail of the lower register of the folio of* The Crucifixion and the Holy Women at the sephulchre *from* Rabbula Codex *Cod.*

[4]I want here to emend my original interpretation of this sequence from my essay, "On the Visual and the Vision: The Magdalene in Early Christian and Byzantine Art and Culture" in *Mariam, The Magdalen, and the Mother* ed. Deirdre Good (Bloomington: Indiana University Press, 2005), 123–49; in light of my reading of Polyvios Konis, "The Post Resurrection Appearance of Christ. The Case of the *Chairete* or 'All Hail'," *Rosetta* 1 (2006): 31–40.

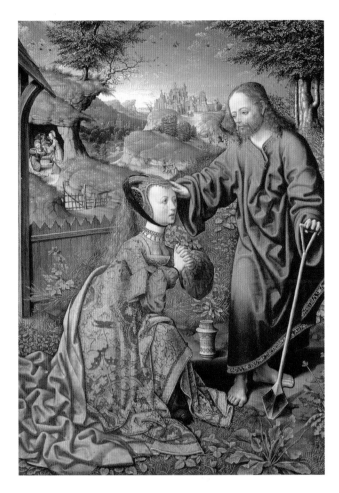

Illustration 57 *Jacob Cornelisz van Oostanen,* Christ the Gardener *(1507: Gemäldegalerie Alte Meister, Kassel).*

(*c.* 1472/1477–1533).[5] Originally identified as *Christ the Gardener* (Illustration 57), this was the artist's first documented work, and his meticulous linear and complex patterns reflects his careful sensitivity to Catholic symbolism and doctrine, and to scriptural narrative. Therefore, the viewer will note a subtle division between the encounter of the two major players in the foreground of this painting, and extended narrative sequences diagonally in a curvilinear configuration across the middle ground into the background from above the kneeling figure of the Magdalene. First, the Three Marys discover the Empty Tomb and then move toward a meeting with the Risen Christ. Moving upward, these scenes are followed by his encounter with the Pilgrims on the Road to Emmaus and ultimately central point level with Christ's head the Supper at Emmaus.

[5]I am grateful to my colleague, Henry Luttikhuisen for sending me his article "Intimacy and Longing: Jacob Cornelisz van Oostsanen and the Distance of Love," in *Ut pictura mor: The Reflexive Imagery of Love in Artistic Theory and Practice, 1500–1700* (Leiden: Brill, 2017), 532–46.

However, it is the reunion between the distraught Mary Magdalene and the Risen Christ in the lush enclosed garden in the foreground that dominates the viewers' attention. Positioned slightly off-center, the elegantly garbed figure of the kneeling Magdalene dominates the painting in her golden brocaded dress, blue underdress, and salmon colored mantle. The elegantly brocaded botanical symbols on her golden dress are highlighted in red and the hem of her garment is trimmed with pearls (which were associated, especially in the Mediterranean, with the goddess Aphrodite (Venus) and as a jewel symbolic of tears given their origin from irritants in oyster shells). The dramatic pose of the Magdalene emphasizes the hapticity of her body as she kneels on her right knee and positions her left knee in an almost perfect vertical line with her tightly clenched hands and the meeting of Christ's left hand on her forehead. Her tear-stained face is further embellished by her extravagant headdress from which her long blond tresses flow down her back.

The standing figure of the Risen Christ is torn between a comforting gesture and the pragmatic hold of his gardener's spade. His lower limbs pull away from the distressed Magdalene as his bare feet are situated akimbo while his torso leans toward the subject of his sightline. His luxuriant blue silk garment is trimmed in gold with the embroidered letters spelling out in Latin *Maria non me tangere / nondum enim ascendiad Patrem.*

Her alabaster jar placed on elevated ground equidistant between them and is covered with two rows of decorative blue and gold geometric configurations divided by a row of blue Roman numerals dating the painting. The vertical line that rises from the ornate salmon-colored cap rises toward the copious sleeve ballooning at the Magdalene's elbow and then escalates not simply to the profuse folds of the hem of Christ's sleeve but highlights again how his left hand touches her forehead. Obviously, van Oostsanen intends the viewer to recognize not simply that Christ touches the one he tells "do not touch" but does so in a way that recalls the so-called *"ne me touché pas"* gesture that results in the living skin fragment on the Magdalene's skull in the reliquary in the crypt of Saint Maximin-La-Sainte-Baume.[6]

Mary Magdalene *experiences* the fullness of the mystery of the Resurrection and is the witness to what she has *seen.*[7]

O ye *blind* unbelievers, deceivers and transgressors, who disbelieved Christ's arising as though it were a lie: What do you *see* that is unbelievable? That Christ, Who raised up the dead is risen?[8]

[6]The skull of Mary Magdalene is preserved in an elegant reliquary of gold and glass in the crypt of the Cathedral of Mary Magdalene in Saint-Maximin-La-Sainte-Baume. The glass cover not only reveals the skeletal face but a smaller container inside its base in which the piece of "living skin" from her forehead is preserved and which is known as the *ne me touché pas* from the French for "do not touch" as pious tradition affirmed that any part of a human body touched by Christ was sanctified and had eternal life.

[7]Thomas' empirical need to touch to believe contrasts sharply to the Magdalene's faith affirmed by *seeing*. This engendered comparison is emphasized in the western Christian iconographies of the *Noli Me Tangere* and that of the *Doubting Thomas*.

[8]*Matins, Ode 8, Tone 2* for the Sunday of the *Myrrophores*. The italicized emphasis is mine.

13

Preacher

The Old French *precheor/prechor* is one who advocates or proclaims a message or a doctrine. The Eastern Christian affirmations of the Magdalene as "the holy equal-unto-the-apostles" found in liturgical prayers and documents highlighted the testimony of her post-Pentecost activities of teaching and preaching in Jerusalem and Rome. She is reported to have preached Christ's Resurrection to the Emperor Tiberius, to have welcomed Paul to Rome, and to have witnessed his trial (Rom 16:6). Later in the city of Ephesus, she assisted John in the writing of the first twenty chapters of his Gospel.

Depictions of the Magdalene Preaching were common in medieval art, literature, and theology, and affirm her importance as she moved from the early medieval female saint identified in the narratives, plays, and depictions of the Passion of Christ to the topic of many *vitae*, artworks, legends, and hymns by the fourteenth century.[1] Beginning in the eleventh century, the many *vitae* which were circulated from her cult in Vézelay, the alternative site of her relics in France, initiated the transformation of her persona. By the twelfth century, the information provided in the many *vitae* including her missionary activities in France was accepted as historical fact including the use of the term *apostolorum apostola*, or "apostle to the apostles," in Western liturgical and theological documents. The first Western depiction of her dispensing the news of the Resurrection to the male disciples was found in the *St. Albans Psalter* (1120–30). By the fifteenth century, several major liturgical dramas were written specifically about Mary Magdalene as the evangelist to France, the most significant being *The Digby Magdalene*.

The Master of the Magdalene Legend (fl.1483–1527) was renowned for an altarpiece originally composed between 1515 and 1520, of four interior and two exterior panels. His iconographic plan surveyed medieval *vitae* and legends, *The Golden Legend*, and was no doubt influenced by the seventy-two grisaille miniatures highlighting her imagery as a dancer, hunter, and preacher as well as the anointer and a sister of Lazarus. These miniatures were created by the Flemish illustrator Godefroy

[1]Jansen, *The Making of the Magdalen*; Diane Apostolos-Cappadona, "From *Apostola Apostolarum* to Provençal Evangelist: On the evolution of a medieval motif for Mary Magdalene" in *Mary Magdalene in Medieval Culture: Conflicted Roles* ed. Peter Loewen and Robin Waugh (New York: Routledge, 2014): 163–80.

le Batave (fl.1516–26) for François Demoulins de Rochefort's (*c.* 1470/80–1526) *Vie de la Magdaléne* that had been specially commissioned as a devotional book by Louise de Savoy (1476–1531), the mother of the French King François I.[2]

The interior four panels were intended to be "read" from left to right as if it were a written text. The first panel, *Saint Mary Magdalene Hunting, or The Hunt of Saint Mary Magdalene*, begins the narrative. In the foreground an elegantly dressed and coiffed Magdalene holds a hawk, a hunting bird, as she searches for the white stag which was a symbol for Christ and the stag hunt a metaphor of "longing for Christ." In the background, Christ preaches to an attentive Mary Magdalene. The second panel, *Dinner in the House of Simon the Pharisee*, depicts Mary Magdalene anointing and kissing the feet of Jesus of Nazareth. Her open ointment jar allows the aromatic ointment to fill the air. The third panel, *Resurrection of Lazarus*, includes Mary Magdalene weeping for her loss of her brother Lazarus.

The fourth panel, *Saint Mary Magdalene Preaching* (Illustration 58), includes two levels of visuals at the center of which is a woman garbed in golden brocade trimmed in dark green and wrapped in a shimmering white and soft blue mantle. Three women are seated in the foreground but only one has a child, ostensibly a son. In her right hand, she holds an apple which the child reaches for with his right hand similar to images of the Madonna and Child where the apple signified Original Sin. All three women are attentive to the central female figure who stands on an elevated dais framed by four trees with a hewn branch resting horizontally before Mary Magdalene allowing her to place her left hand, palm side down, upon this branch and to raise her right hand in a traditional preaching posture. To her right, a youth dressed in white, like a server or acolyte, rests his left hand on his heart; while on her left, two gentlemen gesture in conversation. No one in the congregation suggests either by hand gestures or bodily postures that it was unusual that a woman is preaching.

The background elements, especially the docked boat and the woman asleep in the cave, corroborate the Magdalene's missionary activities, for after their conversion to Christianity the King of Provence and his pregnant wife embarked upon for a pilgrimage to the Holy Land. The storm-racked seas so traumatized the Queen as she gave birth to her son that she lost consciousness. Mistaken for dead, the "lifeless" mother and her weak infant were abandoned on an island. On his return voyage, the King found his wife and young son in the care of Mary Magdalene. To the far right is Zosimas dressed in a monastic grey habit and kneeling ostensibly before a vision of the Elevation of Mary Magdalene.

Across these four interior panels, the viewer has been moved from the Magdalene as hunter to the Magdalene as preacher, from Christ's preaching to her to her preaching about Christ to others.

[2]See note 8 on page 21 of this volume.

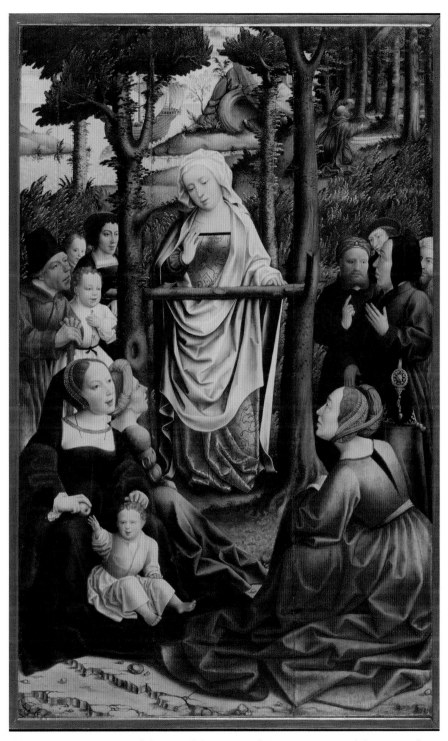

Illustration 58 *Master of the Magdalene Legend*, Saint Mary Magdalene Preaching
(c. *1500–20: Philadelphia Museum of Art, Philadelphia).*

14

Contemplative

The Latin *con* + *templum* means meditation on spiritual things, the act of considering by attention, musing, study. This motif developed from the Lucan account of Lazarus's two sisters, Martha and Mary, as female metaphors of the active and contemplative lives. When Jesus came to their home in Bethany, Mary attended to spiritual instruction at his feet. Martha had to complete all the necessary household duties alone. When she voiced her displeasure, Jesus replied that Mary had chosen the better part. The personification of the active life, Martha was characterized by pragmatism, efficiency, domesticity, and industriousness. The embodiment of the contemplative life, Mary exemplified spirituality, quietude, tranquility, and otherworldliness. As the confusion of Mary Magdalene with Mary of Bethany occurred in earliest Christianity,[1] depictions of the Magdalene as a contemplative balanced the emotively charged images of her mourning at the foot of the cross or the entombment.

The tranquility and otherworldly indicative of the motif of contemplation are displayed in the early-sixteenth-century French limestone sculpture of the *Saint Mary Magdalene* (Illustration 59). This statue of the stylishly garbed female saint related to those late medieval sculptures and fifteenth- and sixteenth-century artworks of the Magdalene as an individual seemingly removed from a particular scriptural or legendary narrative.

This graceful but thoughtful figure maintains her precious ointment jar on her left hand as she slightly tips open the lid with her right hand. Her lavish hair extends beyond the confines of her elegant headpiece to flow down her shoulders and her back. Her calm composure in an encounter as consoling as Christian anointing exudes from her inner quietude. The classical perception of the affinity between physical and spiritual healing is transmitted to the Christian sacraments of chrismation and unction. Not simply the preserve of the dead and dying, holy anointing is the Christian ritual seal of spiritual solace and protection. This refined sculptural interpretation of the Magdalene proffers a similar ambience for her audience.

[1]Mark Goodacre, "The Magdalene Effect: Reading and Misreading the Composite Mary in Early Christian Works" in *Rediscovering the Marys: Maria, Mariamne, Miriam* ed. Mary Ann Beavis and Ally Kateusz (London: Bloomsbury T&T Clark, 2020): 7–24.

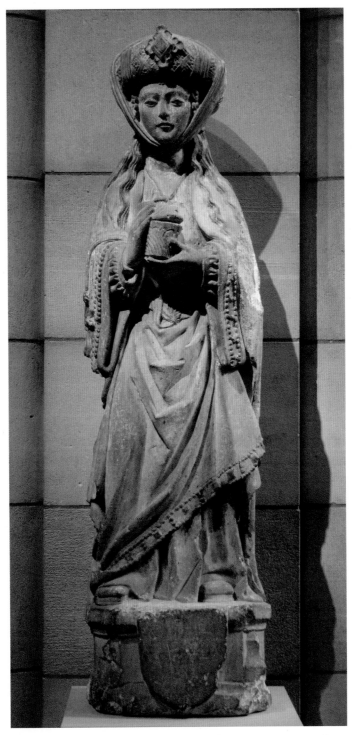

Illustration 59 Saint Mary Magdalene (c. *1500–25: Metropolitan Museum of Art, New York*).

Depictions such as this limestone sculpture of *Saint Mary Magdalene* reference not simply the multiple biblical unction episodes but may be related to the apocryphal account in which "the old Hebrew woman" placed the foreskin (and "navel-string") of the recently circumcised Jesus in an ointment jar to preserve it. This same jar was purchased by "Mary the sinner" for his anointing.[2] Thereby image and story merge into a ritualizing act which clarifies what had been previously obstructive for the soul.

The seventeenth-century French artist Georges de la Tour (1593–1659) created a series of paintings of the *Repentant Magdalene* (Illustration 60) in poses of spiritual introspection and corporeal calm. Cognizant of her role as the symbol of the Sacrament of Penance for contemporary Roman Catholics, La Tour exercised a minimal and somber palette to correspond with the simplification of forms and elements within the frame of this painting. His visualization of the power of the dialogue between light and shadow was not simply as mood inducers or representatives of good and evil, rather this artist encourages reflection on the traditional principles of the light coming out of the darkness as both spiritual enlightenment and visual clarity.

The unpretentious composition shows the Magdalene seated quietly in relative obscurity and positioned with her shadowy yet curvilinear left arm supporting the extension of her hand and elongated fingers. She digitally investigates the form and features of the skull that rests upon a thick bound volume, ostensibly the Bible, while across the covered table is a wooden-framed mirror. At first glance in the mirror, it appears that there is a snake reminiscent of the biblical episode of the Temptation and the Fall winding its way up the tome, though in reality this is most likely a ribbon place marker. The artist draws attention to the single candle flickering beyond the skull as it illuminates the Magdalene's right arm and segments of her facial profile as well as casting a reflection of the skull in the mirror on the far border of the frame.

This candlelit scene endorses the poignant silence that is often identified with the Magdalene as both a figure of penance and a hermit-like existence during her thirty years in La-Saint-Baume. As she tranquilly meditates on the meaning of her previous sinful life and the forgiveness she received from Christ, La Tour's Magdalene is surrounded by those symbols of *vanitas* and *memento mori* — respectively the mirror and the skull—that signify the transitory nature of life and the certainty of death. So she is not simply the symbol of the Sacrament of Penance but the confirmation of the meaning of metanoia and metamorphosis.

[2] *The Arabic Gospel of the Infancy of the Saviour*, Chapter 5. I am grateful to my former student, Daniel G. Callahan, for calling my attention to this story; see note 2 on page 108 of this volume.

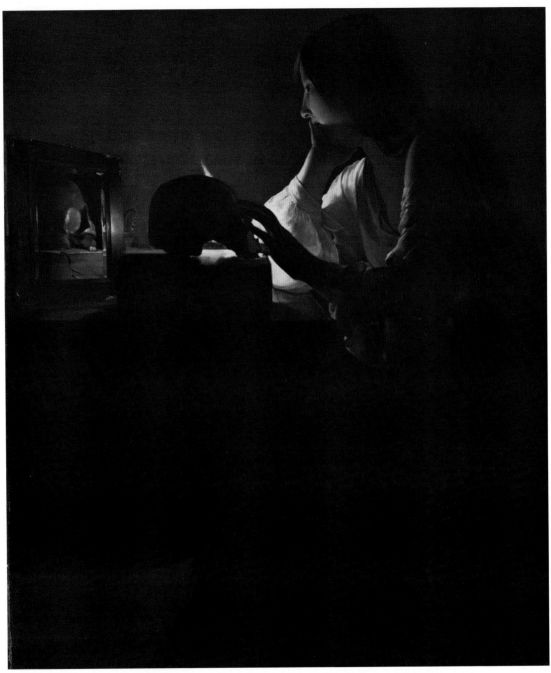
Illustration 60 *Georges de La Tour,* The Repentant Magdalen *(c. 1635–40: National Gallery of Art, Washington, DC).*

15

Reader

The Old High German *rātan/rāten* means to discern, to interpret. The act of reading is an encounter with a silent world of ideas, an experience of introspection; so the Magdalene as reader manifested contemplation. The medieval perception of reading was as an act of devotion evidenced by the representations of absorption in the text and which was internalized as reflected in the intense body posture of the reader. In the Middle Ages, reading could be explained through the then-common metaphor of the book as food—the reader ruminated carefully to digest the masticated text. She assimilated and then eliminated the text. To the medieval mind, this bodily elimination was significant as it was only possible once the *meaning* of the text had been absorbed—the excretion was the longed-for devotional vision. Medieval depictions of a reader engaged in meditation upon a text are deceptive to modern eyes for the surface beauty is subordinate to the radiance of the reader's vision. If the medieval picture of the reader is an *exemplum*, that is a moralizing image, then the inclusion of her vision demonstrates the lesson.

During the Middle Ages, readers formed personal relationships with their books, most especially with those illustrated texts which permitted access to religious devotion. Illuminated prayer books, such as Books of Hours, were personalized to fortify individual meditative practice. The emerging lay devotional movements such as the *Devotio Moderna* and the Brotherhood of the Common Life advocated literacy and favored the production of affordable devotional books. In her pioneering essay on "Medieval Women Book Owners," the feminist historian Susan Groag Bell affirmed the value of Books of Hours for medieval women readers whose "public participation in spiritual life was not welcomed by the hierarchical male establishment; a close involvement with religious devotional literature, inoffensive because of its privacy, took on a greater importance for women."[1]

Rogier van der Weyden's (1399–1464) *The Magdalen Reading* (Illustration 61) is the first known painted depiction of this saint as a reader and his iconographic innovation found favor among the

[1]Susan Groag Bell, "Medieval Women Book Owners: Arbiters of Lay Piety and Ambassadors of Culture," *Signs* 7.4 (1982): 742–68.

Christian community, especially in the northern countries, and established an artistic vogue for this theme.[2] The exquisite painting references simultaneously her Christian dedication and the active principle of female literacy among the followers of the *Devotio Moderna* as well as among communities of female monastics and tertiaries such the Beguines.

She is dressed in elegant fur-trimmed green silken overdress with a linear pleating on the bodice which was accentuated by the blue sash that descends from her waist down her left side to the floor.

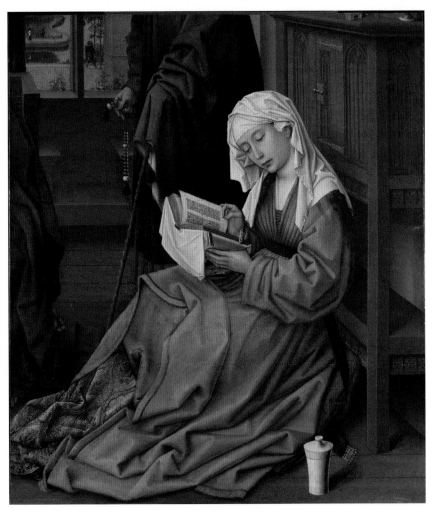

Illustration 61 *Rogier van der Weyden,* The Magdalene Reading *(before 1438: The National Gallery, London).*

[2]Ambrosius Benson, Adriaen Isenbrandt, and the Master of the Female Half-Lengths among other Northern artists each produced a corpus of paintings of the Magdalene reading after van der Weyden, see Max J. Friedländer, *Early Netherlandish Painting* (New York: Praeger Publishing, 1967), Volume 7: plates 148, 175; Volume 12: plate 42.

Her sash ends in a golden beaded tassel which highlights her otherwise simple white alabaster jar. Her voluminous and layered skirt is folded back atop her knees and reveals both its grey fur trimmed lining and her underdress of elegant light green brocade trimmed at the hem with pearls, rubies, and sapphires. While this sartorial elegance was typical in medieval and Renaissance depictions of Mary Magdalene, it clearly alludes to her former life of luxury while the simplicity of her overdress and fluted white headdress signify the spiritual austerity of her dedication to the religious life.

The semicircular formation of her body curving around the open book in her hands was a visual means of expressing the significance of both her act of reading and her absorption in her text. Rogier has deftly created a triangular harmony from the white book-cover or *chemise* in the Magdalene's hands upward to her ruffled headpiece and then downward to her white alabaster jar creating additional emotive response in his viewers. The employment of the color white highlights her delicately-manicured hands and her elongated fingers in which she holds her Book of Hours; the flow of her red tresses escaping from her headpiece down her shoulders with the wisps over her left ear; and that ever-present alabaster jar.

The careful demarcation of her own space implies the intimacy of her private devotions which are interrupted visually by the artist's alignment of three significant devices—a simplified alabaster vessel, a Book of Hours, and a linear amber rosary—in a diagonal progression moving upwards from the lower right corner toward the window. This carefully situated confluence affirms the identity of the subject of this painting as the Magdalene. The alabaster jar is the attribute symbolic of her role as anointer while her Book of Hours signifies the daily spiritual devotions popular among medieval Christians especially women. The rosary beads held by Saint Joseph intensifies the devotional prayers and contemplative life of the Magdalene. Further, to the medieval mind her ointment jar confirms that she was the first witness to the Resurrection; her Book of Hours that she was a paradigm of Christian devotions; and the rosary beads that she meditated upon the salvific meaning of the Incarnation and the Resurrection.

16

Patron

The Latin *patrōnus* is the protector or defender of a believer. Christian tradition identifies a patron saint as a celestial advocate of a nation, place, activity, a family, or an individual person. Given her remarkable narratives and flexibility, Mary Magdalene was the celebrated patron of a diversity of professions, individuals, and causes including couturiers, hairdressers, healers, nurses, hospitals, penitents, monastic orders, and perfumers and perfumiers. Throughout the Middle Ages and into the Renaissance, she was the spiritual advocate of confraternities that practiced self-flagellation as a corporal penance for the remission of the sins of the wider community.

The Tuscan artist Spinello Aretino (Spinello di Luca Spinella) (*c.* 1345/52–1410) received a commission from the *Confraternita di Santa Maria Maddalena* (Confraternity of Saint Mary Magdalene) in the city of Borgo San Sepolcro[1] (Sansepolcro) in Arezzo for a six feet by four feet processional banner that featured a hieratic image of Mary Magdalene (Illustration 62) which could also be used as an altarpiece. Founded in the fourteenth century (*c.* 1334), the *Confraternita di Santa Maria Maddalena* was dedicated to the rehabilitation of prostitutes and the shelter of indigent women including support for new lives in either marriage or the convent

Confraternities were voluntary groups of laymen who functioned on behalf of their community separate from the organized auspices of the church. Dedicated to experiential piety and charitable corporate activities including the burial of the dead (both members and the poor), the feeding of the poor, and in some cases self-flagellation as mode of communal penance, confraternities did not require members to take religious vows. Prominent members of a community, flagellants wore sack-like hooded robes (*sacci*) with slits cut for their eyes and an opening on their backs for the scourging. In accordance with Christ's command that almsgiving should be anonymous and against vain prayer (Mt. 6:1–5), their hoods left them faceless and unidentifiable.

[1]*San Sepolcro* is Latin for "Holy Sepulchre" and this town was established in Arezzo in the tenth century by pilgrims from the Holy Land who brought with them relics from Christ's tomb which provided an immediate evocation of Mary Magdalene.

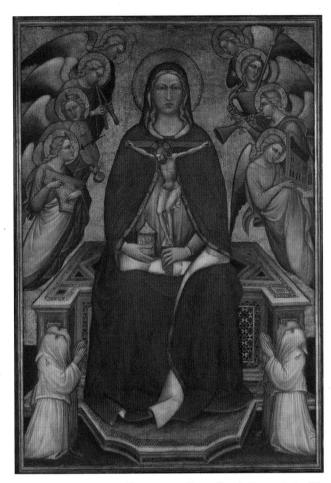

Illustration 62 *Spinelli Aretino (Spinello di Luca Spinelli), Mary Magdalene Holding a Crucifix (c. 1395–1400: Metropolitan Museum of Art, New York).*

As a group, these laymen performed well choreographed activities including processing with lit tapers, gilded processional crosses, and their banners. They chanted and sang *laudi*, which were hymns of praise and devotional songs to their patron similar to those of the music-making angels that surrounded the Magdalene daily at La-Sainte-Baume and in Aretino's work. Banners identified the group and provided visual and devotional stimuli to members during religious processions. Directed to the audience to encourage devotion, the front of a banner was composed of a highly stylized formal image of the confraternity's patron saint surrounded by its members. On the lower register of Aretino's presentation of Mary Magdalene enthroned, two pairs of kneeling hooded flagellants were identifiable by her emblem on their shoulders and each held a cord with three glittery metal barbs. The back of a processional banner was directed to the members as visual affirmation of their group character and purpose so that Aretino painted the reverse with an image of the Flagellation of Christ.

Dressed in a blue garment and covered in a gold-trimmed and white-lined red mantle which covers her body and her head as several blonde tresses escape over her forehead and shoulders, Aretino's depiction of Mary Magdalene clearly signals her role as anointer and witness. In her right hand, she holds a gilded container with a closed triangular lid capped by a stopper incorporating a globe topped by the cross signifying the universal message of Christianity. As an obvious trinitarian reference her anointing "emblem" is repeated three times: first in her right hand, and then on the shoulders of the two pairs of kneeling flagellants.

Some observers of this banner have identified the golden container in the Magdalene's right hand as a *pyx*[2] and associate it with her role as the anointer. However, the pyx is the small round container used to transport the consecrated host to the sick and those otherwise unable to come to church. Perhaps more importantly when referencing the Magdalene's affected metanoia and metamorphosis, the pyx conveyed *viaticum*[3] which is the consecrated host for the Eucharist offered to a person near or in danger of death.

In her left hand rests a large tau-shaped wooden cross, above which rests the superscription almost like a clasp atop her mantle. The figure of the crucified Christ slouches toward his right as both his feet rest on the *suppadaneum* (footrest). The blood from the lance wound in his side spurts in the Byzantine fashion toward the cross atop the Magdalene's gilded container. His sloping head is encased in the cruciform nimbus signifying the simultaneity of his death and the promise of his resurrection—both events for which the Magdalene stood as witness.

[2] The term *pyx* comes from the Latin transliteration of the Greek *pyxis* for boxwood container.
[3] The term *viaticum* comes from the Latin for "provision for a journey."

17

Feminist Icon

Deriving from the Latin *femina* for "woman" and the Greek *eikon* for "portrait or likeness," this conceptual language expands the traditional categories of the equality of the sexes and of a sacred image for religious worship. Building on the late-twentieth-century concept of a popular culture icon, a feminist icon could be defined as a representation of a monumental figure whether male or female, or an institution representative of any movement advocating for the rights and equality of women. Thereby, referencing the Magdalene as a feminist icon reflects both her singular identity and her corporate role within Christian cultural history. Perhaps her most singular characteristic is that she was an independent woman not identified by a male relation—husband, father, brother, or son. Mary Magdalene may be the most flexible and thereby complex female figure in Christian art as she projects inspiration and empowerment as well as anguish, anxiety, and yet serenity throughout the scriptural and apocryphal narratives, devotional and legendary texts, and pious traditions.

More often than not, biblical narratives about women emphasize that they are typically either silent or voiceless, and yet defined by their actions in the face of injustice, false accusations, or societal hypocrisy. Whether we find Mary Magdalene anointing, preaching, or even weeping she is an active agent and not simply a passive subordinate. No matter how briefly mentioned other unique women in the Christian scriptures may be, especially the Samaritan woman, the woman with the issue of blood (or Haemorrhissa), and the Canaanite (or Syrophoenician) woman signify dramatic and unconventional actions by Jesus highlighting a more egalitarian relationship between men and women. Of all the women in the New Testament, the Magdalene represents most dramatically the struggle against female oppression consistent with patriarchal institutions, vernacular, and societies. However, hers is the most fully developed persona among the women of the New Testament with the exception of the Virgin Mary, so the Magdalene became a timeless yet malleable symbol for the cultural transformations of women and their roles in Christian history.

Revisionist, especially feminist, studies of the pre-fourth-century Christian culture have endorsed the principles that the marginalized, including women like Mary Magdalene, found activities and roles, even leadership, in the new social order promoted by the message and the praxis of early

Christianity. However once Christianity became the official religion of the Empire, it adapted not only the structures and protocols of the imperial court but also Rome's fundamentally androcentric vocabulary and values. So that the marginalized were once more submissive to patriarchal exclusivity, and women like Mary Magdalene were no longer the agents of religious discourse but simply saintly exempla as they suited the purposes of the ecclesiastical hierarchy.

Yet, Mary Magdalene endured, was transformed, and even flourished throughout Christianity's two millenia to become a symbol for the feminist revolutions of the late nineteenth to the twenty-first centuries. Perhaps without the vociferous speeches, dramatic activities, or social media of the suffragettes, Equal Rights Amendment promoters, or "Me Too" survivors; nonetheless, Mary Magdalene has motivated the voiceless and the discouraged. No matter how insignificant or docile her behaviors of weeping, speaking, praying, or anointing might be characterized, her actions encouraged both men and women in the struggle for liberation and agency in all its forms economic, political, social, and spiritual.

Looking as if she is caught between leaning forward as if to kneel or backwards to sit, American artist Frank Sabatté has offered a unique twist to his early-twenty-first century depiction of *The Magdalene* (Illustration 63). Wrapped in a simple mantle of lustrous shades of red ranging from garnet to burgundy, this Magdalene suggests a naturalness of a lethargic calm having completed her task as her unlidded unguent jar rests in the foreground. Her reddish tinged long and thick hair flows down her back. Ostensibly she looks simultaneously outward toward viewers and upward toward Jesus who is seated in our midst.

The inscription to her left reflects the notable, especially for feminists, passage from Mark 14:9 (and Mt. 26:13) in which her action as anointer is not simply acknowledged but celebrated. This scriptural text is written in variations of blues and reds corresponding to the woven trim in the center of her mantle. The coordinated use of text and image harkens back to the early Byzantine and medieval practice of highlighting the critical reference within the frame of an image. Here the artist honors the Magdalene, her action, and the ritual of anointing as this is all "in memory of her."

In tandem with the tradition of Byzantine icons, the American artist Richard Stodart painted *Mary Magdalene* (Illustration 64) in a frontal pose as her enlarged eyes engage her viewers. Her eyes emphasize compassion as they draw the viewers' attention upward toward the center of the white veil that covers her head, and then across its luminescent highlights toward the white egg in her upraised left hand.

The artist's inspiration came from the tradition of the Magdalene's testimony before the Emperor Tiberius in Rome when the white egg in her hand turned red as proof of the Resurrection.[1] For

[1] See the discussion of this tradition and its liturgical significance in Eastern Christianity on pages 25–7 of this volume.

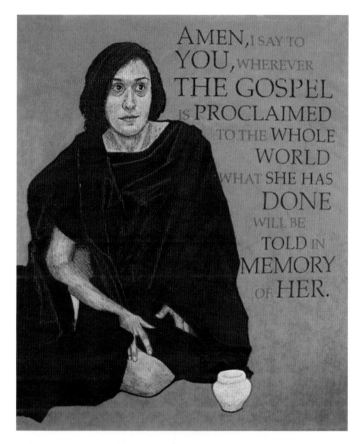

Illustration 63 *Frank Sabatté, CSP,* Mary Magdalene *(2003–4: Collection of the Artist).*

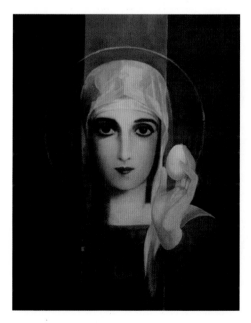

Illustration 64 *Richard Stodart,* Mary Magdalene *(1995: Collection of the Artist).*

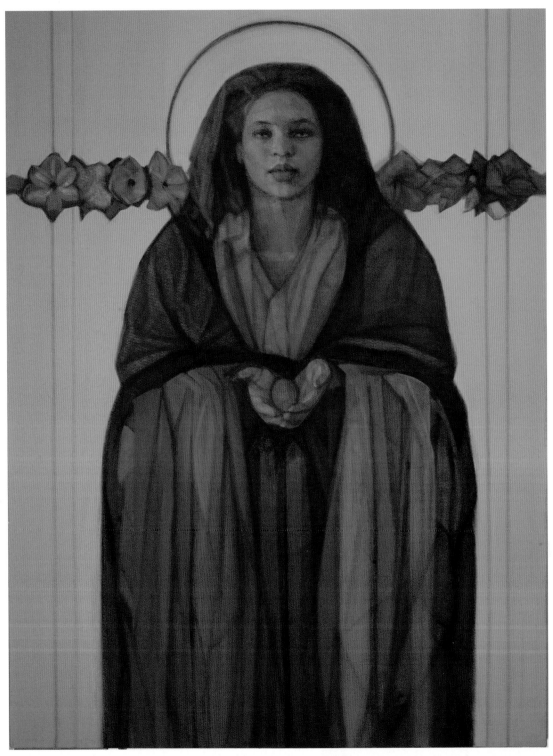

Illustration 65 *Janet McKenzie,* Mary Magdalene—An Invitation to Love *(2010: North Congregational United Church of Christ, Columbus, OH).*

Stodart, the white egg underscores her "faith that it will turn red" and he notes that his specific use of green signifying the generative earth for her dress, the red lines positioned over her heart to denote earth, sky, and spirit, and blue vertical column over her head as a centering point. She presences the eternal gifts of metanoia, unction, and transformation even for contemporary artists and viewers.

Janet McKenzie expands our preconceived boundaries of race and ethnicity in her painting entitled *Mary Magdalene—An Invitation to Love* (Illustration 65). Hers is a rendition of the Magdalene who exudes calmness and composure as she offers forth that red egg in her open hands—both hands to signify her open heart. The soft lushness of her earth tones in her voluminous garment both shelter her body but do not hide her femaleness which is highlighted in the soulful beauty of her face. Her eyes—open to the world and to all who see her—project a gentle but palpable confidence as she stands dignified and empowered as her own agent and yet simultaneously as every woman. McKenzie's Magdalene is not confined in a specific time or place but offers through her multi-racial physiognomy and skin color a recognition of the Magdalene's geographic heritage and of the future of a more just world.

The artist was familiar with the Eastern Christian narrative of Mary Magdalene standing alone before the Emperor Tiberius and confronting him—the ultimate earthly power in control of her world—with the white egg. When I asked why she selected this episode as significant for her twenty-first-century painting of Mary Magdalene, she stated:

> This story resonated deeply with me, as a woman and became very personal. We as woman so often are not believed but must prove what we say, create, and do, time and time again. I feel like we must work twice as hard. My life is filled with my own versions of this story. I grew up hearing the stories of my grandmother and mother and friends over time who experienced the same thing. Of course, we were and are not blessed to have such concrete proof as a red egg changing before the male non-believer, but the essence of the story remains the same. Mary Magdalene, who is such a beloved and hopeful archetype for women the world over, was the first one sent forth to proclaim the Resurrection, was faithful to Jesus' vision of the realm of God in which all are included—and justice reigns. She speaks to women.[2]

[2]From our email correspondence of September 24, 2021.

Afterword: A Reflection on Exhibitions

Upon reflection, an overview of the six major exhibitions focusing on Mary Magdalene highlight her journey into the twenty-first century. The earliest twentieth-century retrospective, and perhaps the largest, display of her iconography in traditional works of art and popular devotion, was organized by Marilena Mosco for the Galleria degli Uffizi as part of the celebration of Florence as the European Capital of Culture in 1986. Entitled *La Maddalena tra Sacro e Profane da Giotto a De Chirico*, this exposition of over 127 works traced the traditional themes relating the Magdalene to biblical narrative and Christian theology beginning with the art of the late Medieval/early Renaissance into the twentieth century.[1]

Maria Magdalena éxtasis y arrepentimiento was curated by Odile Delenda for the Museo Nacional de San Carlos, Mexico City, in 2001.[2] Over 96 works of art were coordinated from both small and large international museums, and again focused on the traditional topics beginning with the texts of the Gospels and concluding with the Magdalene legends. The following year, *In Search of Mary Magdalene: Images and Traditions* curated by Diane Apostolos-Cappadona was organized for the Gallery of the American Bible Society in New York City.[3] This more diverse display of over 80 works of art and objects of material and popular culture including paintings, prints and engravings, drawings, sculptures,

[1]Marilena Mosco, *La Maddalena tra Sacro e Profano da Giotto a De Chrico* (Milano: Arnoldo Mandadori Editore, 1968). This exhibition catalogue includes interpretive essays, catalogue entries, multiple full-color illustrations, and an extensive bibliography. It was published in Italian. The exhibition was on view at the Galleria degli Uffizi from May 24 to September 7, 1986.

[2]Odile Delenda, *Maria Magdalena éxtasis y arrepentimiento* (Colima, Mexico: Conaulta INBA, 2001) followed a traditional museum format with interpretative essays and catalogue entries, full-color illustrations, and an extensive bibliography. It was published in Spanish. The exhibition was on view at the Museo Nacional de San Carlos in the summer of 2001.

[3]Diane Apostolos-Cappadona, *In Search of Mary Magdalene: Images and Traditions* (New York: The Gallery of the American Bible Society, 2002). While following the traditional format of an interpretive essay with appended catalogue motifs, and full-color illustrations, this volume included a series of specialized bibliographies. It was published in English. The exhibition was on view at The Gallery of the American Bible Society from April 5 to June 22, 2002.

devotional items, icons, book jackets, CD and album covers, and film stills traced the iconography of Mary Magdalene from her biblical origins into the consciousness of twentieth-century viewers.

A sensitively arranged dossier exhibition *The Prado at the Meadows: Jusepe de Ribera's Mary Magdalene in a New Context* was curated by Gabriele Finaldi for the Meadows Museum at Southern Methodist University, Dallas, in 2011–12.[4] As part of the ongoing exchange between the Museo Nacional del Prado in Madrid and the Meadows Museum, this concerted presentation was complemented by *The Many Lives of Mary Magdalene: A Selection of Images from the Bridewell Library Special Collections* organized by Eric M. White. These rare books, manuscripts, and prints and engravings added wider devotional and theological contexts to the paintings on view.

The journalist and critic Vittorio Sgarbi curated *La Maddalena tra Peccato e Penitenza* for the Museo-Antico Tesoro della Santa Casa, Loreto, in 2016–17.[5] This display of over 50 works of traditional art spanning the Middle Ages onwards into the nineteenth century was organized as part of the Jubilee of Mercy celebrated in 2016 and highlighted the Magdalene as being a fully human woman caught between sin and penance. Clearly influenced by both contemporary novels such as *The Da Vinci Code*, and movies, television documentaries, and popular culture, Sgarbi's interpretation of the Magdalene emphasized her emotional and intense relationship with Jesus Christ.

Most recently, Lieke Wijnia has curated the exhibition entitled *Mary Magdalene: Chief Witness, Sinner, Feminist* for the Museum Catharijneconvent, Utrecht.[6] As with many other programs planned for 2020, this exhibition had a delayed opening in June 2021. The many and diverse works on view including painting, sculptures, illuminated manuscripts, prints and engravings, devotional items, and photographs were complemented by an interactive website and digitized multidisciplinary expert interviews. While offering a chronological display of the many themes and motifs related to Mary Magdalene from the early Christian era to the present, this exhibition accentuated the interests of twenty-first century feminist scholars and artists and offered insights into revisions of the Magdalene through a feminist lens into the twenty-first century and beyond.

A prominent figure in the popular consciousness for over two-thousand years, the cultural, theological, and artistic history of Mary Magdalene remains open to further investigations. When I returned to Spain for research in 2019, especially during my days in Barcelona and Vic, I was once

[4]Gabriele Finaldi, *Jusepe de Ribera's Mary Magdalene in a New Context* (Dallas: The Meadows Museum, 2011) followed the traditional museum format of interpretive essays, catalogue entries, full-color illustrations, and an extensive bibliography. It was published in English and Spanish. The two exhibitions were on view at The Meadows Museum from September 18, 2011, to January 15, 2012.

[5]Vittorio Sgarbi, *La Maddalena tra Peccato e Penitenza* (Milano: Silvani Editore, 2016) includes interpretive essays, catalogue entries, full-color illustrations, and bibliography. It was published in Italian. The exhibition was on view at the Museo-Antico Tesoro della Santa Casa from September 4, 2016, to January 8, 2017.

[6]Lieke Wijnia, *Mary Magdalene: Chief Witness, Sinner, Feminist* (Zwolle: Waanders Publishers, 2021) incorporates interpretative essays, full-color illustrations, and a bibliography. It was published in both an English language and a Dutch language edition. The exhibition was on view at the Catharijneconvent from June 25, 2021, to January 9, 2022.

again reminded how little has been published in English or studied about this biblical woman in terms of the religious art and history of the Iberian Peninsula as well as the so-called "New World" of Latin America, South America, and the Caribbean. Given the many works of art, especially altarpieces, dedicated to her along with works of literature and musical compositions, it is clear she played a significant role for nuns and abbesses as well as lay women. Presentations of the Magdalene not simply as a penitent or first witness but as an apostle and preacher can be found in the museums, convents, and churches of Catalonia.[7] Further documentation of her significance in the religious lives of Catholic Spain can be found in the literature (sermons, homilies, poems, letters, and discourses) written by abbesses for whom the Magdalene as preacher was an inspiration and a defense.[8]

There is much to be gained in terms of investigations into the cultural meanings and symbolism of Mary Magdalene in African and Asian Christianity, and in the Eastern Christian traditions particularly in the Middle East and North Africa. Additionally, individual volumes can easily be written about the Magdalene in literature, in the performing arts, in cinema, in photography, and in popular and material culture as well as in the continuing evolution of gender, race, and ethnic studies. *Mary Magdalene: A Visual History* is an initiation into her iconography and cultural history but hopefully raises for readers new questions leading to the many avenues in Magdalene studies yet to be written "in memory of her."

[7] I was quite stunned by the several altarpieces of varying sizes used either for personal devotions, in chapels, or on ecclesial altars which were on display in the fourteenth-century Real Monestir de Santa Maria de Pedrables in Barcelona. Further medieval and renaissance altarpieces devoted to Mary Magdalene can be found in Girona, Vic, and other locations in Catalonia as well as in the collections of the Museu Nacional d'Art de Catalunya in Barcelona and the Museo Nacional del Prado in Madrid.

[8] For example, Teresa of Avila referred to Mary Magdalene as an exemplar for preaching women, see Carol Slade, *St. Teresa of Avila: Author of a Heroic Life* (Berkeley: University of California Press, 1995). Further excellent sources on the Magdalene as an inspiration for Catholic women in Spain include Jessica A. Boon, "A Full Figured Paradox: Mary Magdalene as Prostitute, Apostle, Virgin, Ascetic and Contemplation" and María Cruz de Carlos Varona, "Saints and Sinners in Madrid and Naples: St. Mary Magdalene as a Model of Conversion and Penance" in *Jusepe de Ribera's Mary Magdalene in a New Context* edited by Gabriele Finaldi, pages 91–101 and 79–90, respectively.

Select Bibliography

As with other figures whose lives and influences cross over a variety of fields from art and art history, cultural history, and performance studies to theology and women's studies as Mary Magdalene does, the bibliography is fundamentally endless. Beyond the journal articles and books listed in the occasional footnotes throughout this present text, the following select books, currently available and in English, provide the most recent scholarship related to the visual history of Mary Magdalene.

Anderson, Joanne W. *Moving with the Magdalen: Late Medieval Art and Devotion in the Alps*. London: Bloomsbury Visual Arts, 2019.

Arnold, Margaret. *The Magdalene in the Reformation*. Cambridge, MA: Harvard University Press, 2018.

Beavis, Mary Ann and Ally Kateusz (eds). *Rediscovering the Marys: Maria, Mariamne, Miriam*. Scriptural Traces. London: Bloomsbury T&T Clark, 2020.

Coletti, Theresa. *Mary Magdalen and the Drama of the Saints: Theatre, Gender and Religion in Late Medieval England*. Philadelphia: University of Pennsylvania Press, 2004.

Erhardt, Michelle A. and Amy M. Morris (eds). *Mary Magdalene: Iconographic Studies from the Middle Ages to the Baroque*. Studies in Religion and the Arts. Leiden: Brill, 2012.

Fedele, Anna. *Looking for Mary Magdalene; Alternative Pilgrimage and Ritual Creativity at Catholic Shrines in France*. New York: Oxford University Press, 2013.

Haskins, Susan. *Mary Magdalen: Myth and Metaphor*. London: HarperCollins, 1993.

Jansen, Katherine Ludwig. *The Making of the Magdalen: Preaching and Popular Devotion in the Late Middle Ages*. Princeton: Princeton University Press, 2000.

Jolly, Penny Howell. *Picturing the "Pregnant" Magdalene in Northern Art, 1430–1550: Addressing and Undressing the Sinner-Saint*. Burlington: Ashgate Publishing, 2014.

Lejmann, Anne-Sophie, "The Rising of Mary Magdalene in Feminist Art History" in *Doing Gender in Media, Art, and Culture*. New York: Routledge, 2009; 134–50.

Loewen, Peter V. and Robin Waugh (eds). *Mary Magdalene in Medieval Culture: Conflicted Roles*. New York: Routledge, 2014.

Lupieri, Edmondo F. (ed). *Mary Magdalene from the New Testament to the New Age and Beyond*. Themes in Biblical Narrative. Leiden: Brill, 2019.

"Mary Magdalene" in *Encyclopedia of the Bible and Its Reception*, Volume 17: 1207–32. Berlin/Boston: Walter de Gruyter, 2019.

Wijnia, Lieke (ed). *Mary Magdalene: Chief Witness, Sinner, Feminist*. Utrecht and Zwolle: Museum Catherijneconvent and Waanders Publishers, 2021. Exhibition catalogue.

Wijnia, Lieke. *The Lamentation of the Dying Mary Magdalene: Melchior de la Mars (c. 1580–1650) and the Power of emotion in the Counter-Reformation*. Antwerp: The Phoebus Foundation Chancellery, 2021.

Index